The Theater Posters of James McMullan

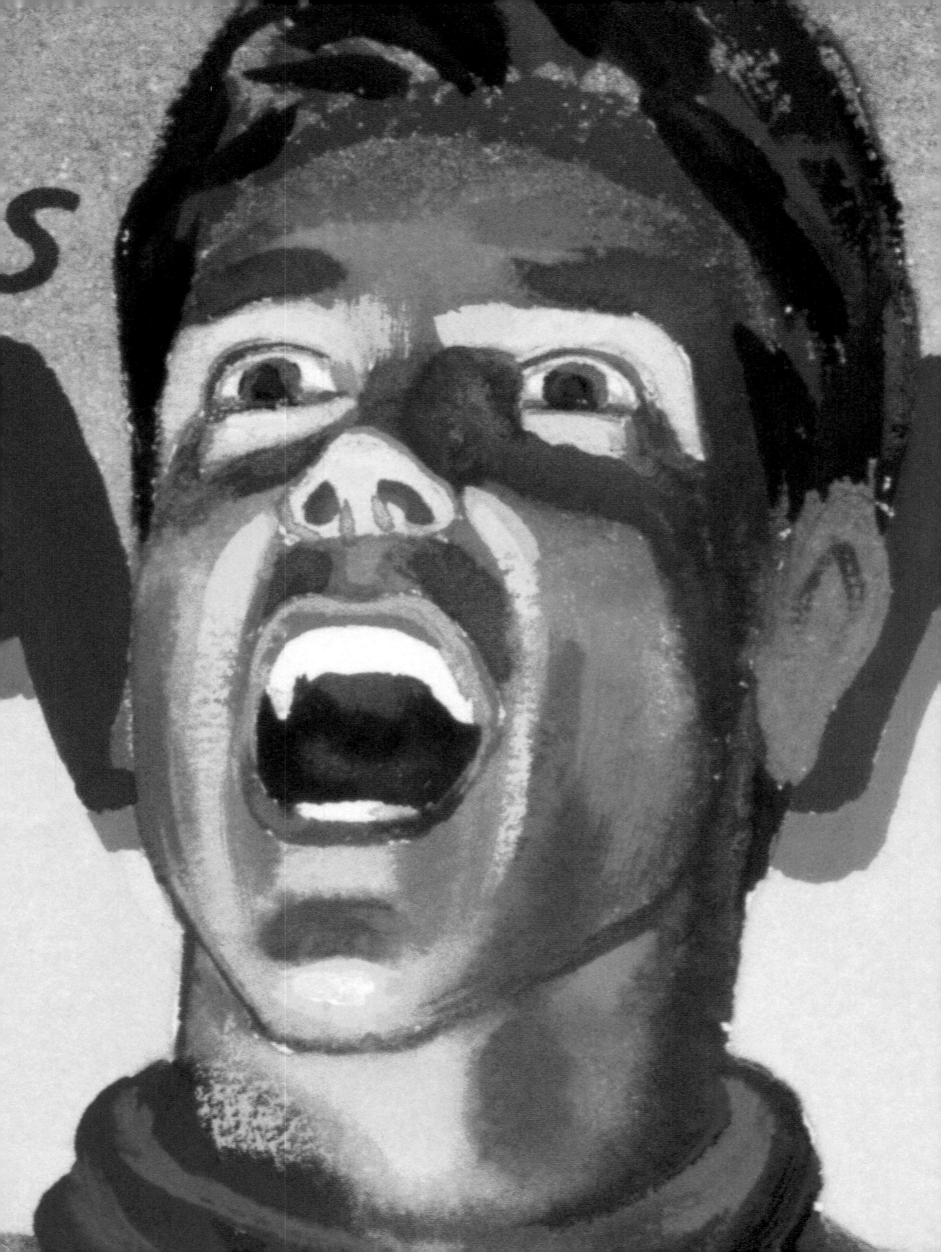

The Theater Posters of James McMullan

James McMullan

Foreword by Bernard Gersten

Introduction by John Guare

PENGUIN
STUDIO

For Kate

PENGUIN STUDIO
Published by the Penguin Group
Penguin Putnam Inc., 375 Hudson Street,
New York, New York 10014, U.S.A.
Penguin Books Ltd, 27 Wrights Lane,
London W8 5TZ, England
Penguin Books Australia Ltd, Ringwood,
Victoria, Australia
Penguin Books Canada Ltd, 10 Alcorn Avenue,
Toronto, Ontario, Canada M4V 3B2
Penguin Books (N.Z.) Ltd, 182–190 Wairau Road,
Auckland 10, New Zealand
Penguin India, 210 Chiranjiv Tower, 43 Nehru Place,
New Delhi 11009, India

Penguin Books Ltd, Registered Offices:
Harmondsworth, Middlesex, England

First published in 1998 by Penguin Studio,
a member of Penguin Putnam Inc.

1 3 5 7 9 10 8 6 4 2

CIP data available
ISBN 0–670–87683–6
Printed in Japan

Designed by Richard Mantel

Acknowledgments

This book could never have existed without the opportunity given me by Lincoln Center Theater to do its posters, and the generous support of many people in that institution. Foremost I would like to thank Executive Producer Bernard Gersten (we were introduced by Alexander Cohen, my original poster patron), who chose me and thereby gave me a life-changing gift. Bernie's championship of my work has been creatively supported by both Greg Mosher and André Bishop, and I thank both of those Artistic Directors for the thoughtful way in which they responded to my designs. The Lincoln Center Theater Board has also been generous in its recognition of my work. I particularly thank Mary and John Lindsay, Joe and Joan Cullman, and Linda Leroy Janklow for their friendship and support. Tom Cott, as Director of Marketing, and Jim Russek in his leadership role at Russek Advertising have been amazing allies over these eleven years, and I can't imagine the endeavor without their friendly participation. Russek's designer, Janice Brunell, has adapted my designs for the newspaper and other uses with great sensitivity.

Just as the experience of certain productions stands out in my memory, so does the cooperation of certain directors: Jerry Zaks for helping me with all his plays, particularly with the photographing of Ed Lauter for *The Front Page*; Ulu Grosbard for taking me to an Orthodox Temple when I was preparing to do the poster for *The Tenth Man*; Gerald Gutierrez in directing the photo shoot of Cherry Jones for *The Heiress* poster. Remembering Cherry Jones's wonderful posing reminds me of how much she and all the other actors have contributed to the posters. Ed Lauter, of course, James McDaniel in *Six Degrees of Separation*, John Mahoney in *The House of Blue Leaves*, Spiro Malas in *The Most Happy Fella*, Sam Waterston in *Abe Lincoln in Illinois*, Michael Hayden in *Carousel*, Richard Clarke and Josef Sommer in *Racing Demon*, Matt McGrath in *A Fair Country*, Spalding Gray in *It's a Slippery Slope*, Kate Nelligan in *An American Daughter*, Sam Trammell in *Ah, Wilderness!* Playwrights have been a particularly vivid and memorable part of my experience with the theater, and I am grateful to Richard Nelson, Wendy Wasserstein, Jean-Marie Besset, Tom Stoppard, Jon Robin Baitz, Craig Lucas, and Tina Howe for helping me to understand their plays. One playwright I have left to thank separately, not only because our deliberations were particularly intense on all three of his plays, but also because he has so generously written of my work in the past and has provided this book its one moment of literature—his incredible introduction. That playwright, of course, is John Guare. Thank you, John.

The making of this book itself owes a huge amount to the organization, personal support, and opinion of my talented assistant, Robert Babboni. Without Rob's rational perspective and help with the details it would have been very difficult to tackle this project at all. Another major co-conspirator in this project has been Richard Mantel, the book's designer. Richard worked for three months trying out various ways of organizing the material in the book so that it would make sense without looking didactic. His solution is wonderful, and I am grateful to him for putting my work in the best possible light. My wife Kate McMullan's editing provided this book with its first line of defense against incoherence. I thank her with all my heart, not only for her sleight of hand on my behalf, but for going through the wars of my creative life with me and not forgiving my enemies even after I have.

I also want to thank my literary agent, Rosemary Sandberg, for introducing me to Michael Fragnito, the publisher of Penguin Studio Books, and to Christopher Sweet, my editor, as well as associate editor Rachel Tsutsumi, and assistant production manager Stacy Rockwood. Rosemary made the perfect match between book and publisher, and because of that I have enjoyed Michael's great enthusiasm for this project and Christopher's intelligent guidance through all the stages.

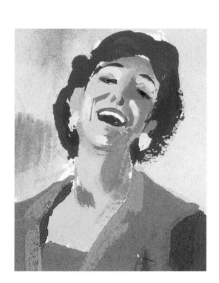

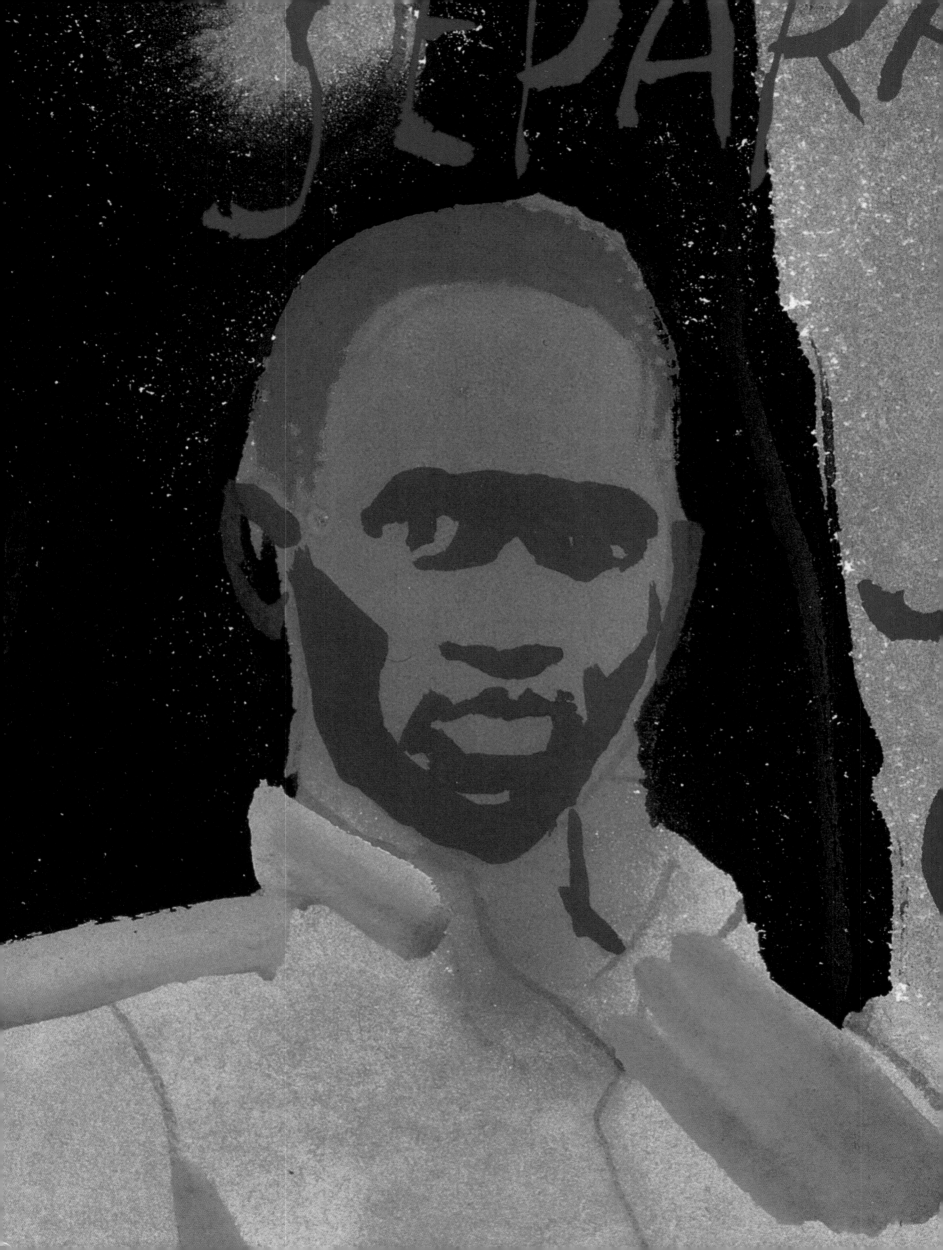

Foreword

Since the reestablishment of Lincoln Center Theater in 1985, Jim McMullan has painted thirty-five posters for thirty-three theatrical productions and in so doing has created a visual identity and style that demark the theater, conveying in a single image the title of the play, a vivification of one or more characters in the play in a dramatic moment, the names of the author and the director of the play, and the theater where it is being performed. In the case of McMullan posters for Lincoln Center Theater, we believe something significantly more is communicated: the posters, springing as they do from a single sensibility, McMullan's, represent his illustrative fix on a very diverse lot of plays and musicals. Simultaneously, the posters reflect the theater that has produced these plays: they are a kind of laminate communication device, a composite of three sensibilities—the artist, the play, and the theater. It's a lot to get into a 42-by-84-inch four-color poster!

Designing theater posters exists in a Bermuda Triangle of fine art, illustration, and advertising, and the poster artist needs exceptional skills to survive the process. The way "the process" works at Lincoln Center Theater is something like this: a play or a musical work is selected for production, either singly or as one of a group of plays planned for the two theaters at Lincoln Center or for one of the frequently utilized Broadway theaters. The producers, the marketing director, and the head of the advertising agency confer, either by phone or at a meeting, to discuss visual imagery for the play or plays. This is the start of the hunt for the poster that will be the visual metaphor, that will convey in one frame the key information about a complex and detailed play (or musical), that will catch the attention of the viewer, that will break from the pack of similar information being offered in similar locations about similar plays, that will "read" best in its full-size, full-color lithograph version but will be equally enchanting when presented in a black-and-white newspaper in two columns by six inches amid a riot of ads all crying for the attention of the reader. Or should it perhaps be a photograph rather than a painting?

Once the decision to have Jim do a poster is reached, he is sent the script, urged to read it quickly, and asked how-soon-can-he-have-a-sketch-there-are-ad-deadlines-and-it's-already-late. Frequently there are discussions between Jim and the director of the play or even the author. Ideas incubate. Sometimes Jim phones to say he has one or more pencil sketches he'd like to bring in. Sometimes Jim phones to say he's painted a little painting that he kind of likes and can he come right over. Sometimes Jim decides to photograph a model or models in a simulated situation—a kind of pose—with hints of costumes and props. Sometimes Jim is stuck, and tortuous discussions ensue.

Eventually the day of reckoning arrives: Jim has a poster to submit. The hard question is whether he should deliver it in person or send it by messenger. This seemingly simple decision hinges on the feelings of the artist as well as the feelings of those who are going to "audition" the painting upon arrival. No rule prevails: if Jim unveils the art, he has to endure the moments between presentation and response, daring the viewers—almost always the Philistines—not to like it, not to understand what the artist is getting at. There is the delay while the executive producer, the artistic director, and the marketing director consider the painting, reach individual conclusions, and then express their opinions, each trying to be truthful, each wanting to love the submission, and each having to be honest, painful as that sometimes is. When Jim sends the art, the discussion can be less guarded, differences of opinion can be argued, a consensus reached. Some posters are immediate buys, engendering unanimous enthusiasm and general euphoria at having an extraordinary poster. Others need to be lived with and looked at over a number of days; finally either they are accepted, modifications are negotiated, or Jim is asked to start over.

Before a poster is finally approved, it is submitted (as a courtesy as much as out of necessity) to the author, the director of the play, and the star or stars who are depicted (a whole other set of problems!) or, worse yet, omitted or represented by a stand-in for the leading character. Not until all resistance is overcome, and the range of opinions of diversely opinionated individuals is brought into some approximation of agreement, is the poster finally approved and granted the status of "production art," now to be shaped into three-sheets, window card posters, bus ads, *Playbill* covers, title art, and color and black-and-white newspaper and magazine advertisements.

Lincoln Center Theater is not absolutist; there is no supreme leader whose regard for a piece of art would overwhelm all contrary opinions. Sometimes Jim himself convinces the uncommitted to allow the poster to grow on them, and he frequently carries the day. Over time, virtually all the McMullan posters have won the hearts of the theater companies he has illustrated; they understand and appreciate that they have been painted by an artist.

Productions of plays are momentary things: they appear, they strut and fret their hour upon the stage, and then are heard no more. The actors disperse, the scenery goes into a Dumpster, the theater falls in love with a new work, little remains except in the memory of those touched by the play. But one of the remains is that unusual artifact that played an essential role in the life of the play, capturing and transmitting a visual essence, often informing even the actors of some inner truth perceived and revealed in a painting by an extraordinary master of theater poster art, James McMullan.

—BERNARD GERSTEN, *Executive Producer, Lincoln Center Theater*

Introduction

John Guare

The theater poster. What is it but a rectangular piece of cardboard with stars' names on it? Right? When I was a kid, another of the prime reasons to be a playwright was you would have a poster with your name and the title of your play on it that you could then hang in the living room of your inevitable penthouse. The poster as souvenir.

In the early 1950s, I read in Walter Winchell's column that the new musical *Damn Yankees* had opened to smash reviews but, mysteriously, was doing no business. Winchell knew why. The poster. The poster? The poster showed the star, Gwen Verdon, in a baggy baseball shirt and cap and great legs, winding up to toss out a slapstick comedy pitch. With sibylline authority Winchell pointed out the arcane truth that the public always avoids shows about baseball (as well as plays and movies with "love" in the title). The producers saw the error of their ways and quickly changed the baseball poster to one that flaunted a skimpily dressed Gwen Verdon as the brazen Lola, belting out a song. The public flocked. The show ran the proverbial years. The poster as mind control?

In 1971 my play *The House of Blue Leaves* opened off-Broadway to good reviews, but one real problem. Nobody could come up with a poster that caught the spirit of a comedy about a songwriting zookeeper about to commit his wife to a mental hospital. A friend of the producers had a five-year-old son who scrawled a house with a tree on fire that for a while became the logo for the program. I would like to say "and that kid grew up to be Jim McMullan"—but no, that kid's logo didn't work, didn't define or capture the spirit of anything. Maybe we could borrow Gwen Verdon in a bikini. When we won the Obie and the Drama Critics Circle Award for best American play that year, the producers issued a solemn green poster listing the prestigious awards, with a bright orange disc behind the title. The play closed after ten months when the theater burned down. A tree on fire? Maybe the five-year-old could see the future. So I had a play, ostensibly a hit, that left in its wake no poster—nor a penthouse to hang it in. The next plays were done at the Public Theater, which didn't do posters unless you transferred. Then you were rewarded with a monumental Paul Davis—remember Sam Waterston's cry as Hamlet, Raul Julia's imperious, impervious Mack the Knife in *The Threepenny Opera*? Or Martha Swope's glittering photograph of *A Chorus Line*? Alas, I didn't transfer. Absence of poster as proof of failure.

In late 1985, after a period of darkness, Lincoln Center Theater opened under the new aegis of Bernard Gersten and Gregory Mosher, who would revive *The House of Blue Leaves* as their second production. They wanted to establish their presence in the city with a poster campaign for the play that would appear in the papers and in train and subway stations. I didn't have high hopes. Over the years I had

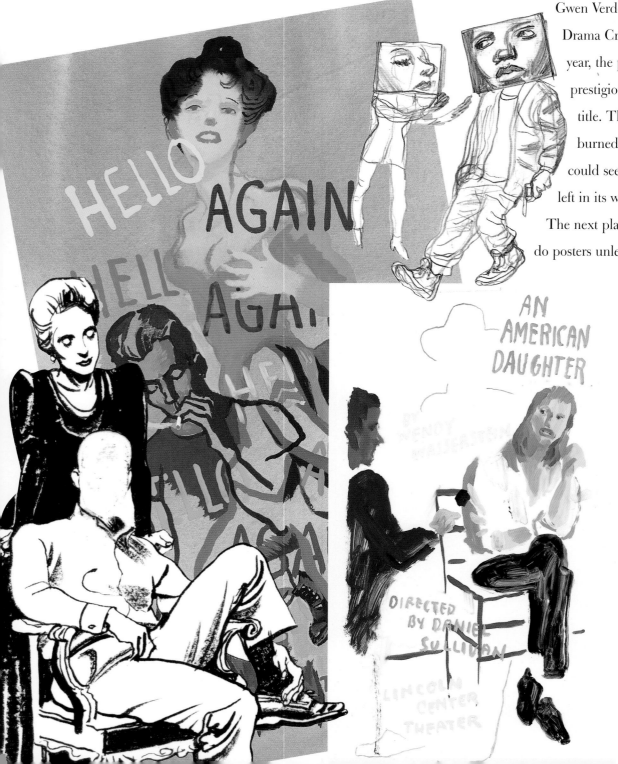

seen various posters for the play in different productions that were mostly cloyingly sensitive: delicate blue leaves. My play was poster-resistant. But Gersten, after leaving Joe Papp, worked with the Broadway producer Alexander Cohen, who had commissioned an illustrator named James McMullan to design the posters for two plays: Trevor Griffiths's *Comedians* and Eugene O'Neill's *Anna Christie*. The two posters had become classics. Bernard called me up to his Lincoln Center office to meet McMullan and see his design for my play.

The poster—the original watercolor is in front of me now—was so simple. A man in work clothes, sitting jauntily on a red kitchen chair, turns to sing directly to us, the viewers, as he manically plays an upright piano for our approval. He sits in a pale yellow spotlight; the agitated watercolors around him are purple and green, which conjure up something vivid—but also unhealthy. The title of the play bounces over his head like lettering on a movie marquee. Why was the poster instantly so merry and inviting—and yet so unsettling? To use something as evanescent as watercolor in a poster that demanded instant attention against all the other posters in public places seemed daring. Don't posters demand hard-edged acrylics? And yet it worked. The very wateriness of the watercolor gives the singer's happiness an extraordinary transitory feeling. There is something desperately impermanent and heroic about its joy. McMullan understood the play so well. His solution seemed obvious—it's a play about a man who wants to bring joy? Show him at his happiest. That simple.

McMullan has said, "I don't invent from thin air, but from my response to real physical information. . . . The vitality of the human body, closely observed in its idiosyncrasies, is what has always fascinated me about the posters of Toulouse-Lautrec. . . . The body itself became a quickly understood gesture like the movement of a mime or a dance."

I can imagine a lot about McMullan by knowing a few facts of his life: that he was born in China, in Tsingtao in Shantung Province, the son of missionaries who later lived in India and

Canada, getting out the word. I see McMullan as a theater missionary, getting out the word to as many people as possible. His birth in Shantung, the source of legendary silk, makes me think of McMullan turning out beautiful silks. I think of his lettering as calligraphy. Realities? He went to Pratt in the 1950s. Did he ever want to be a painter? No, he has said: "Because of the kind of painting that was being done then—Abstract Expressionism—it was hard for me to work up any enthusiasm for the idea of myself as a painter. I was simply too interested in what I believed to be the high possibilities of figurative art." Influences? "Ben Shahn was a giant . . . the passionate social sentiment he acknowledged in his work, which had an obvious implication for an illustrator: that it was possible to illustrate—especially serious and emotional subject matter—without necessarily losing esthetic integrity. His painting of Sacco and Vanzetti gave me more hope for what could be done in illustration than any other work I saw during those years. [Also] the work of Maurice Prendergast was confirming and encouraging a track I was already on. That track, simply put, was an emphasis on the energy and expressive power of the brush strokes themselves." I admired McMullan for one simple fact, that he worked the way I did—not in any logical way, but on instinct, on gut feelings, on a musical sense with lots of false starts. He said, "My most creative mode is a somewhat chaotic one in which I leave open many options at once, including the option to fail."

He's done five posters for my plays: two posters for *Six Degrees of Separation*—one for its original showing in the Mitzi Newhouse, the drawing of the young African-American dressed very nattily in black tie, sitting at a tilted angle in a Chippendale chair, smiling

challengingly up at us. What is that smile offering? McMullan did a new poster for the transfer upstairs to the Beaumont; the young black man, now in a lurid pink shirt, with blue hair, confronts us—a fierce fauve gouache—something of the startle of Picasso's *Demoiselles d'Avignon*. The Stockard Channing character leans over him in fierce protection.

The posters kept coming for Lincoln Center Theater. Jon Robin Baitz said, "I finally feel I'm in the theater. A set by Tony Walton. A Jim McMullan poster." Walk in the underground entrance to the Lincoln Center Theater and see the gallery of McMullan posters. Jim Cartwright's *Road*: the sudden apparition of the ragman hanging off the lamppost, illuminating the dark with a quick-flaring match—Come in, he says to us. The Lartigue woman of *Anything Goes*, winking that naughty French postcard wink that says, "I'm serious. Anything *does* go." His poster for *The Little Foxes*: Stockard Channing's Regina rushing up the stairs into the dark, carrying her light. But we are the dark. In the poster for Wendy Wasserstein's *An American Daughter*, we are the paparazzi shining the harsh light on the illustration's central figure. Look at the figure of the god Eros in *Four Baboons Adoring the Sun*, shooting his arrow at us. Duck!

To prove its success as commercial art, the theater poster must be perceived in one gulp, as the speeding Amtrak train hurtles past platforms in Baltimore and Philly, or as the subway careens around the stations of the five boroughs, or out of the side of your eye as you dodge a passing bus. Theater posters are pieces of commercial art whose sole raison d'être is to persuade people to buy a seat. Right? Like a soap powder or soup or flying a particular airline. All these shows compete for your time. Try me. Buy me. But McMullan's posters somehow transcend that simple commercial thrust. How? They share a sense of uneasiness that makes them *not* the stuff of commercial art. Would an ad for an airline want to make you feel that uneasy? McMullan's great breakthrough illustration for me accompanied an article on paranoia—the weight of a mysterious shadow on the back of the central figure. All his work has that sense of a challenge being flung out, a promise of "I dare you." The poster as contract? What was I reminded of?

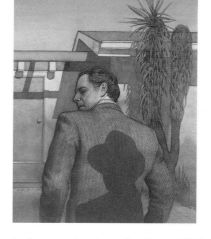

Back in time. In the early 1960s I was a student at the Yale School of Drama; these were the days when shows would try out in theaters on the northeast corridor before coming into the Great White Way. The announcement of one new show coming to try out in the spring of 1963 at the Shubert Theater excited the hell out of me. The poster (not a McMullan) featured a cartoon drawing of Zero Mostel in a toga starring in a new musical called *A Funny Thing Happened on the Way to the Forum*, with a book that Burt Shevelove and Larry Gelbart had based on the comedies of Plautus and Terence. The young genius lyricist, Stephen Sondheim, was the composer as well. The show would be directed by the legendary George Abbott. I liked to usher at the Shubert most every night in order to see the new shows change from performance to performance in the week of their New Haven engagement, to watch the authors pace in the back of the orchestra. Most of the time I knew how to solve it, if they'd only ask me. The first night of *A Funny Thing* began. The lights dimmed. The overture played. Then a wonderful character man I didn't know—quick look at my program—named David Burns, dressed in a toga, came out into a spotlight and sang: "Love is in the air / This morning. Bachelors beware, / Fair warning." The audience swooned with delight. He bowed and was off. Then Zero Mostel and the cast came out and did funny things in ancient Rome, but there was one horrible and embarrassing lack: nobody laughed. You knew everything was funny except for that horror—it didn't work. The show played to something approaching silence. It received bad reviews, performance after horrific performance; you could feel the actors' panic—"flop sweat" is its technical name— pouring over the footlights, see the authors in the back of the theater pacing, mystified. How would you fix it? They fired the ingenue. It moved to Boston, got bad reviews, even with a new ingenue, then moved to Washington, D.C., where I heard on the grapevine or read in *Variety* that the producers had posted the

closing notice. The show would die in D.C. Then the next thing I knew, it opened in New York triumphantly and ran for years. And still is running. I went to see the show. It was virtually identical to what had opened in New Haven disastrous weeks before—except now it was breathtakingly funny. Everything worked. What had happened? I learned later that the wizard Jerome Robbins had come to Washington to see his friends' show before it closed. He said after the performance, I know what's wrong with the show.

Yes? Everyone gathered around. The poster tells you the problem. The poster? The poster says you're going to see Zero Mostel in *A Funny Thing*, but when it begins, a character man whose name I don't know sings a romantic song about love being in the air. I have to take my attention away from the stage to look at my program, see who it is singing that sweet song. Already I've lost my concentration. Then the song is over, and Zero Mostel comes out in a rowdy play that is not about love being in the air. I'm not laughing, because I don't know how to react. How to fix the show? Listen to the poster. Deliver what the poster promises. The poster tells us that we're going to see Zero Mostel in a comedy tonight—as a matter of fact, Steve, go home and write a song with that title. Which Sondheim did that day. The new opening went in the next night. Mostel came out and sang, "Something familiar! Something peculiar. Something for everyone! A comedy tonight!" The audience roared. Robbins had revealed something startling. The theater experience begins the minute you see the poster for a play and what it promises and you decide to buy a ticket. The poster as contract.

McMullan draws the best contracts in the business. They are fair, they are honest, they are inventive. They are beautiful. They are disturbing. McMullan illustrates plays at the highest intention their authors imagined; that's his gift. And the fact of his work is his gift to the landscape.

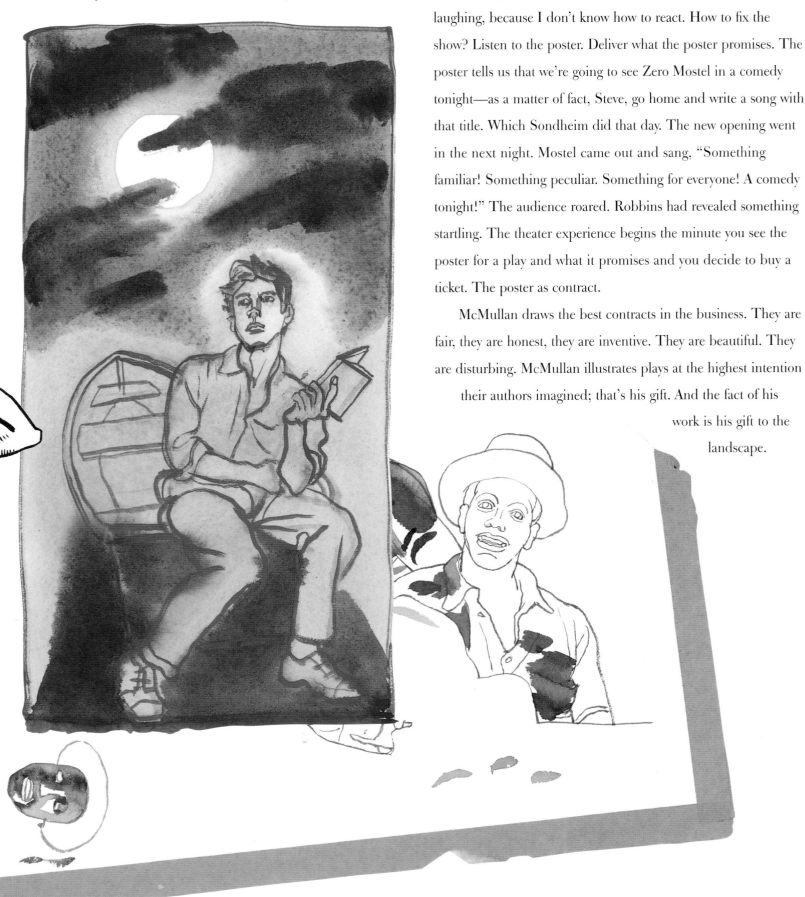

Comedians

By Trevor Griffiths. Produced by Alexander H. Cohen. 1976

Comedians was my first theatrical poster. Alexander Cohen produced the play, a dark comedy written by Trevor Griffiths about English class politics. It was directed by Mike Nichols.

The play was set in a working-class comedy club. There, the desperate-for-laughs comedians reveal the anger underlying their jokey routines. Jonathan Pryce, in his first starring role in the United States, plays the most bitter of the comedians, and the one who brings the play to its harrowing conclusion.

I did some initial sketches, which neither Alex Cohen nor Mike Nichols liked. In explaining his problem with my ideas, Nichols gave me a good piece of advice. He said my sketches looked too much like book jackets. I thought about his remark, and in some fundamental way it sharpened my own understanding of exactly what it was I was aiming for in posters. It's difficult to articulate the difference between a book jacket and a theatrical poster, since in a way they are both posters. It certainly has something to do with the difference in scale between the two, and with the more intimate, cerebral context of confronting a book jacket versus the more public and emotional context of looking at a theatrical poster. A poster for a play has to state its case more quickly and overtly.

Alex Cohen gave me the production photos from the English staging of *Comedians*, and they helped me tremendously as I began my thinking about a second sketch. They were the usual badly cropped, mostly useless close-ups of the actors, but one photo caught my eye. It was of Jonathan Pryce, who would be repeating his role in New York, doubling up in laughter as he confronts a crude blow-up doll dressed as a fancy lady. There was something over-the-top, verging on hysterical, about Pryce's laughter. It seemed to express the funny/not-so-funny dichotomy in the tone of the play—ha-ha-ha's that are about to spill over into sobs or even furious, finger-pointing diatribes.

1.
A color study that Mike Nichols felt looked too much like a book jacket.

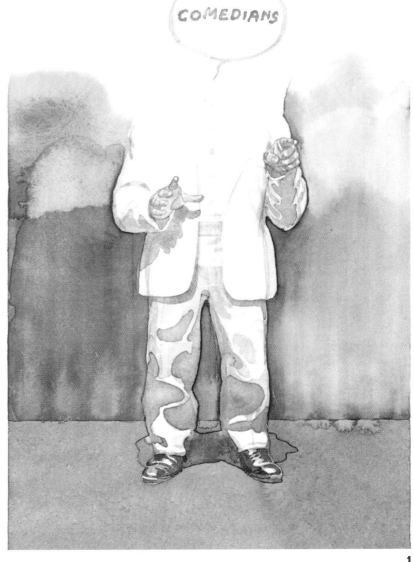

1

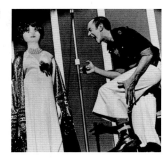

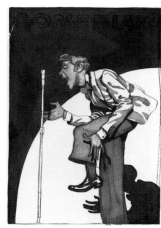

2.
Photo from the English production of the play, showing Jonathan Pryce laughing at a blow-up doll. This figure of the actor became the inspiration for my poster.

3.
A first try at using the photo as my reference. The sketch's stodginess showed me I had to bring more energy to the pose and to the drawing.

4.
The pencil sketch and a subsequent color study in which I articulated my concept of the figure as a storklike bird. The leg became longer and the shapes became spikier and more aggressive.

I began making drawings based on the photo of Jonathan Pryce. I changed his casual outfit to a tuxedo so he would more clearly look like a typical nightclub performer. At first, despite the strong expression the photo gave me as a starting point, my studies looked mundane.

But after much sketching and studying the photo, I suddenly saw Pryce as a bird of prey, a strange cross between a hawk and a long-legged stork.

In my next drawing I extended his supporting leg and lifted his whole figure farther up the rectangle of the poster, and the image suddenly came alive for me. The angularity of the pose and the sense of the head darting forward took the figure beyond the information of the photo and overlaid it with the feeling of a laughing yet dangerous bird.

From this point I proceeded to do a sketch that both Alex Cohen and Mike Nichols were enthusiastic about, and then I painted the art that was printed.

As I write this text in 1997, twenty-one years after completing the *Comedians* poster, I feel both connected and disconnected to the artist I was then. I still like the poster's emphasis on the gesture of the body, yet the art is careful and controlled in a way I doubt I could carry off anymore, as my enthusiasms have moved so strongly toward more spontaneous drawing and painting.

As I think about my own changing attitudes and try to decipher those of other artists, it seems that as we get older, we become more impatient to get to the nub of the matter. We seem willing to exchange complexity of technique for a simpler evocation of our subject.

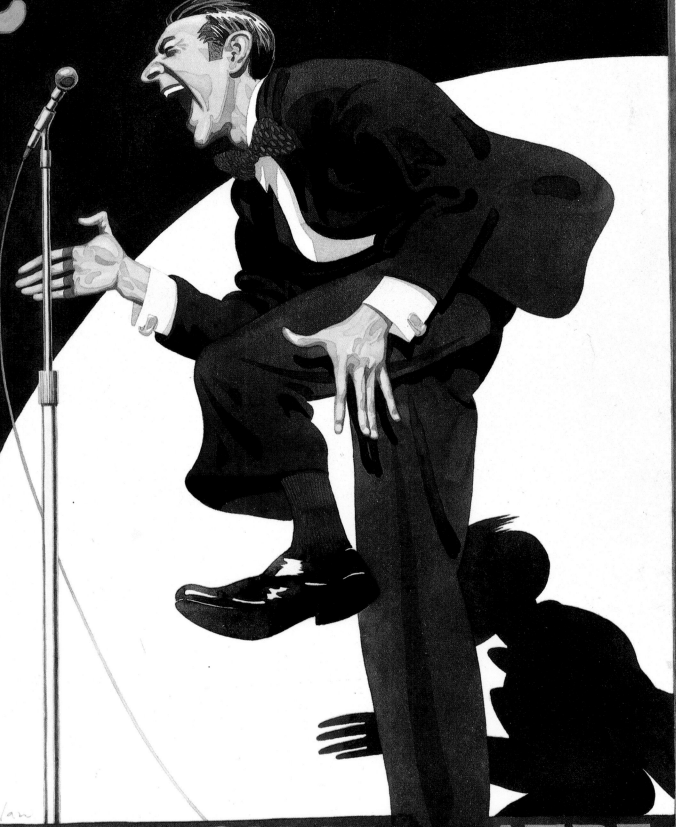

Anna Christie

By Eugene O'Neill. Produced by Alexander H. Cohen. 1977

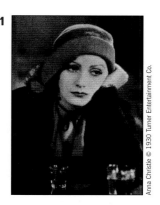

Early in my research for the *Anna Christie* poster, I came across an image in a photograph that kept returning to me and finally affected my choices in the last stages of design. The photo was of Greta Garbo as Anna Christie in the 1930 movie of the same name.

Sitting at a table with her head leaning heavily on her hand, her eyes sadly staring into the middle distance, she ignores the drink in front of her. It was a marvelous Garbo photograph, and the only record I found of an *Anna Christie* production, either on stage or on screen, in which the heroine seemed psychologically modern enough for the dilemma in which O'Neill had placed her. Although much about the play is heavy and almost archaic, the story of the central character is decidedly modern. Garbo strikingly expressed this spirit of twentieth-century ennui in the photograph, and as I look back on the path my choices took, I see that I tried to create my own version of what was so telling in Garbo's haunting slump.

The star of Alex Cohen's production was the remarkable Liv Ullmann, and while developing the design for the poster I was able to photograph her. By the time I took the photos, I had already done a sketch of the general idea. I showed her the sketch to give her a sense of the gesture I was aiming for. She looked at it intently and then turned her incredible face toward me and said, "You know me so well already."

Having been thus initiated into the Obsessed Fans of Liv Ullmann Club, I expressed my sense of homage in a watercolor portrait study. I thought it did capture some of her intensity, and it prepared me to do the likeness in the final poster.

A paint-stroke background separates the two worlds of the play: the interior of the bar Anna sits in, and the foggy harbor outside. I saw the possibilities in this idea when I impatiently scribbled with a pencil over a sketch to "cancel" a previous notion of having Anna literally sit in front of the sea. The paint-stroke background has become my favorite aspect of this poster.

1.
A photo of Greta Garbo from the 1930 movie version of the play.

2.
Photos I took of Liv Ullmann after I had developed the basic image of the poster.

3.
A portrait study I did from the photos.

4

Play Memory

By Joanna McClelland Glass. Produced by Alexander H. Cohen. 1978

Play Memory was the last of six posters I did for the producer Alexander Cohen. I was so disappointed in the final art that circumstance led me to produce that I did not even keep a copy of the poster for my files. I liked one sketch well enough to include it here.

My interpretation of *Play Memory*, in which the character of the alcoholic father became the poster's focus, was not shared by Mr. Cohen. Part of my fascination with the father character, and the reason I found it so hard to let go of, was that my model, Ray Barry, did an extraordinary job of acting my idea out for me. Because of the photos that resulted from my modeling session with him, I was able to do a sketch that had a tone of comic nastiness that I particularly liked. The minuscule mother and daughter sitting on the slanted table seem like such perfect victims for the elegant stream of whiskey coming from the giant's tumbler.

I thought that there would be thousands of people who would be fascinated by this scene of familial torture and would want to see what the play was about, but Alex Cohen disagreed. He insisted that there are too many people with drunk relatives at home that they could watch without buying a ticket, and we had to give people something on the poster that was more exotic—like an image of the play's dreamy daughter.

This is the character that I ended up using on the poster, but it occurred to me that if Alex Cohen thought that a dreamy daughter was more exotic than a funny drunk, he'd forgotten what it was like to have a teenager in his house.

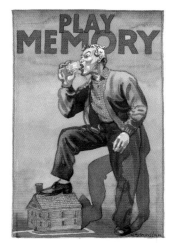

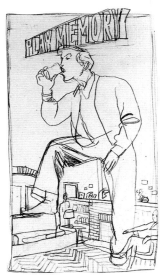

1, 2.
A color and a pencil study of alternative ideas for the alcoholic father who dominates his family's life.

3.
The photo of my model, Ray Barry, which was the visual reference for the art on the opposite page.

The House of Blue Leaves

By John Guare. Directed by Jerry Zaks. 1986

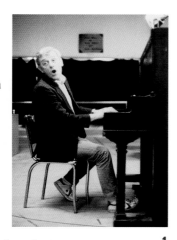

This was my first poster for Lincoln Center Theater. Bernard Gersten, the Lincoln Center Theater's executive producer, and I had met when he worked briefly with Alexander Cohen and I was doing Cohen's posters.

Bernie and Gregory Mosher, the artistic director for Lincoln Center Theater, had come up with a concept for the *House of Blue Leaves* poster. They wanted to show John Mahoney, the actor playing the central character of Artie Shaughnessy, spiritedly singing and accompanying himself on the piano. Bernie and Greg remembered my *Comedians* poster, which had a similarly active physical image, and called me up.

Not long after their phone call, I found myself in a dim rehearsal room in the bowels of Lincoln Center, photographing John Mahoney banging away at the piano and singing the songs from John Guare's play. The light was terrible, coming from harsh fluorescent tubes hanging above the piano (I learned from this experience always to bring my own lights), but the spirit of the photos was wonderful.

My three sketches (since lost) all began with similar side views of Mahoney playing the piano, but they ranged in style from quite flat to fairly realistic. In other words, from a cooler to a warmer psychological tone.

For Bernie and Greg, the more realistic of the three sketches had the vitality and the warmth they had hoped for, and I proceeded to paint a finished version of that sketch.

I was understandably nervous about my first (and as far as I knew, last) commission from New York's most powerful institutional theater. However, even though it's not one of my favorite images, the poster worked—for me—very nicely. Lincoln Center Theater tried me on another poster, *The Front Page*, and then—why not?—on another. This continued until, in some unofficial way, I finally became the poster artist for the theater, giving me a once-in-a-lifetime opportunity to do a connected body of work.

1

1, 2.
Photos of John Mahoney, the lead in *The House of Blue Leaves*, playing and singing John Guare's songs, just as he does in the play.

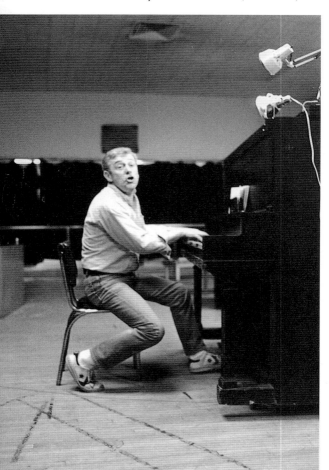

2

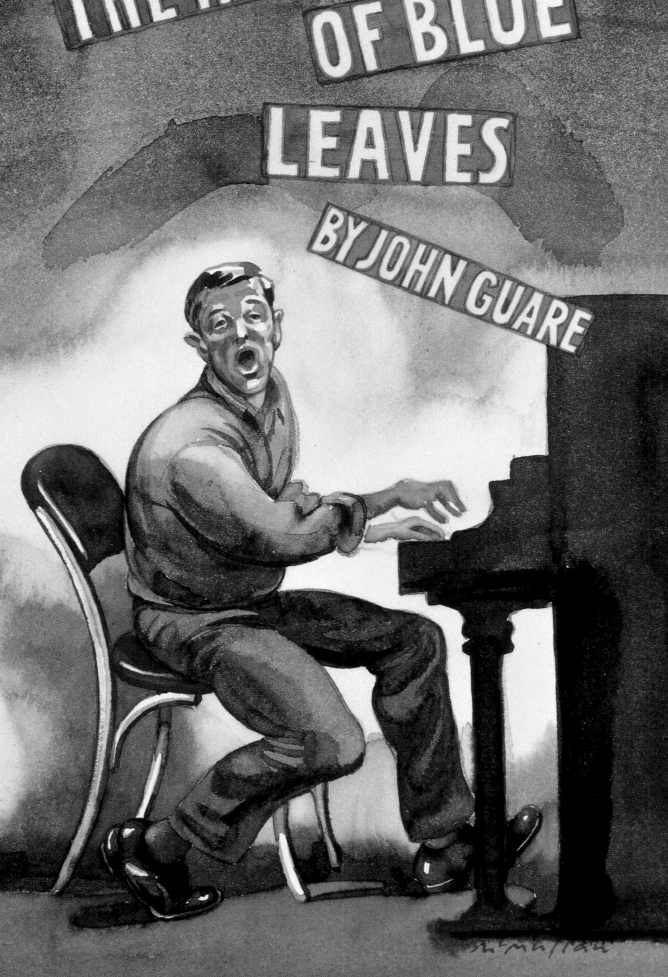

THE HOUSE OF BLUE LEAVES

BY JOHN GUARE

The Front Page

By Ben Hecht and Charles MacArthur. Directed by Jerry Zaks. 1986

I've been asked whether my own opinions of a play affect what I do with the poster. That's a complicated question to answer. This is partly because I usually have to do the poster before I've seen the production, so my reaction to the play is based entirely on my reading of it, which may change after I've seen it performed. My decisions about a poster are also complicated by the fact that I can be particularly touched by one scene in a play, yet feel that it's not the right moment to capture in the poster. Or what I most like about a play may not be translatable into visual terms. The most honest answer I can give is that if a play provides me with material for a dramatic image, it's irrelevant whether I like the play or not. I would also add that compared to many contemporary magazine pieces that I have illustrated, even a not-so-great play offers me a rich mine of ideas.

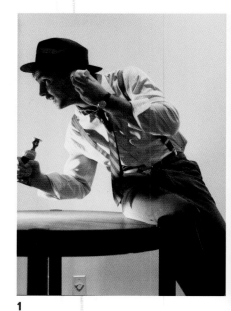

1

This was the case when I tackled the poster for *The Front Page*. In reading the play script and in watching an old movie version on video, I found the plot too mechanically driven for my taste. It had the rat-a-tat action of a story out of a 1940s pulp fiction magazine. But it also had great physical scenes and a definite hard-boiled flavor. As grist for my particular mill, I recognized that I couldn't ask for any better subject than a tough-talking reporter covering an execution. All the 1930s paraphernalia was right up my alley—black stand-up phones, beat-up fedora, suspenders, and the physical burlesque of the play.

The image that came to me for the poster was of a reporter sitting on a desk, probably not his own, and twisting around to pick up the phone to have a conversation with a lot of shouting in it. For some reason the twisting-around posture of the man was very important to me. It was an idea, as are many of these initial visions, like the details in a dream—strange but necessary, and come unbidden.

I posed my assistant, Garnet Henderson, with a hat pushed back on his head and a loosened shirt and tie, sitting on a table, twisting around, talking on a phone. From the resulting photo I did a sketch, which I showed to Gregory Mosher and Bernard Gersten.

Greg said, "I like it, Jim, except it's not tough enough. The guy looks too young and polite."

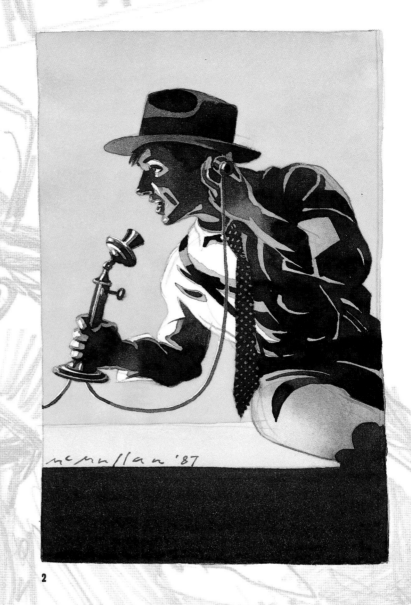

1.
A photo of Garnet Henderson, my assistant at the time, acting out my idea of a reporter yelling into a phone while sitting on a desk and twisting his body around.

2.
The sketch I presented, which elicited the criticism "The guy looks too polite to be a reporter."

3.
One of the photos I took of the actor Ed Lauter talking on the phone as a definitely "un-polite" reporter.

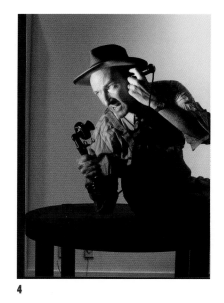

4

"Let me have one of the actors from the cast to photograph," I told him. "And I'll give you tough."

In answering my request, Greg came through in spades. A few days later Jerry Zaks, the director, and Lori Steinberg, his assistant, carrying an old phone and a "tough detective" outfit, arrived at my studio with the actor Ed Lauter. Ed put on the 1930s clothes and sat on a table. In a complete transformation from the affable gentleman he had been only seconds before, he grabbed the phone, twisted around, and started giving an amazing, testosterone-heavy performance of a nasty reporter barking his story across the wires to his editor. It was thrilling for me to see Ed Lauter bringing my own idea for the poster to life. Rather than giving me a moment from the play, as the producers had asked John Mahoney to do for the *House of Blue Leaves* poster, Lauter quickly and powerfully insinuated himself into the posture I had imagined.

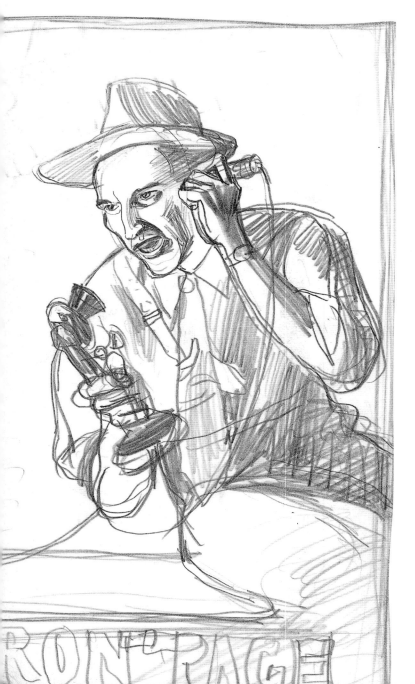

The photos of Ed Lauter were so on target that I needed only to study them and draw them. To "toughen" the texture of the poster, I had decided to draw in brush and ink. I never start a drawing with preliminary guidelines, so it takes me a few tries to feel out the action and the proportions of the reference image. In this case, however, although my first drawing was slightly skewed, it was much better than it had any right to be considering the level of risk involved. My second attempt was buoyed by this early success. I knew after I finished it that I had the basic ingredient for the poster. Ed Lauter had quite literally inspired me to do one of the most energetic drawings I had ever done. After sending the drawing out to be copied in black and white, I did the lettering and added the color. It amused me to do the author's name and the name of the theater in Speedball lettering, a quaint early 1940s pen-nib system that took me back to my early days making posters for plays in high school.

Several people told me that the *Front Page* poster seemed to pop out from the other images on subway station walls. Because of its dramatic black contrasts, it also read extremely well in the newspaper ads. I am proud to add that it was later included in a Japanese book called *100 Best Posters of the 20th Century*.

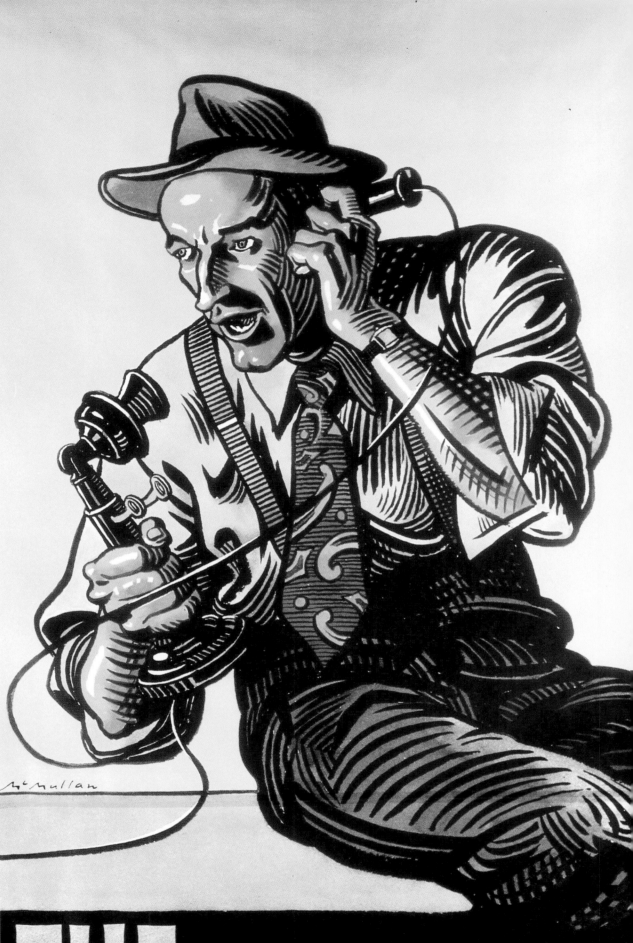

THE HECHT & MacARTHUR'S FRONT PAGE

LINCOLN CENTER THEATER at the VIVIAN BEAUMONT

Death and the King's Horseman

Written and directed by Wole Soyinka. 1987

There was a line in the *Death and the King's Horseman* script that I should have taken as an omen: "Your eyes were clouded at first," the king says to one of his courtiers. As things turned out, it could have been the playwright talking to me.

The process started uneventfully enough. I read the play's dense, formalized language and understood that its basic story was about the ritual suicide of a tribal king during the time when Nigeria was emerging from British rule. I decided that the physical tone of my image should try to

match the stylization of the text by being dancelike, suggesting slow, hieratic movement. I arranged to watch a class at the Alvin Ailey School, and I chose a male dancer in his early twenties who agreed to let me photograph him as he worked out ideas I had about supplicating or prayerlike gestures. The dancer was very elastic in the way he moved, if somewhat lacking in the gravity I had imagined for the piece. Yet from the photos of him I did a sketch I liked of a man kneeling in front of a faded Union Jack and lifting his arms to an unseen God. I sent the sketch to Lincoln Center Theater by messenger because it turned out to be too difficult to schedule both the producers and Wole Soyinka, the playwright/director, for a meeting where I could present the sketch in person.

A meeting was speedily arranged, however, when it turned out that Wole Soyinka didn't like my sketch and was willing to tell me why. I arrived at the theater office expecting to sit down with Soyinka, Greg Mosher, and Bernard Gersten. But to my surprise, Bernie simply introduced me to Soyinka and then left the two of us alone in the room.

When the door closed, I found myself facing a man of formidable mien. Wole Soyinka is a gravely serious intellectual man who in his deep, English-inflected voice and in the almost accusatory directness of his gaze seems to carry the whole history of Africa's past and the inventory of colonial crimes that it had endured. I began to understand why the producers had chosen not to take part in this critique.

1.
Photo of my model, a dancer from the Alvin Ailey School.

2.
A study from the photo.

3.
A drawing investigating the gesture of supplication, similar to the one in the color sketch, figure 5.

4.
The photo from which I worked.

5.
The first sketch I showed to Lincoln Center.

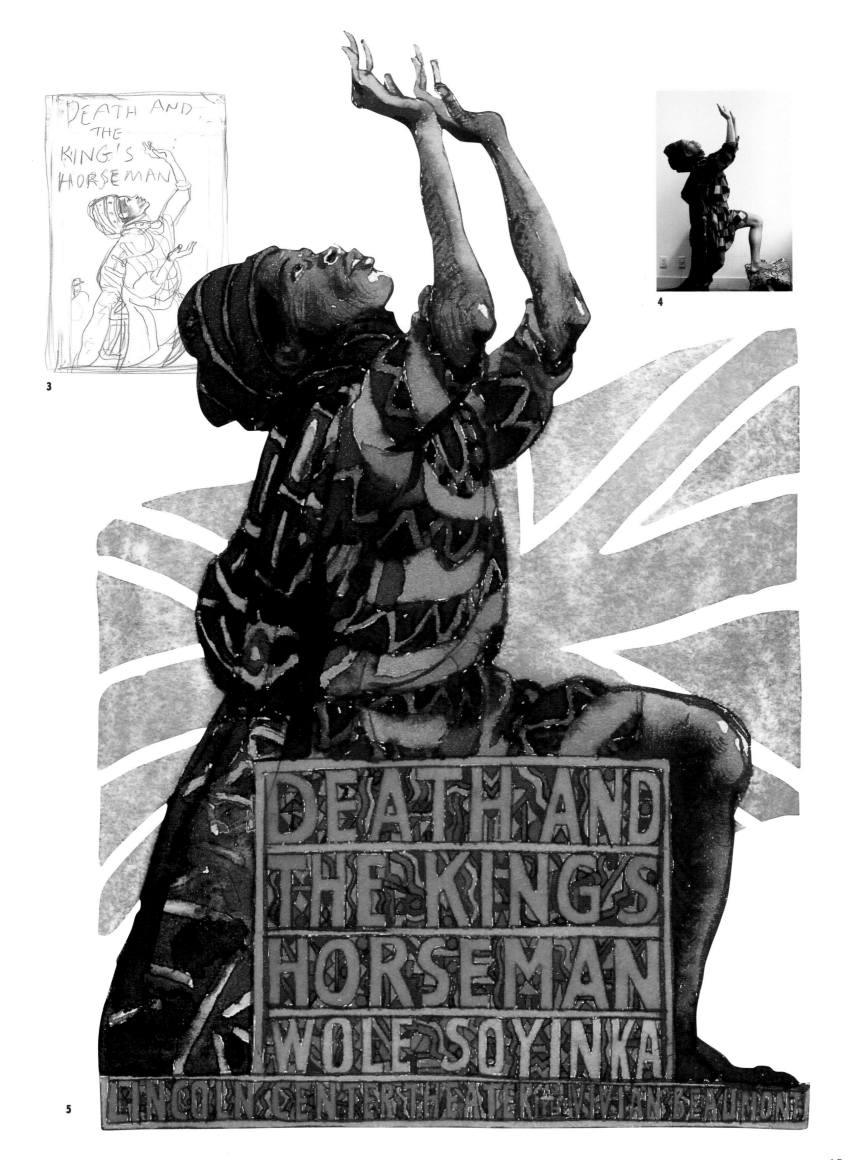

3

4

5

Wole Soyinka had also just won the Nobel Prize for Literature. So here was I, the grandson of English missionaries, ancestrally guilty, meeting to discuss my Western response to a complex Nigerian play with the man who had written the play, and who bestrode the literary landscape like an avenging African angel.

Actually, Mr. Soyinka didn't seem to want to talk to me at all but simply sat in polite, self-contained silence. I tried to get a dialogue started by confessing my guilt and saying that my first sketch was simply a suggestion, and that I was eager to do something better and more appropriate to represent his play. He gravely murmured his agreement to this plan.

"But, Mr. Soyinka," I quickly went on, "I need to know more specifically what it is you don't like about my sketch so that I know what to aim for in my next sketch."

He made a slightly annoyed movement of his head and told me that it would be too difficult to explain his reactions. I persisted, however, and after another demurral, he finally agreed to explain. His play, he said, was abstract, and my image was too realistic, too prosaic, too specific. I assured him that I fully appreciated the abstraction of his play but that finally I had to find something physical, something I could illustrate, to represent that abstraction. He was clearly unhappy that I was pressing him for clarification. With a world-weary sigh, he pointed to a poster on the wall behind us and said something like this: "The artist who did this poster was also dealing with a complex idea in a particular culture. He had to sum up the unfairness of the prison system, the voraciousness of the media in covering the sensational execution of a murderer, and the corruption of the state's governor. Yet this artist avoided these specific events in his poster and managed to find a single image that acts as a powerful symbol for the whole play—a man shouting into a phone."

The purpose of his speech, of course, was to spur me on to do a more intellectually rigorous and appropriate poster for his play, yet he clearly doubted my ability to produce an image as wonderful as that on the poster he pointed to.

I didn't interrupt Mr. Soyinka until he had made his point completely. Then I informed him that this paragon of successful metaphor was my own poster for *The Front Page*. His reaction to this news was another slightly annoyed shake of his head, as though this were some kind of trickery on my part. We parted in silence.

My second sketch was approved without further discussion, and the poster went on to win the Society of Illustrators' Hamilton King Award. Yet after all is said and done I feel that I have Wole Soyinka to thank for provoking me to do a poster that was indeed less realistic, less prosaic, less specific than my first sketch. The king, it seems, was finally satisfied.

6.
Photo of a second model.

7.
One of many variations I did of my final idea. I like the spideriness of the lettering in this version.

7

16

Anything Goes

By Cole Porter. Directed by Jerry Zaks. 1987

This was only my fourth poster for Lincoln Center Theater, and Bernard Gersten, Greg Mosher, and I were still getting used to one another. For *Anything Goes* I tried a way of working with them that didn't pan out.

I thought that if I read the script, thought about the musical, and did some rough sketches, the sketches would provide a basis for my initial discussion with Greg and Bernie and Jerry Zaks, the director. After our first round of talk, I then planned to take reference photos to give me what I needed for more serious sketches.

The trouble with this MO was that the rough sketches I showed Greg, Bernie, and Jerry shook their confidence in me. I think they saw the crudeness of the sketches as proof that I had suddenly lost my faculties. They said very little at our initial meeting, but a day later Jerry Zaks called me to say that they thought I had gotten off on the wrong foot with the sketches and that they had all come up with an idea that they would like me to try. This sounded ominous. I found myself imagining the meeting they had had, where they all agreed I couldn't be trusted to come up with an appropriate idea. I pictured them putting their heads together to find an idea to spoon-feed me. I thought how quickly I had lost any credibility I had gained from my previous posters.

Yet all was not as dark as it seemed. The concept Jerry gave me turned out to form the basis for what would become my best-known poster. Jerry said he and the others would like me to do a poster in which Reno Sweeney, the leading lady, looks seductively out at the viewer. That was it: a simple idea that gave me lots of room to find my own way of expressing it.

My friend Piper Smith agreed to ride with me on the Staten Island Ferry so that I could photograph her leaning on the ship's railing and looking seductive. The ferry's railing was nothing like the sleek teak-and-painted-iron railings of a 1930s ocean liner. I managed to convince myself that the harbor light was slightly more oceanic than it would have been had I taken the shots on the roof of my studio building.

Piper was a terrific model, and the spirit of the final art owes much to her unique insouciance. I made a serious mistake in the clothes I asked her to wear for the shoot, however. They were 1930ish, it is true. But they were too dark to show any of the drape of the clothing that I needed to see. After I had done a few sketches of Piper wearing these dark clothes, I realized that not only could I not see shadows, but the spirit of the clothes was also wrong. I looked through a book of Henri Lartigue photographs to see what women were actually wearing in the 1930s and came across a wonderful

1.
An early pencil idea.

2.
Four rough sketches I showed to Lincoln Center, which I thought were good enough to start a dialogue about solutions for the poster. The half-baked quality of the sketches raised some doubts.

3.
My friend Piper Smith, photographed on the Staten Island Ferry.

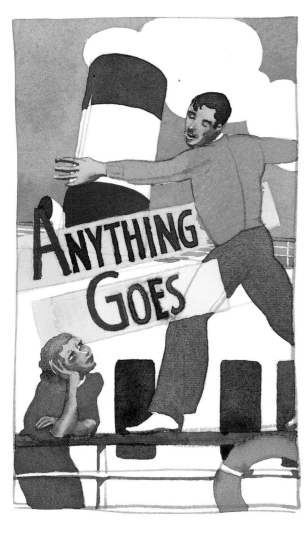

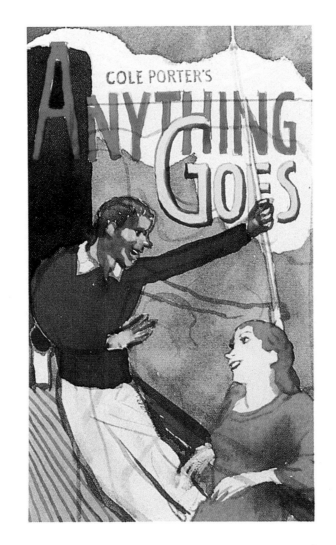

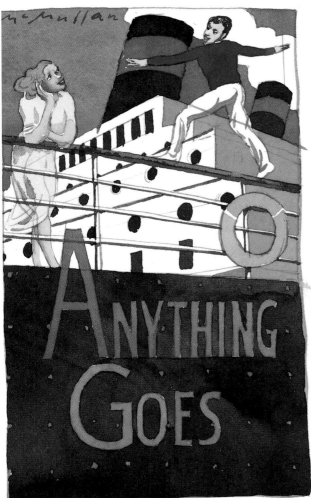

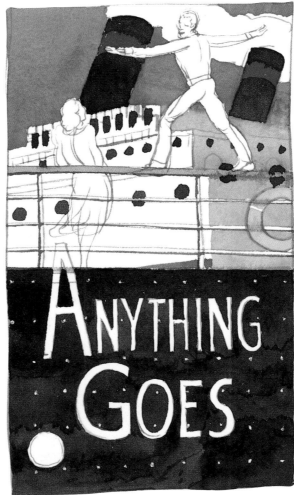

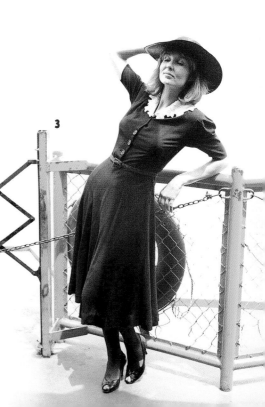

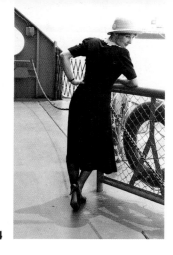

4.

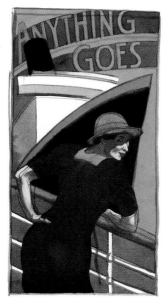

5.

6.

4.
Piper's saucy pose, which became the basic ingredient for the finished poster.

5.
The "football shoulders" sketch.

6.
I needed more information about the shadow on the face and a more summery costume than the one Piper had worn, so my wife, Kate, obliged.

photo of his wife, Bibi, in a sailor outfit with wide white pants. At this point I asked my wife, Kate, to dress in a light-colored outfit and a big hat and pose for me. We had no railing handy, so I asked her to lean on the back of our car. (What the UPS man thought we were up to when he pulled into our driveway at that moment, we'll never know.) Because it was much sunnier on the day I took these shots of Kate than it had been on the ferry, I got a more interesting shadow on her face and a lot more information about the shadows on her body. I combined references from the Piper photographs with those from the Kate photographs in the final sketches for the poster.

My first sketch ran into criticism from Bernie and Greg. They felt I had made Reno's shoulders so broad that she looked like a football player. I reduced the size of Reno's shoulders in the next sketch. But I didn't narrow them too much; I realized that if she was going to look over her shoulder, she had to have a shoulder to look over! This sketch was approved.

I usually have a feeling about the texture for a particular poster, and in the case of *Anything Goes*, the texture that came to mind was of looping lines, demarcating relatively flat areas of color. Something about the 1930s and about Cole Porter in particular evoked in me this vision of elegant patterning.

Having an idea for the texture helped a lot in the way I approached the drawing. I saw the gesture of Reno's arms, for instance, as a chance to create open arcs that would play against the large black wedge of the ship and the strong pattern of the railing she leans against. As the art evolved, the forms became very edgy, linear, and directional: the angle of the railing working

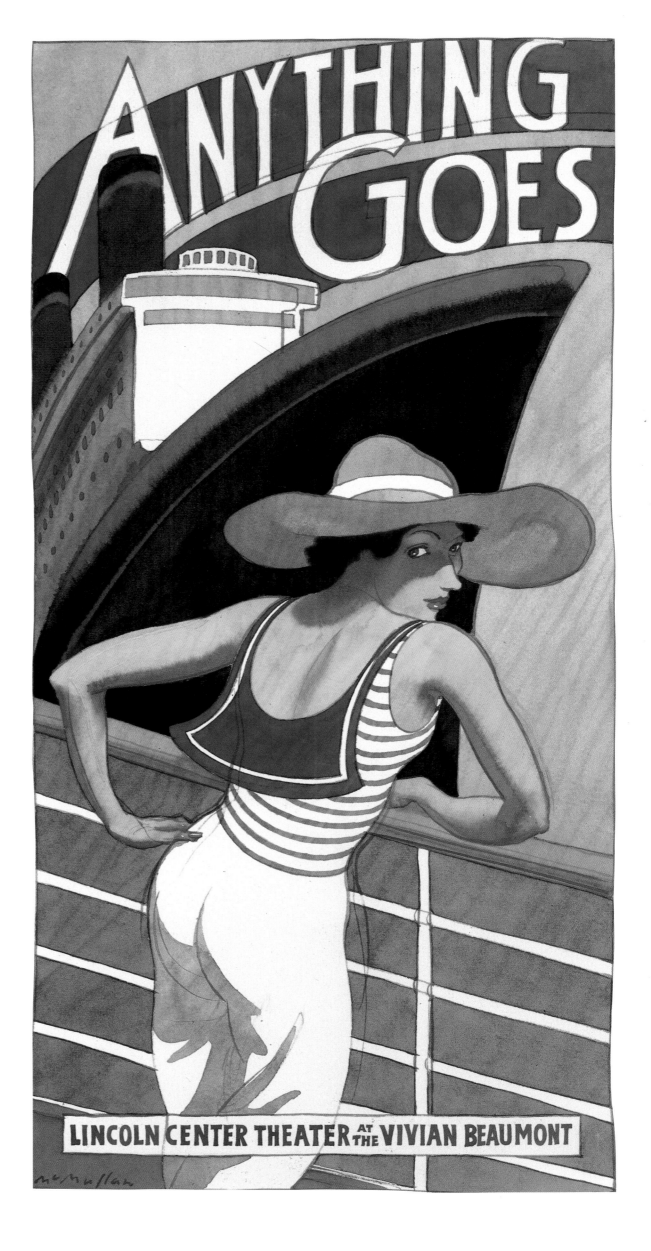

against the curve of the ship, the jaunty attitude of the woman's body playing complexly against all the other shapes. It seemed inevitable, finally, for the lettering to follow the form of the curve of the ship's hull.

The poster was very popular, and it provoked a moment at the end of the first act in which Patti LuPone, playing Reno Sweeney, stands looking seductively over her shoulder at the audience, mimicking the poster, just as the curtain falls.

Anything Goes was a great success. It ran for more than seven hundred performances, and this long run precipitated my doing a bus poster for the show, and then a second version of the poster.

Bernie Gersten had an amusing way of describing this latter assignment: "Jim, I'd like you to do a second poster as though it was just a few seconds later in the show and Reno has simply turned around to face the audience. We'll see how many people notice the difference and who's paying attention."

It was a funny idea, and I found it interesting, if somewhat limiting, to come up with a new image under these terms. Some people found the second poster more appealing than the first, although I'm sure that there are more people who would agree with my own assessment—in her directness, the Reno Sweeney character in the second version lost a little of her edge and mystery, and the design lost a little of its dynamic. From this experience I learned either to leave well enough alone or to start a second version from an entirely different premise, as I later did with the second poster for *Six Degrees of Separation.*

7.
The first-version bus poster in situ.

8.
About eight months into the show's run, Bernard Gersten asked me to design a variation on the first poster. My solution, seen here, was like seeing the figure "a few moments later"—Reno Sweeney turns to look at us more directly.

9, 10.
Bus posters based on the first and second versions of the three-sheet art.

7

9

10

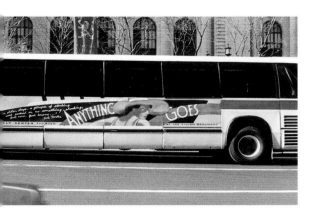

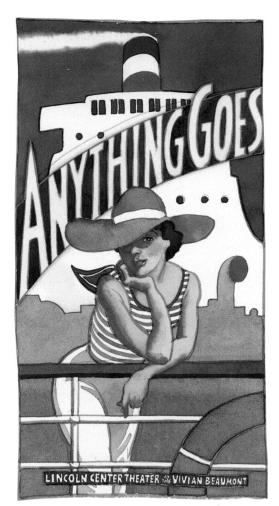

8

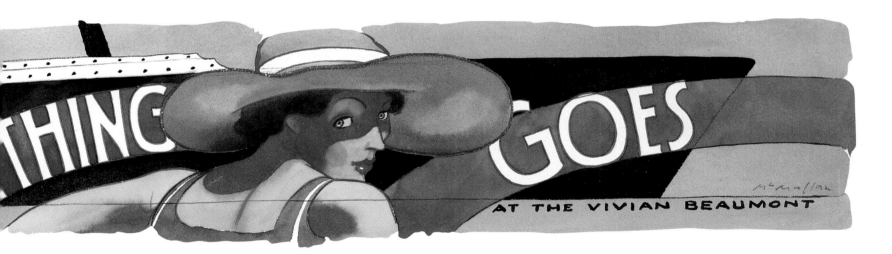

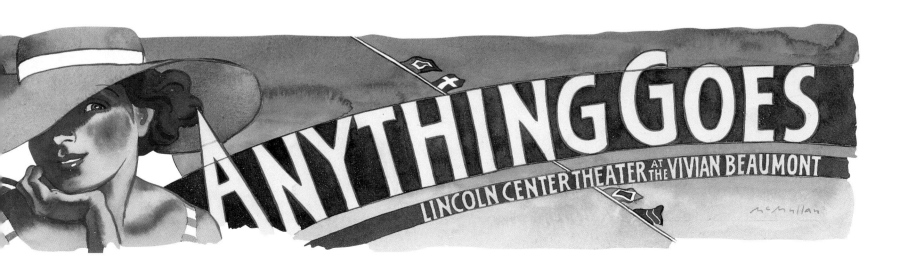

Road

By Jim Cartwright. Directed by Simon Curtis. 1988

1.
A detail from the art on the printed poster.

2, 3, 4.
Color sketches, one of which I showed to Lincoln Center and which is very close to the final painting.

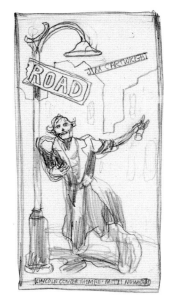

Blackness.

A match is struck. It is held underneath a broken road sign. The name part has been ripped off, leaving a sharp, twisted, jagged edge; only the word "Road" is left. The sign is very old and has been this way for a long time.

The flame moves across to illuminate a man's face. He holds the match there until it goes out; at the same time a spotlight creeps up on his face.

As I read these words from the first scene in *Road*, I could see in my mind's eye the match lighting the character's face from below as he leans on a lamppost and beckons us to join him in the play's grim Lancashire neighborhood. After I finished reading the script, the image from the first scene seemed a perfect way to represent the whole play.

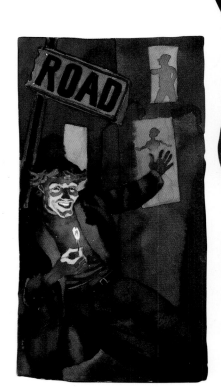

2

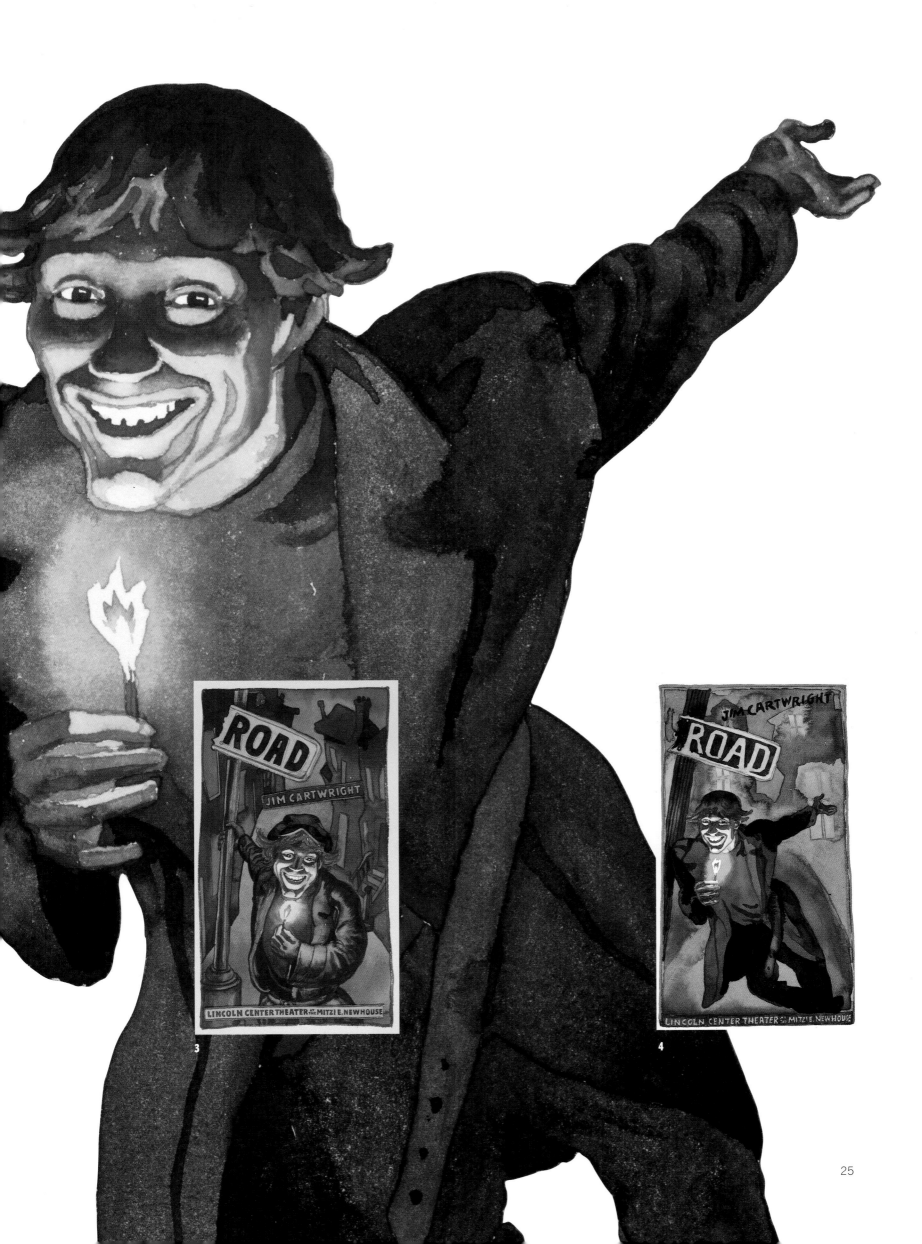

I began doing sketches for the poster from my imagination. I pictured the leaning figure dressed in a ragged coat to help establish the right mood of grungy melodrama. Taking my cue from the script again, I saw that I could incorporate the name of the play as half of a broken sign hanging from the post.

The model I hired happened to have a haircut that, when his hair was brushed forward, curled off his head like a helmet. It was a style I could never have imagined, but as soon as the model raked his hair into this odd fringe, I knew it was right. It complemented the mad gleam in his eye and the eccentric slouch of his body. The raincoat, which I had bought from a used clothing store, drooped in just the right dispirited wrinkles, and the model's loose turtleneck and sloppy jeans completed the "I've slept in these clothes a coupla nights" look.

Kevin Bacon was the star of this production, and as I painted the face on the figure, I was probably thinking a little of this well-known actor. But basically I just tried to make the harsh underlighting of the match convincing in the face so that it had the effect of a grinning mask.

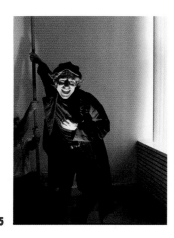

I saw the buildings in the back of the figure as windows casting their light dimly through the English fog. It felt like the right color and texture for the poster, and it suited the soft fusions of watercolor that I used to paint the image.

A great deal of the pleasure in creating this image came from working in transparent watercolor in a dense series of interlocking washes, possibly the most painterly approach I've used on any poster. It felt like building a tight-knit space that was both atmospheric and appropriately claustrophobic. With the drama of the face to anchor the effect of the poster, I could afford to be more subtle in the way I painted the background, using a palette of close-hued smoky colors.

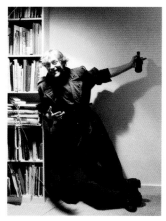

This is one time I wish that the star of the show had been available to pose for the poster. It really would have been fun to have done a portrait of Kevin Bacon as the devilish maître d' inviting us into this particular neighborhood of hell. Given Bacon's star status in films, it would have been as close as I'd get to doing a movie poster.

5, 6, 7, 8.
Using a spotlight from below to stand in for the lit match in his hand, I created a demonic glow on my model's face. He provided the unique hairstyle.

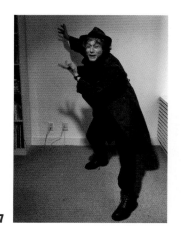

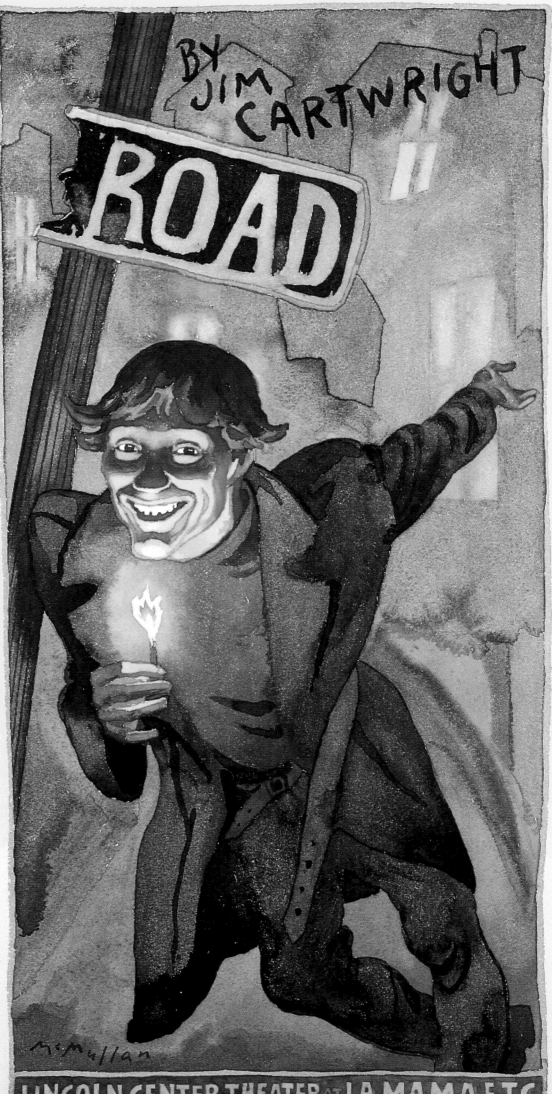

Waiting for Godot

By Samuel Beckett. Designed for but not used by Lincoln Center Theater. 1988

1.
A primitive pre-photography sketch in which I tried out my basic concept for the poster.

2.
Kevin Dooney, my assistant, giving me a wonderful range of funny walks to form the basis of my going-both-ways-at-once suit of clothes.

3.
A variation of color and lettering.

In a book of behind-the-scenes stories about what went into the making and the approval of thirty-six different theatrical posters, one story probably represents the best-case scenario (I would choose *A Fair Country*), while another represents the worst. This story is the latter.

It all began on the lawn of E. L. Doctorow's house in Sag Harbor, at his annual end-of-the-summer party. Among the many distinguished guests was Mike Nichols, the soon-to-be director of a production of *Waiting for Godot*, which was slated for Lincoln Center Theater that fall, starring Robin Williams and Steve Martin.

I had worked with Mike Nichols on my first Broadway poster for *Comedians*. As that project had ended well, I felt comfortable in talking to him about the poster for *Waiting for Godot*, since I knew that Gregory Mosher and Bernard Gersten already had me in mind for it. Mike Nichols responded a little coolly to my query, but finally allowed that he had imagined the poster as a still life of broken-down boots, or maybe boots and a hat. We left it at that. I didn't start work on the project until many weeks later, when I received the official commission from Bernie.

Bernie mentioned that Mike Nichols had actually requested another artist for the poster, but he added that it was his decision that I should do it. This was the first little sign of trouble.

I wasn't interested in doing Mike Nichols's idea of boots, partly because I didn't see a way to make the boots represent the play dramatically, and partly because of my basic decision to do all the Lincoln Center Theater posters with figures. However, the boots-and-hat idea did make me think about the theme of clothing, and of clothes "making the man." I felt there was a connection between the existential nothingness of what the two main characters, Vladimir and Estragon, represent, and the idea of an animated yet empty suit of clothes. In itself this wasn't a powerful enough idea, but I kept rereading the play and thinking about how my idea might turn a corner.

At the end of the first act of *Waiting for Godot*, Vladimir and Estragon keep threatening to leave the anonymous place in which they find themselves, but they always end up turning back at the edge of the stage. There is a moment when they are both walking back and forth, passing each other, always leaving and always returning. Here was the key that finally gave me the turn I needed to make my empty-clothes idea come alive. I realized that the figure I made from the clothes could be walking in two directions at once! It seemed to be exactly the right emblem for the searching, crisscrossing characters in the play. Not only did it feel right as a symbol for the

meaning of the play, but it also hit the right tone of serious tomfoolery of Beckett's profound comedy. This idea, when it finally became clear in my mind, must have tapped into something fairly important in my subconscious, because I was very excited by it.

I knew that the two main characters in the play would be costumed in vaguely turn-of-the-century ragged coats and pants and battered bowler hats. The woolen pants and long coat suited my purposes perfectly, because in my mind's eye I saw the strut of the walking amplified by the heavy wrinkles of the old-fashioned, weighty fabric.

I went to my friend Dorothy Weaver, who has a marvelous vintage clothing business, and I rented the appropriate clothes. Then I asked my assistant Kevin Dooney to put on the clothes and stride back and forth in front of my camera like a character from the *Monty Python* show, doing "funny walks."

The photos turned out exactly as I had imagined. I did sketch after sketch of them, varying the color from deep purples and reds to versions that were almost beige. I didn't try any other idea because I felt so strongly that I had found the right basic metaphor for a dynamic poster. I phoned Lincoln Center Theater to say I was ready to present my idea—in four different color schemes, no less—and they asked me to come up two days later, when everybody who would have to pass on the poster would be available.

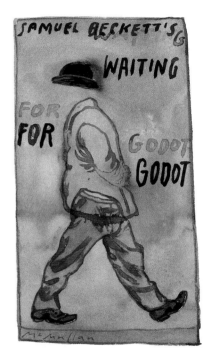

3

I arrived at the appointed hour and was ushered into Gregory Mosher's office, where already waiting was a larger group than usual. I immediately sensed that the mood in the room was tense. Jim Russek, the head of the advertising agency, leaned over to me and whispered, "Whatever you do, don't embarrass Bernie." I didn't understand his remark exactly, but it certainly gave me a heightened sense of the pins and needles everyone seemed to be sitting on.

As we waited for Mike Nichols to arrive, Bernie and Gregory asked to have a preview of my sketches. I spread them out on the coffee table in front of everyone. The reaction was overwhelmingly positive, as enthusiastic as any I'd ever had from a first-version piece of art. Everyone in the room seemed to share my feeling that I had come up with a particularly apt image for *Waiting for Godot*.

About fifteen minutes later, Mike Nichols entered the room. He glanced at the sketches on the table, bent down to look at them briefly, and then straightened up and sighed significantly. "Who's going to tell him?" he asked, looking from face to face. An embarrassed silence filled the room as each person took in the significance of his question and chose not to be the person to lead the attack.

For clearly Mike Nichols was asking that everyone join him in the negative opinion of my sketches that his demeanor expressed. Since every one of the six people who had been in the room previous to

his arrival had already expressed an opinion that the sketches were "great" or "brilliant" or "perfect for the play," it was difficult for anyone to follow Mike Nichols's lead.

Receiving only silence from the participants, Nichols chose a volunteer. He asked Bernard Gersten to start things off.

Bernie responded by saying something about any given piece of art eliciting different opinions from different people.

This was clearly not a satisfactory response as far as Mike Nichols was concerned. He brusquely pointed down at the sketches and said he didn't see how anyone could think this art might represent Beckett. He questioned the "miasma" of color, claiming that "Beckett is black and white." He added, "It doesn't look as if the artist read the play."

Nichols knew I was sitting there. His insulting reference to me in the third person, as though I weren't present, told me that he wasn't simply turning down a piece of art, he was getting revenge for something that he felt he had been denied. Perhaps his request to have his own artist; maybe something that had nothing to do with me or the poster. I still don't know.

However, despite Jim Russek's caution not to "embarrass Bernie," I couldn't keep myself from responding to his last remark.

"You're entitled to any reaction you have to my idea, Mike," I said, "but I don't think thoughtlessness is one of the things you can accuse me of. This concept comes directly out of the end of the first act of the play."

He claimed he couldn't see the play in my art. Then he proceeded to tell me that the poster should be the two tramps silhouetted against a large moon.

I couldn't help myself. "Oh, you mean just like the cover on the paperback book?" I asked.

He insisted that his concept was nothing like the cover of the paperback. He insisted that the paperback cover had a sun behind the two figures. "On a deep blue nighttime sky?" said I.

It was a silly fight. Even when I insisted that someone get me the paperback edition of the script from another office, and I turned out to be right, it didn't matter.

In the end Lincoln Center Theater hired a photographer to carry out Nichols's idea, and that became the poster for the play.

The image I had created didn't die with Mike Nichols's rebuff, however. Several months later, the image was reproduced as a small poster by the Art Association of Iowa. I was speaking at their club, and they had asked me to choose a piece of art that they could print as a poster to commemorate the event. That poster has become one of my best-selling images at Triton Gallery, where my theatrical posters are sold. I am always amused and gratified to see the poster framed in the homes of the people from Lincoln Center Theater who were connected to the play. I somehow feel that, despite Mike Nichols's rejection, the art has become a kind of underground image for that production of *Waiting for Godot*.

Samuel Beckett's
Waiting
for
Godot

Lincoln Center Theater at the Mitzi E. Newhouse

Measure for Measure

By William Shakespeare. Directed by Mark Lamos. 1989

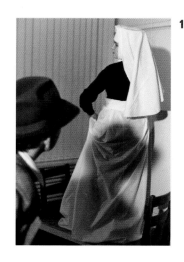

The idea for the *Measure for Measure* poster was, in a sense, my own idea, but I had to be reminded of it by the director, Mark Lamos. He remembered a cover I had done for *New West Magazine* on the subject of paranoia. The cover showed a man from the back looking suspiciously over his shoulder while an ominously fedora'd shadow falls over his tweed jacket. Mark suggested that I do a variation of this for his modern-dress production of the Shakespeare play. The concept intrigued me.

In my reading of the play, the best candidate to be shadowed was the beautiful and innocent nun, Isabella. There were several malevolent men who could have been the shadower, so I left that up to the viewer's imagination.

I remembered that in my *New West* cover, the tweed jacket was an important element of the paranoiac because it gave an enriching complication to the shadow. Changing the color of the tweed as it fell under the shadow made the shape convincing in a way that it wouldn't have been without the texture. In the *Measure for Measure* poster I realized that the sweeping drapery of the nun's white habit could play the same role as the tweed, changing the color and light of the shadow as it adapted to the hills and valleys of the fabric.

From the photos I took of my assistant Amy Head, I was gratified to see that the contrast between the two kinds of light illuminating the figure, warm light from my tungsten bulbs and cool, bluish light from the window, was even more dramatic than I had imagined. I decided to draw Isabella in a classically inspired red-ocher line to sustain an elegant feeling in her figure, which is then violated by the somewhat cruder shadow—a kind of Michelangelo meets the comic-strip Phantom.

This poster gave me a chance to use two of my favorite ideas—shadows falling over things and "beautiful" styles or subjects being desecrated by more primitive, "ugly" styles.

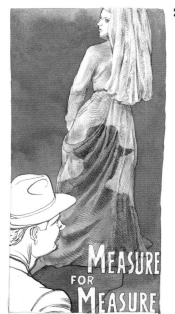

1.
Garnet Henderson and Amy Head play shadower and shadowee to give me information on what happens when a shadow falls over the folds of the nun's habit.

2.
A sketch that relied too much on a rough linear style.

The Tenth Man

By Paddy Chayefsky. Directed by Ulu Grosbard. 1989

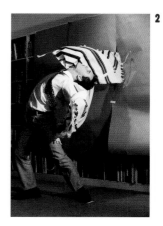

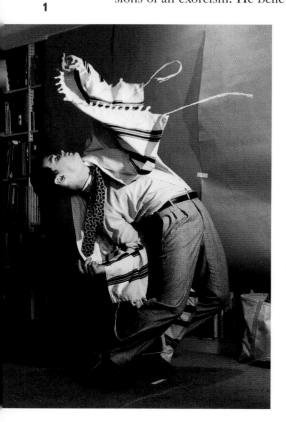

In thinking back on the story of the *Tenth Man* poster, something that happened long after the production closed is the first thing that floats into my mind. What I remember is a meeting I had with John Guare to discuss what I might do for the *Four Baboons Adoring the Sun* poster.

"Don't do to me what you did to Paddy Chayefsky on *The Tenth Man!*" he exclaimed.

"What do you mean, John?" I asked.

"You gave the story away on the poster, Jim," he replied. "It was a cruel thing to do to a playwright."

He was referring to the image that I showed on the poster of a man going through the convulsions of an exorcism. He believed that this image undercut the suspense in the play because the audience, until the last scene, is led to believe that it is the young woman in the play, and not the man, who is filled with the evil spirit and needs the exorcism.

Maybe John had a point. Nevertheless, the excitement of the actual exorcism and the visual possibilities that it offered were too tempting for me to ignore.

I borrowed a prayer shawl and asked Kevin Dooney, my assistant, to put it on and to try some poses that felt to him like the tumult of having the devil leave his body. He gave me some wonderful stuff. The prayer shawl whipping and snapping in the air as Kevin flung himself around added a great deal to the sense of violence in the image.

The resulting poster was a hit with the producers at Lincoln Center Theater. Ulu Grosbard, the director, didn't mention anything about it giving away the secret of the play.

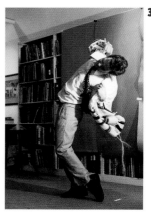

1, 2, 3.
Photos of Kevin Dooney playing the role of a demonized man undergoing exorcism.

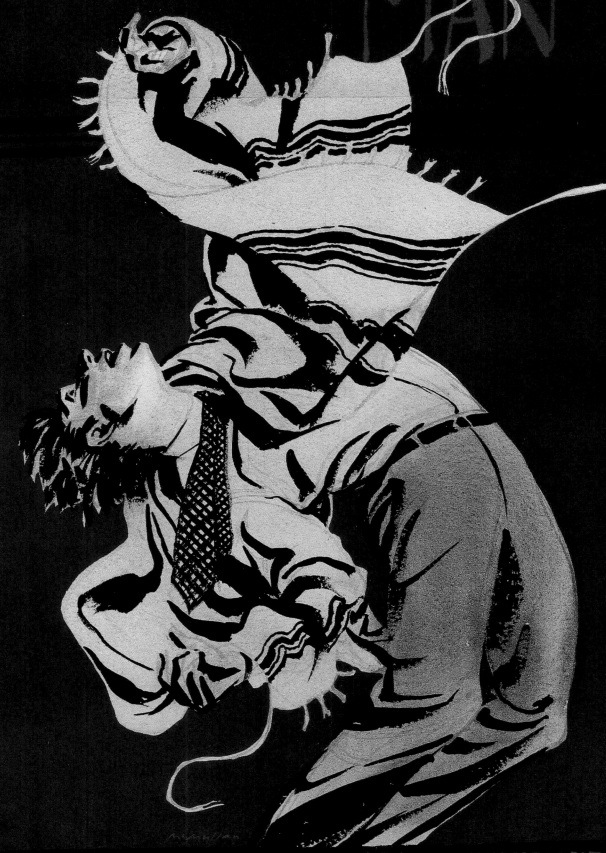

Six Degrees of Separation

By John Guare. Directed by Jerry Zaks. 1990

1.
Photo of James McDaniel, who played the role of Paul in the play. I was fascinated by how James used his hands to suggest the youth and anxiety of his character.

2.
A pencil study to feel out how the figure might be framed in the poster.

I remember sitting up in bed with the script of *Six Degrees of Separation* that I had just finished reading in my lap and experiencing the thrill of foresight: "This is good, and it's going to be a big play." I'd had that feeling twice before, once with a book I was doing illustrations for and once with another play; in neither of those cases was my crystal ball on target. With *Six Degrees*, however, it turned out as I anticipated. The play was a great critical as well as commercial success. It was turned into a movie, and even engendered a very gossipy lawsuit brought by a young black man who claimed he was the real-life character who conned his way into the lives and apartments of upscale families with children at Harvard. Based on the similarities of his life to the plot of the play, this man thought John Guare owed him some loot. This was all in the future, however.

A week after I read the script, I attended a meeting at Lincoln Center with John Guare, Bernard Gersten, Gregory Mosher, and Jerry Zaks, the director.

My good feelings about the play and John Guare's ability to stimulate lively discussion may have had something to do with the fact that it was one of the best, most good-spirited and productive poster meetings I've ever attended. Everyone in the room started talking about a different aspect of the character of the young black man, Paul, but quickly added that the poster couldn't be just about him. We ranged far and wide in our talk, touching on several possibilities for the poster: rich versus

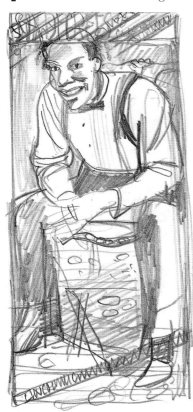

poor, parents versus children, the desperation of the upper-middle class. All interesting, but somehow not entirely gripping. As the energy of the repartee in the room started to ebb, I was sure I felt a relief in the minds of the others that it was, after all, my problem to take back to the studio and solve. At that moment John sat up in his chair and said, "It should be a portrait of Paul as a charmer!"

I understood immediately what he meant, and what a provocative possibility he had just opened up. The simplicity of it was its strength—a portrait of the actor as the character looking out from the poster and charming and intriguing the viewer on the subway platform just as Paul had done with the rich people on Fifth Avenue.

We talked a bit more, and agreed that Paul should be dressed in a tuxedo, as he was in a scene at the Rainbow Room that is explained but never shown in the play. The actor who was playing Paul was in New York and available, so arrangements were made for him to come to my studio.

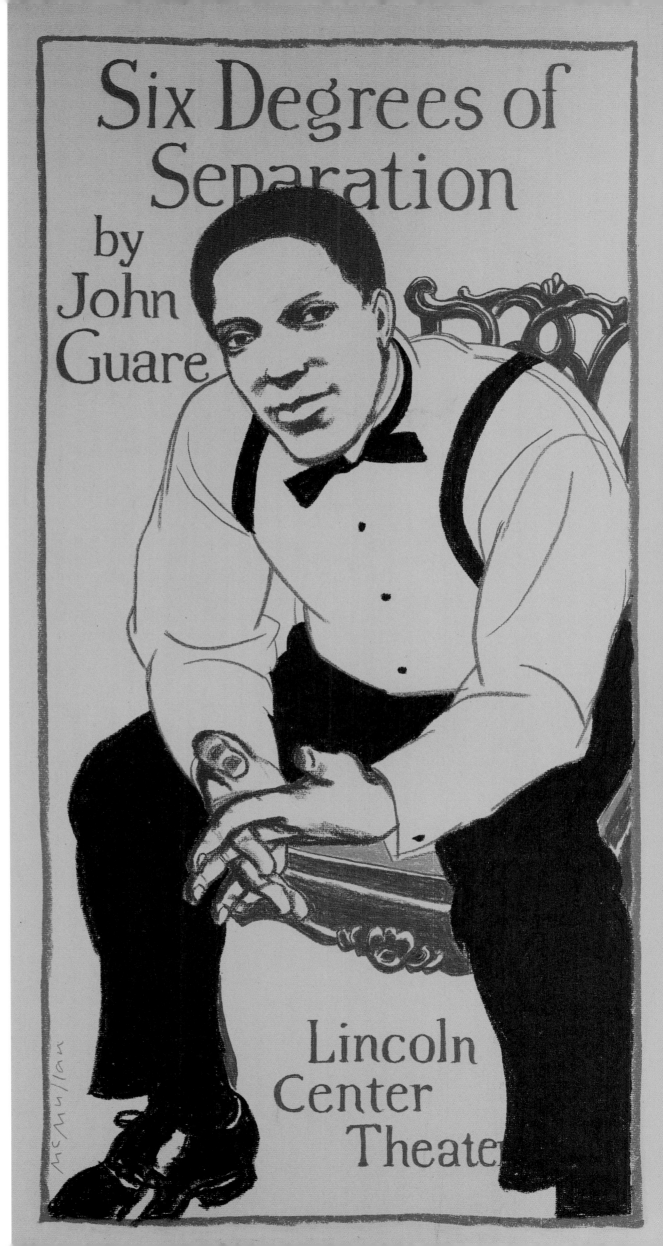

Six Degrees of
Separation

by
John
Guare

Lincoln
Center
Theater

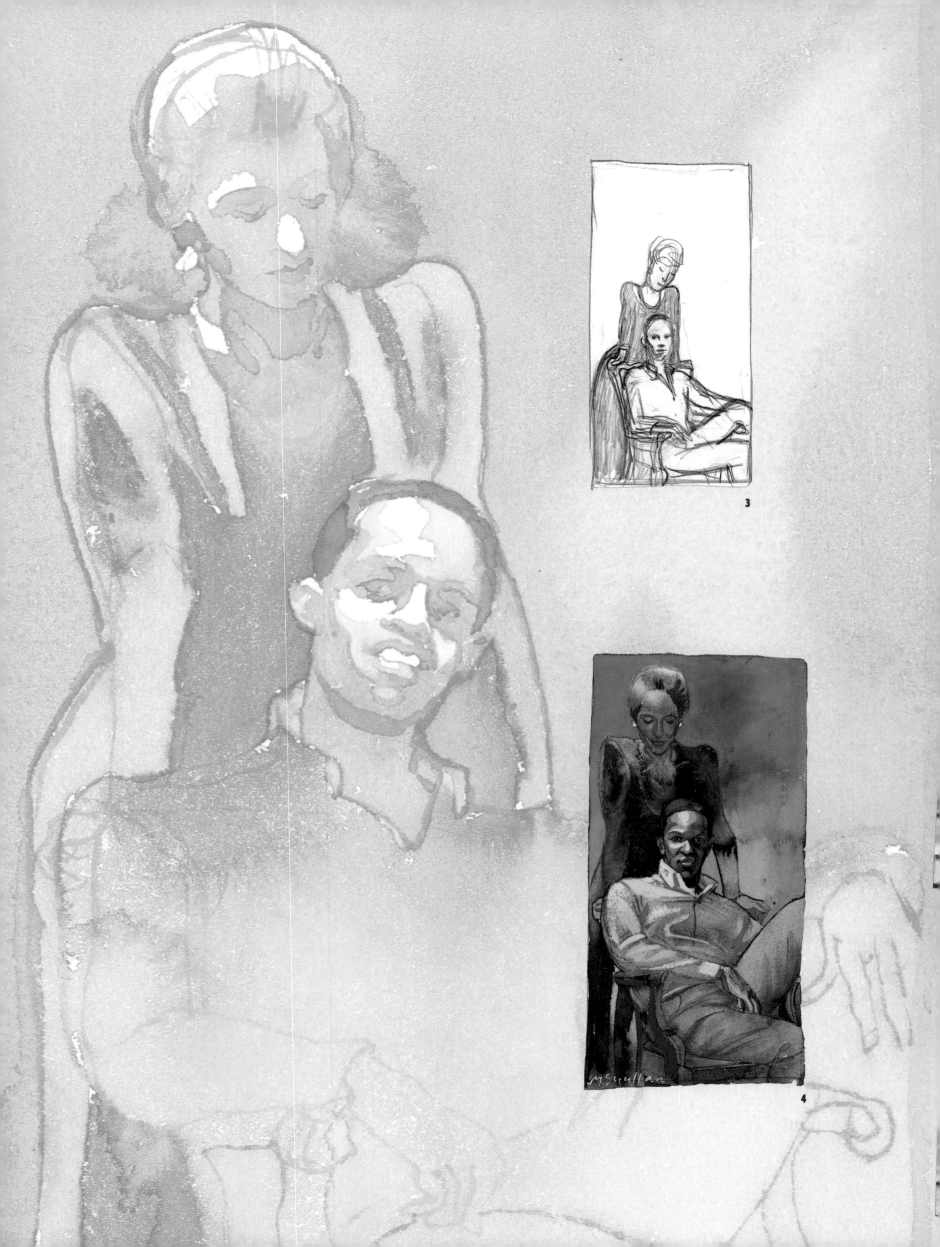

3

4

3.

A pencil sketch I did out of my head, and which Bernard Gersten approved as the idea for the second poster.

4, 5, 6.

Various stages in arriving at a straightforward watercolor painting of Ouisa and Paul. It was an arrangement of the figures I hoped would suggest their complex son/mother/con man/psychic lover relationship. I kept this composition but moved on to more emotional ways carrying it out.

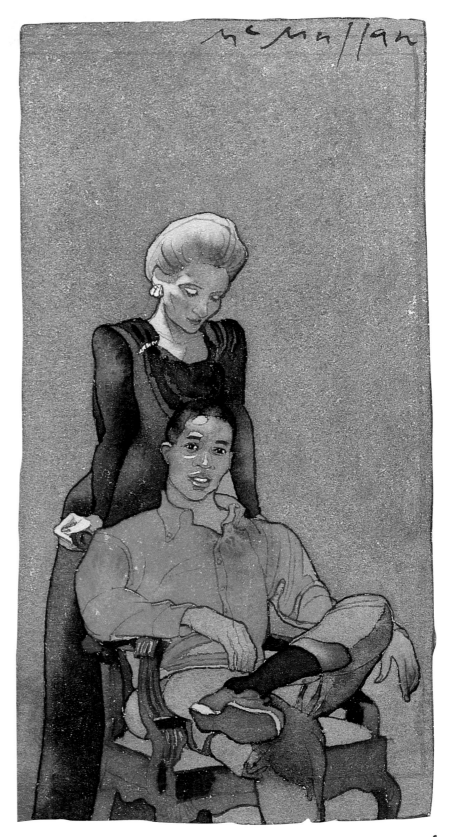

6

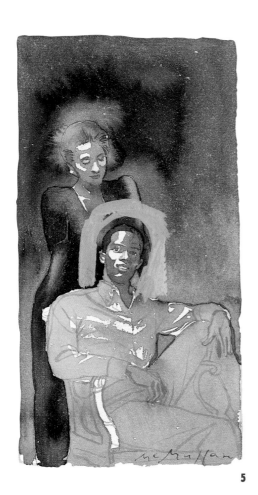

5

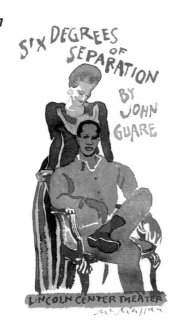

7.
A more calligraphic version of the preceding sketches, which helped me to move away from the linear style and to discover the simplified shapes of the final gouache art.

I experienced a shock when James McDaniel walked through the door of my studio. Instead of the slight young man I had imagined when reading the play, in walked a tall, muscular man with a heavy jawline and a deep voice. We introduced ourselves, and I adjusted the lights and the angle of the fancy chair I had rented. As we tried a few initial poses, I mentioned that he was not exactly what I imagined. He took my meaning immediately and replied, "Because I'm not boyish?"

"Yes, I suppose so," I said.

"Jerry Zaks and I have been working on that," James said. He proceeded to show me small adjustments in the angle of his walk, a certain way of leaning forward in the chair, and, most fascinatingly, a weaving together of the fingers of his hands to suggest an uncertain, youthful anxiety. These transformations made the character of Paul far more interesting than simply casting "the right type" would have been, and these mannerisms became the focus of the poster.

James McDaniel is an exceedingly accomplished and intelligent actor who went on to play Lieutenant Fancy in *NYPD Blue*. The four hours I spent drawing, photographing, and talking with him made it possible for me to invest the final drawing with a good deal of intensity.

My struggles to find the simplicity in the drawing that I finally did are not worth mentioning, except to say that the versions went through a schmaltzy realistic stage before I came to my senses. The final art is a 17-by-34-inch pastel drawing (large for me), in which the details have been reduced to the bare essentials.

The poster was printed and went up around New York City. The play opened to critical raves. About two months later, a story made its way to me, secondhand. John Guare went to his masseur and asked the man if he had seen his latest play, *Six Degrees of Separation*. The masseur said, "Oh, the one about the blacks? No, I haven't."

John and the producers at Lincoln Center felt that this meant that at least some New Yorkers did not understand that the play was about one black character as well as several white characters. It was decided that a new poster should be done, and this one was to include a portrait of the character Ouisa, played by Stockard Channing.

I had also done a second poster for *Anything Goes*; in that case, listening to other voices, I made the poster sunnier, the boat whiter, and the whole mood more trivial. I vowed that this time I was not going to try to repeat the first poster nor listen to any "improving" advice.

I came up with an idea fairly quickly. It was simply to have Ouisa stand behind Paul. I wanted her to have her hands on the chair he is sitting on and to be looking down at him with a kind of complex attention—a combination of mother and sophisticated lover. I pictured Paul looking straight out in a noncommittal way.

I made a small pencil sketch of this idea and faxed it over to Bernie and Greg. It was a measure of my certainty that I was willing to risk presenting them with a very rough idea without my being there. They gave me a go-ahead.

The studies I did in preparation for the final version of the poster are predictable enough up to a certain point. I did one fairly controlled, reasonably elegant sketch after another. Then a sudden change of medium—watercolor to gouache—and I did the painting that became the poster. There is no first version of it, no other attempts in gouache.

I can't really remember how I came to doing this painting except that it was late in the afternoon, I was tired, and I had essentially given up my experiments for the day. The night before, I had watched part of the *Civil War* series on PBS-TV, and I had been struck by how simple and sculptural the planes of the Negro soldiers' faces had been in the early photographs. I know those images were in my mind as I painted, but there is something about the whole painting that is mysterious to me and represents a quality I have tried to recapture without success.

How lucky I was that the relationship with Bernie and Greg Mosher had advanced to the point that they saw the painting the same way I did—as something that we should print and not try to fiddle with or improve.

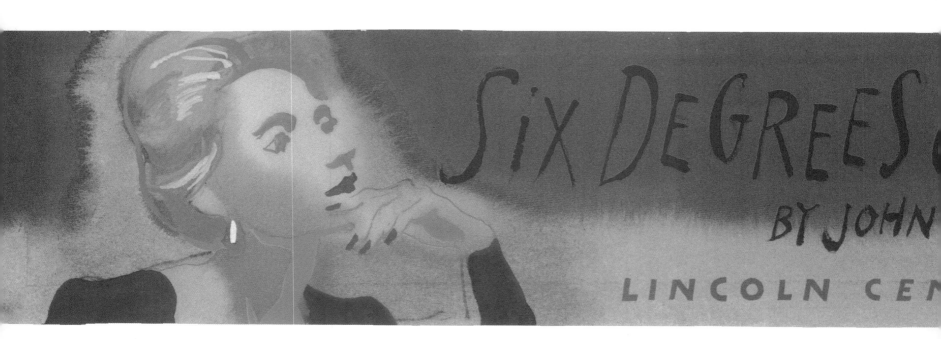

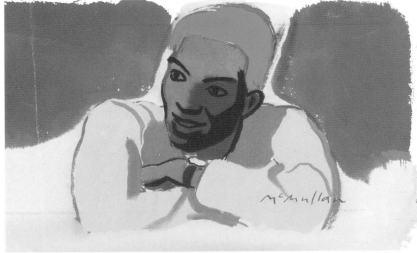

8

8, 9.
Head studies for the bus poster and the final poster.

10.
A photo of the poster moving through the traffic of New York on a city bus.

10

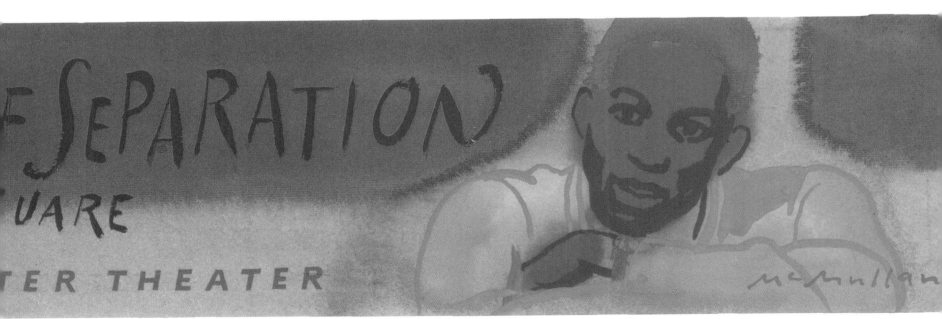

9

Mule Bone

By Langston Hughes and Zora Neale Hurston. Directed by Michael Schultz. 1991

My first take on the poster for this play went off on the wrong track. My idea was to capitalize on the energy of the singing and dancing in the play and to do a flat, stylized design using three figures, with the main one doing a kind of rural jig.

The sketch wasn't warm enough to convey the jokey, familial flavor of *Mule Bone*, and as soon as Bernard Gersten and Gregory Mosher pointed this out to me, I knew they were right.

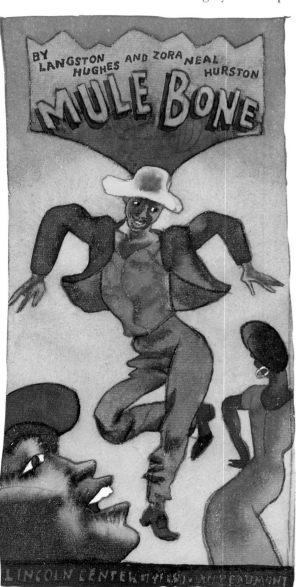

I found a clear new direction for the *Mule Bone* poster by looking at 1930s photos, particularly ones that Marion Post Walcott had taken of groups of people playing checkers on battered store porches, waiting to be paid for picking cotton, or dancing inside juke joints. The texture of the intermingling figures in the photographs set against the faded painted wood and rusted tin signs of a Southern rural store suggested a rich tapestry effect for the poster. I saw a shallow space filled with figures and signs, the color flickering like the remnants of paint on a weather-beaten shanty. I painted the art using a combination of information from the early photographs and photographs I took of cast members.

Around this time the advertising spaces in the subway stations in New York were redesigned so that there were no more sites for large vertical posters (except for the Forty-second Street shuttle corridor). This left the only spaces for large (42-by-84-inch) three-sheet posters on commuter-line train platforms. It was an illogical decision by the MTA, which lost it tens of thousands of dollars in income. Russek Advertising did the best it could in redesigning my art for the horizontal shape, but Lincoln Center Theater from this play on gave up printing posters for subways and in fact—except for big hits like *Carousel*, *Arcadia*, and a few others—gave up printing the posters in anything but small-quantity computer printouts.

1.
A photo I took of the actor Hinton Battle for the center figure in the poster.

2.
My first sketch, which the producers at Lincoln Center Theater thought was too stylized.

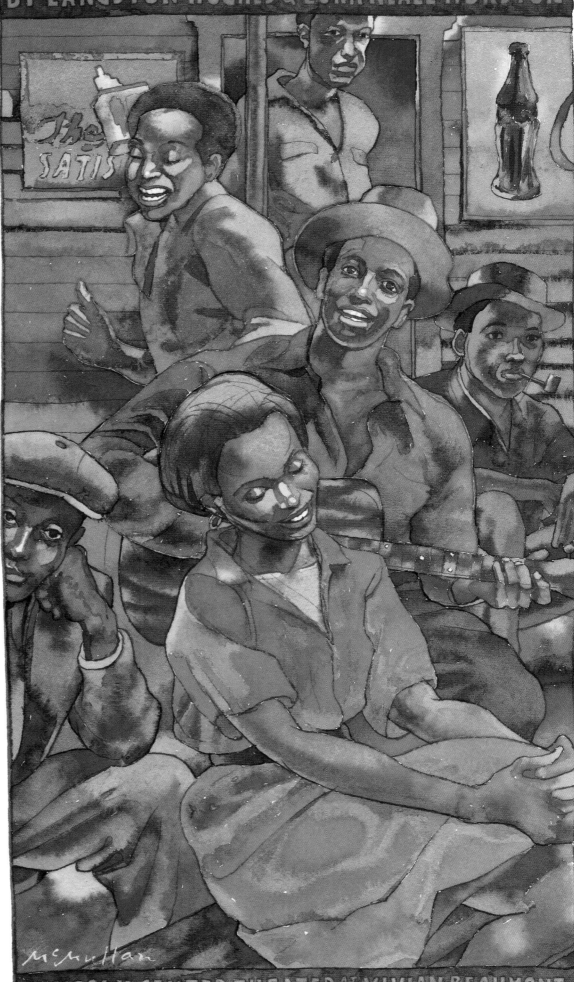

MULE BONE

BY LANGSTON HUGHES & ZORA NEALE HURSTON

LINCOLN CENTER THEATER AT THE VIVIAN BEAUMONT

Two Shakespearean Actors

By Richard Nelson. Directed by Jack O'Brien. 1991

This Richard Nelson play was loosely based on the riots that occurred in New York in 1849, when fans of the British Shakespearean actor William Charles Macready fought viciously inside and outside the Astor Place Opera House with the fans of the American Shakespearean actor Edwin Forrest. This level of audience enthusiasm is a little hard to imagine in an age when Patti LuPone is abruptly fired and Glenn Close is hired to replace her as Norma Desmond in *Sunset Boulevard*, and there is hardly a murmur from anyone's loyal fans. But the 1849 riots, protesting or defending the right of an English actor to challenge the supremacy of the American actor in the title role of *Macbeth*, are historical fact, and in *Two Shakespearean Actors* Richard Nelson has conceived a wonderful close-up view of the major participants.

Jim Russek, the head of the advertising agency for Lincoln Center Theater, suggested that there is an element of farce in the raucous free-for-all that characterized the riots. This notion of farce also colored the sounds of the offstage combatants in the play. Jim Russek felt that the tone of the poster should be broad and humorous, and that perhaps we might be looking at the angry mob as seen from the stage

At first I thought his idea, with its many shouting faces beyond the footlights, was too complicated to make a good poster. But then it occurred to me that if we saw the audience from behind the actor and from between his legs, it could be quite funny. Also, the large foreground shape of a costumed Shakespearean actor would anchor the composition and give it graphic drama.

By coincidence, I had just done a *Time* cover to illustrate a story about the horrors of the Cultural Revolution in China, showing hundreds of angry Chinese students at a rally, waving their little red books. In that case I had used brush and black ink to produce a flat texture of simplified faces, Chairman Mao caps, and upraised arms. I decided to use the same approach for this poster with a subject of similar complication.

I was pleased that in my finished brush-and-ink drawing for the *Two Shakespearean Actors* poster, despite its hundreds of lines, one could sense that the crowd was fighting without focusing

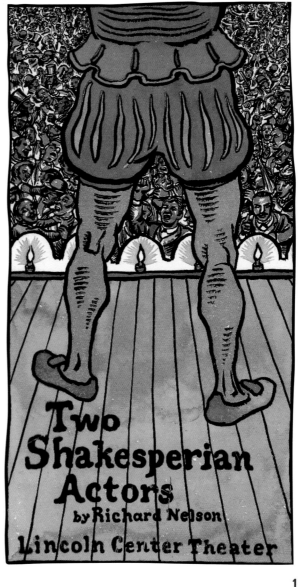

1

down to particular tiny fists smashing into particular tiny faces. The scale of the brush lines moved from the fat, slow-moving lines describing the foreground actor to the frenzy of minute lines delineating the Lilliputian crowds beyond.

I had a transparent acetate made of my drawing. Then, using a light box, I painted the color on a separate sheet. I put the acetate with the black drawing over the color and took the finished art up to Lincoln Center.

The views of Gregory Mosher, Bernard Gersten, and the author, Richard Nelson, about the play couldn't have been more different from the view originally expressed to me by Jim Russek. They fairly blanched at the vaudevillian tone of my sketch. Richard Nelson's reaction was so despairing that I felt guilty for putting him through a terrible experience.

I quickly assured him that I had other tricks up my sleeve and would be happy to do another sketch once he had explained to me the true character of the play. Richard said that what was most important to him about the tone of *Two Shakespearean Actors* was that it was an intimate view of the backstage relationships of these players, and that it would be good if the poster could suggest that we were coming at this life of actors from an odd angle. Not down center aisle and across the footlights, but perhaps, suddenly, from behind a piece of stored scenery.

It was an interesting mental picture that Richard Nelson painted. Greg Mosher concurred with it. I was intrigued to think of some way I might show a candid moment in the life of these characters.

The act of dressing or being only partly dressed: these were the provocative notions that first crossed my mind. The brave Macduff buckling on his sword, still in his underpants! It was certainly not the way the audience would see him or that he would want to be seen.

I phoned Greg and Richard with this rough idea, and they were both enthusiastic.

I arranged for actors and costumes. I rented a full-length, freestanding mirror. I asked the actors to try out variations of the dressing scene in front of my camera. The resulting photos were almost too complicated to serve as the basis for a poster, but

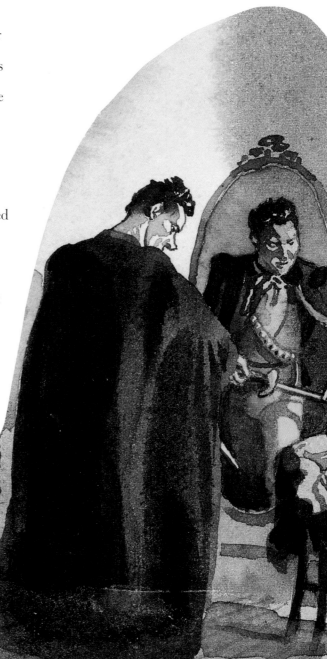

3

something in the information told me that an unusual poster could emerge, so I persevered. Using the drama and simple shape of the swagged curtain in the background, and the dark mass of the actor's cape in the foreground, I stabilized the other details enough to create a design out of this busy scene.

4

The first versions of this image were almost monochromatic, and played the dark specificity of the foreground figure against the misty light coming from the space beyond. I was very attracted to the immediacy of these spontaneous drawings, and I was intrigued with the idea of doing a poster with such limited color. When I showed them to Gregory Mosher and Bernie Gersten, they liked the image but missed the color.

I agreed to do another painting, with more color. It lost a little spontaneity in the process, but it gained a more sensuous effect in the addition of the deep plum of the actor's cape and the warm ochers of the background.

This is a curious poster because it illustrates a real scene more than almost any other poster I have done, and in that sense it moves my work even farther than usual from the reductive modern poster aesthetic. At the same time, despite its illustrative sense of space, the image still feels posteresque to me. The project was also a high-water mark in my working relationship with Gregory Mosher. I think at the time we did this poster, he trusted me and understood what I could do in a way that he hadn't at an earlier stage of our relationship.

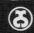

LINCOLN CENTER THEATER PRESENTS

TWO SHAKESPEAREAN ACTORS

BY
RICHARD
NELSON

With
(in alphabetical order)
Tom Aldredge Brian Bedford
Ben Bode Alan Brasington
Michael Butler Jeffrey Allan Chandler
Richard Clarke Frances Conroy Hope Davis
Le Clanché du Rand Mitchell Edmonds Katie Finneran
Victor Garber Laura Innes Želјko Ivanek Judy Kuhn
Tom Lacy David Andrew Macdonald Tim MacDonald Katie MacNichol Bill Moor
James Murtaugh Susan Pellegrino Thomas Schall Eric Stoltz Jennifer Van Dyck Graham Winton John Wojda
Sets David Jenkins Costumes Jane Greenwood Lighting Jules Fisher Sound Jeff Ladman Original Score Bob James Fight Director Steven Rankin
Directed by Jack O'Brien
This production is sponsored by the Lila Acheson and DeWitt Wallace Fund for Lincoln Center, established by the founders of Reader's Digest. Special thanks to CITIBANK, N.A.
and the General Electric Foundation for their generous support of related educational activities.

CORT THEATRE

The Most Happy Fella

By Frank Loesser. Directed by Gerald Gutierrez. 1992

1.
Spiro Malas does a spirited dance for Sophie Hayden and gives me the main ingredient for the poster.

2, 3, 4.
Various sketches in which I am either trying to montage the elements or find the right gesture for the central character.

The story of this musical takes place on the Napa Valley vineyard of Tony Esposito, who writes away for a mail-order bride. Rosabella, who gets his letter and decides to meet him, arrives in Napa Valley and, although she likes the warmhearted hero, complicates the situation when she has a tryst with the vineyard's handsome foreman. Everything is straightened out in the end, with many beautiful songs and rousing dances along the way.

In preparing myself to photograph the two stars of the musical, Spiro Malas and Sophie Hayden, I decided that the idea of them introducing themselves to each other or dancing together would be a good place to start. I took many shots of Spiro Malas singing to Sophie and doing a kind of peasant dance with her, albeit with a cane, since in the story he is supposed to be slightly crippled. From these photos I did a series of studies, many of them using a background of grapes and leaves, and most of them moving toward a primitive kind of drawing.

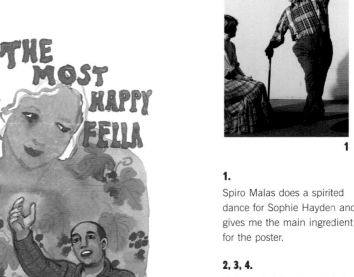

What finally worked took me by surprise. A small sketch done in broad gouache strokes seemed to sum up both Tony's vigorous dance and the color and light of the Napa Valley. It was a cruder piece of art than I had expected to do, but all of my attempts to do it in a more refined way lost some of the charm of the sketch. I decided to present it.

Because *The Most Happy Fella* was a coproduction between Lincoln Center Theater and the Shubert Organization, I had to make my sketch presentation at the Shubert's offices, where the producers from both teams had gathered. The flocked wallpaper and chandelier lights murmured, "Money, Power, Fame," in that order, and I feared that my sketch was going to look very arty and uncommercial in this venue. Bernard Jacobs, who seemed to be the man in charge, looked at the art through hooded eyes and handed it wordlessly back to Bernie Gersten. I left the meeting feeling uncertain as to the fate of my poster. Later that day Bernie Gersten phoned to say that the sketch had been approved as the final art.

You never know.

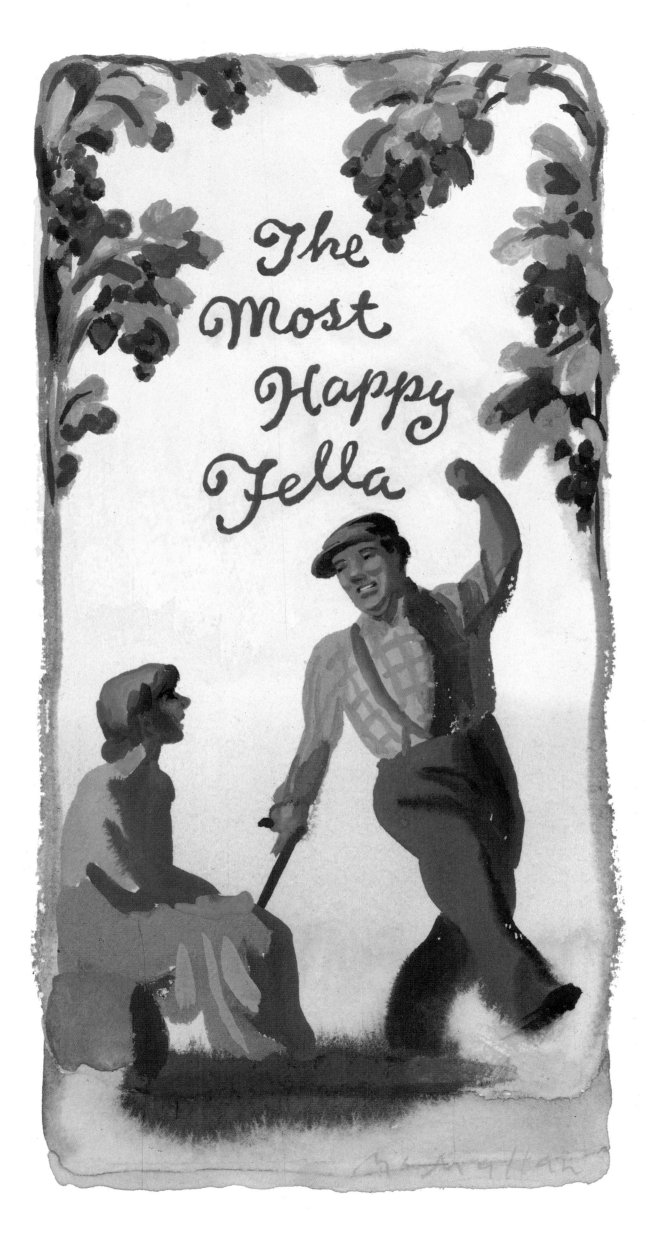

Four Baboons Adoring the Sun

By John Guare. Directed by Sir Peter Hall. 1992

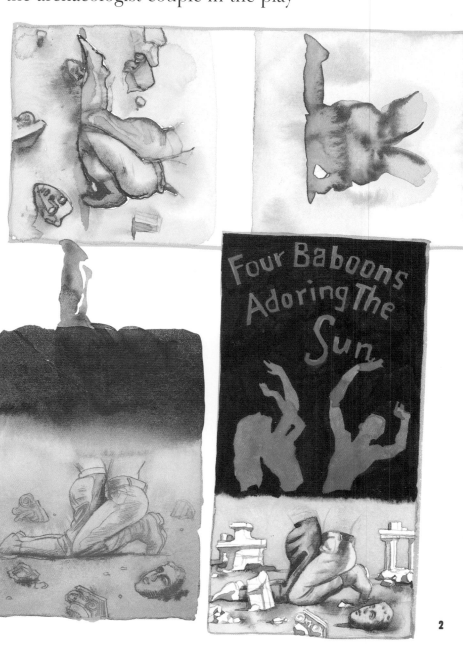

I start every poster with the idea that I will move forward in my art in some way, that I will make the work newer, better, and more revealing of myself than anything I've done before. After I read the play script for *Four Baboons Adoring the Sun*, I thought, "Here's a chance to surprise myself and do something great."

The play was quirky and sexy, and John Guare had obviously surprised himself in writing it. It had an ambitious story of modern sexual love and parental love set against the myths of ancient Greece, as well as an actual character representing the god Eros.

As I thought about the story's tension between lust and spirituality, an idea came to me. I pictured the archaeologist couple in the play kneeling sensuously crotch to crotch amid the ruins, while their torsos, uplifted in a gesture of adoration, explode away from their lower bodies.

The idea seemed inspired in that it was a novel way of suggesting the connection between carnality and the transcendent searching that John Guare was exploring in the play.

I hired a Brazilian couple who were modeling in my life drawing classes at the School of Visual Arts to play the carnal/transcendent roles, and they were wonderful at giving me the intensity I had imagined. The fact that they were intimates in real life was a plus in the posing.

The image I eventually came up with was different in scale from any other poster I had ever done. The individual shapes were smaller and had a finesse that was texturally different from *Two Shakespearean Actors*, the poster that this one most closely

1.

My models play the sexy/ecstatic roles I had imagined.

2.

A precious sheet of 1949 English watercolor paper on which I have fitted various studies of the subject, the color, and the title lettering.

3.

The version that was not approved.

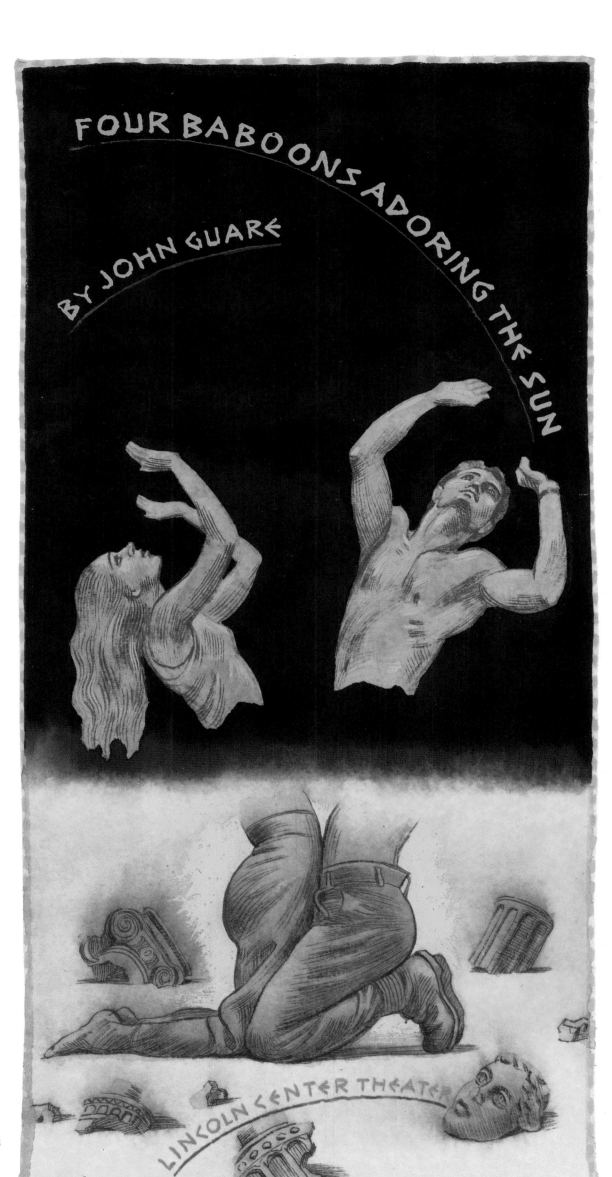

resembles in complexity. I decided to carry out this refinement in the title by using relatively small letters arcing through space, leaving more blank space than usual in a poster.

When I showed this art to Bernard Gersten and John Guare, John had an apt response. "I can hear the noise this poster makes," he said, obviously referring to whatever snap, crackle, or pop bodies separating in this way would produce. His interesting perception, however, did not signal his approval, and he was joined in his lack of enthusiasm by Bernie, who felt that the image wasn't sufficiently posteresque or dramatic.

The small scale of the figures, the relative complexity of the visual idea, and its oddness—all the characteristics that made it seem like a satisfyingly provocative image to me—were the very things that Bernie and John objected to in the poster.

Bernie suggested that, for my next try, I depict the Eros figure from the play. As conceived by the playwright and the costume designer, Willa Kim, Eros was an almost naked youth carrying a bow and arrow. His face was to be made up for the play to resemble the big-eyed satyrs of Greek art, and the hair on his head was to be a wig of golden curls. If I had to abandon my much-loved exploding couple, I couldn't have asked for a more promising subject to replace it than a naked god.

Using the same Brazilian model who had posed for the first sketch, to get information on muscles and attitude I set about doing my version of Eros ready to shoot the viewer with his arrow of love. In the background, and rather suggestively seen between his legs, is the volcano that threatens to erupt throughout the play.

This version was printed. Russek Advertising, doing the ads for *The New York Times*, had a lot of fun stretching Eros' loincloth to improbable lengths so that quotes could be superimposed on it.

4.
A sketch by the great costume designer Willa Kim that inspired the Eros figure in my final art.

5.
The young man from my first photo session acts out a second role, that of Eros taking aim at the viewer.

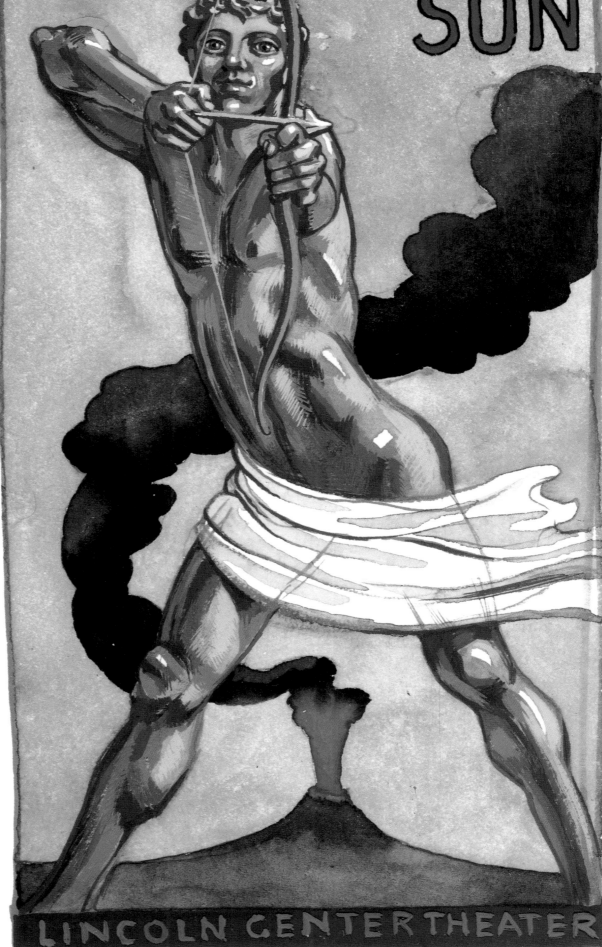

The Sisters Rosensweig

By Wendy Wasserstein. Directed by Daniel Sullivan. 1992

1.
The drawing I did when I first decided on the simple concept for the poster.

2.
My three models pose on my specially rented couch and give me the gestures that became the basis for the poster.

I decided to make the poster for Wendy Wasserstein's *The Sisters Rosensweig* an image of three sisters sitting on and around a sofa: a simple visual completion of the title. Realizing that the couch my models would disport themselves on was an important element in my idea, I went to a theatrical furniture rental house and picked out a vaguely French settee with sweeping side arms and a curved back. I felt that the long scroll shape of the arms had enough gusto to play a part in the composition and give an actress something to lean against. The sofa was delivered to my studio, and the models, arranged for through an agency, arrived.

Since the poster was basically to be a portrait image, with all three women facing the viewer, I was depending on what we could think of on the spur of the moment to give the arrangement some surprise and life. I explained the personality of each sister to my models so that they would have something to think about in trying out poses.

The lucky moment came when the model playing Sara, the dominant sister, threw back her head in a laugh and raised her hands as if in ironic amusement. It was just the right gesture for the character, and it gave the poster its focus.

This was my first poster for Lincoln Center Theater since the arrival of André Bishop as artistic director. When I pulled the art out of the envelope, I heard André breathe a sigh of relief. "Oh good! It's happy," he said, and I realized that he must have felt that some of my posters were too serious and he was anticipating that I might misinterpret Wendy's play and do something inappropriately dark. It was a fortunate start for André and me. There might be serious McMullan posters in his future, but for this moment at the beginning of his leadership I sensed he especially needed an upbeat image for his first Lincoln Center Theater play.

Jane Alexander, who played the central sister in *The Sisters Rosensweig*, told me much later that everyone was convinced that she had posed for the laughing figure on the poster. I think that says less about my powers of portraiture than it does the power of suggestion in blobs and dashes of gouache paint.

Playboy of the West Indies

By Mustapha Matura. Directed by Gerald Gutierrez. 1993

Working from Sean O'Casey's original 1920s drama *Playboy of the Western World* and changing the locale from Ireland to the Caribbean, playwright Mustapha Matura created a main character similar to O'Casey's—a young, handsome stranger who is treated at first as a hero and then as a villain. The point of *Playboy of the West Indies* is that both the good opinion and the bad one are based on shallow misperceptions about the real man.

Much of the first act of the play is involved with the handsome stranger's arrival at a store, which is the village's central meeting place, and the subsequent competition among village women to claim his attention. I thought these two aspects—the man's arrival and the sexy flirting that he precipitates—were important enough to form the basis of the poster. I did two pencil sketches showing different points of view of the man being welcomed to the village store. In one, the stranger is in the

1, 2.
The idea of the hero's first appearance at the village store, as seen from opposite points of view.

3, 4, 5.
Photos of the two models.

6.
A gouache sketch.

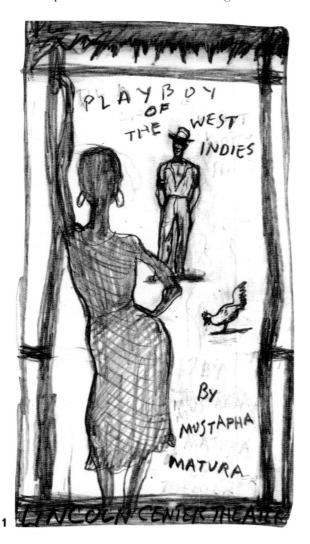

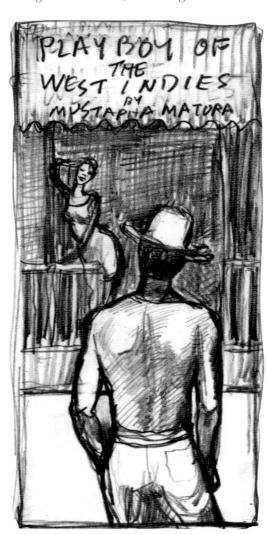

58

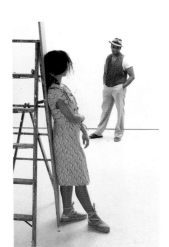

3

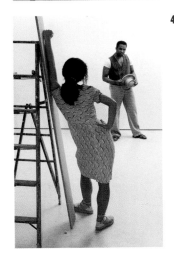

4

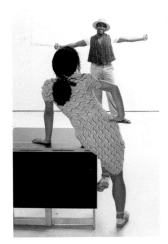

5

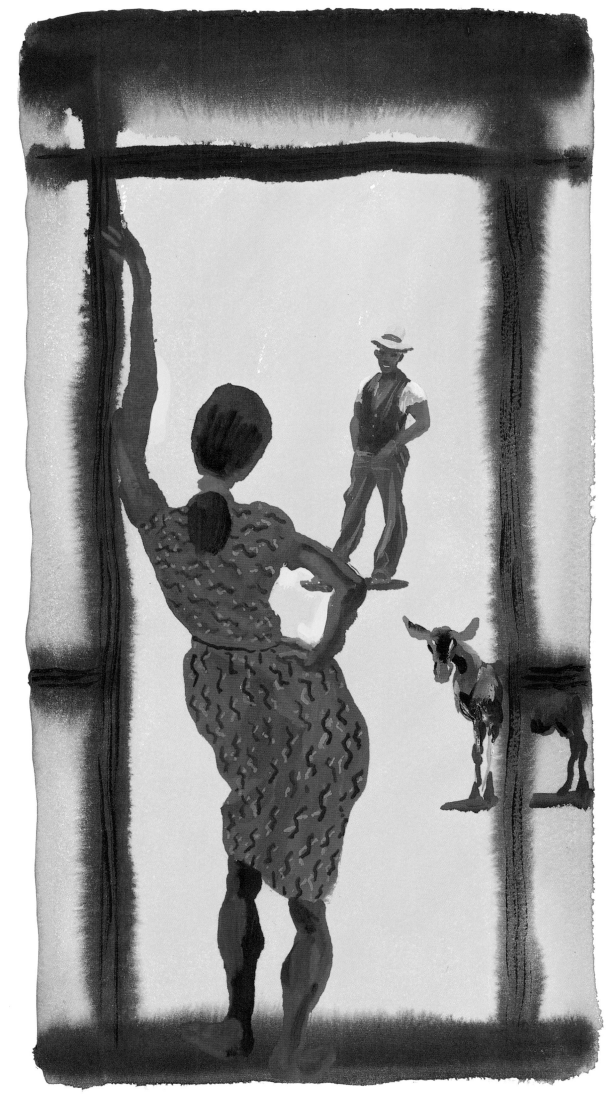

6

foreground and a young woman is in the background on the porch of the store. In the other, we look past the languorous figure of a young woman leaning on a doorpost in the foreground to see the young man in the yard beyond. I added a goat to the second sketch to give it a rural village flavor. I sent both pencils to the Lincoln Center Theater office, and got the most votes for the idea with the woman in the foreground.

To achieve the complex lighting effects I had in mind, I hired Bjorg Arnarsdottir, a young photographer I had worked with once before, to take reference pictures under my direction.

My idea involved shadowy light on the girl in the foreground and bright light on the man in the background. The technical demands of lighting such a scene went beyond my one trick of moving light around so that the shadow of a nose separates from the shadow of a cheek. I also hired two professional models. The female model had no trouble in giving us the sensuous S curve of the leaning pose in the foreground. But the male model had a little trouble finding a pose that cried out, "I'm here! I'm great!" Finally he gave us an arrogant slouch that came close to what I had imagined.

I completed a first version of the poster painted almost entirely in opaque gouache medium. I thought I had achieved a very Caribbean color scheme and an interesting title treatment, even if I had lost the goat somewhere along the way. André Bishop's response to the art was, unfortunately, not enthusiastic. He asked, "Are you showing me two depressed people meeting each other for the first time?" From a beginning like this a discussion of poster design can go nowhere, so I agreed to take two Prozac and try again in the morning.

For the next version of the poster, I worked in transparent watercolor to attain a light feeling and get away from the heavy texture of my first attempt. I also changed the attitude of the man, giving him a big smile and outstretched arms. This happied-up art became the poster for the play.

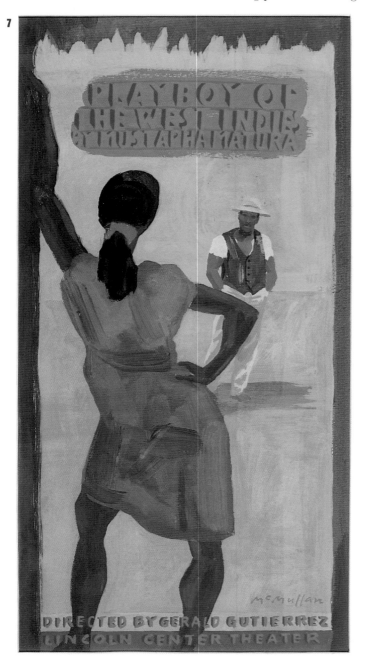

7

In the Summer House

By Jane Bowles. Directed by Joanne Akalaitis. 1993

1.
A photo of Marissa Heller posing for the poster.

2.
A pencil study, which, except for the shuttered windows, corresponds to the color art.

In the Summer House, Jane Bowles's surreal story of an expatriate family and their young daughter's psychological isolation and eventual emergence from it is symbolized in the play by the girl's long hours spent alone in a garden shed. I decided this was my obvious starting point for the poster.

The story takes place in Mexico in the 1940s, and it has the dreamy, dislocated style of a Joseph Cornell assemblage, with scenes of mysterious street festivals fading into beach picnics where something awful seems about to happen. The play has a psychological lushness seemingly inspired by Freud and Tennessee Williams. The director, Joanne Akalaitis, stressed to me that the poster should reflect this 1940s-era romantic surrealism.

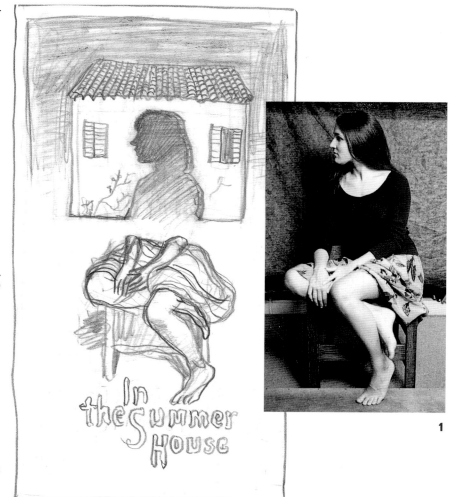

1

2

I have toyed with the vocabulary of surrealism in the past, and I feel it is an exhausted vein for me. It seems to me a style of art that is a tired recycling of Magritte for nearly everyone who persists in using it. However, putting disparate elements together, à la surrealism, can feel inventive for me if I can make the trick work within the possibilities of drawing, and without resorting to the tedious rendering of forms necessary to Magritte's illusion of space.

For the *In the Summer House* poster, I came up with an idea of a portrait of the heroine that involved a disjuncture between her realistic lower body and her flatly conceived top half. It was a simple enough concept of the physical body versus the psychological head, employing a kind of surrealistic change in the character of the body parts. The simplified form of the building, out of which the profile of the girl is carved, also supported the idea of her isolation in the garden shed and gave some rudimentary sense of the Mexican locale.

An intern working in my studio that summer, Marissa Heller, posed as the melancholy daughter in the play. From the photos I took of her, I had a good time painting a solid pair of legs and the heavily draped skirt so that they created an appropriately weighty foil for the ephemeral head. When I was finished, I thought that the artwork felt like my *Waiting for Godot* poster by way of Diego Rivera.

62

IN THE SUMMER HOUSE BY JANE BOWLES
DIRECTED BY JOANNE AKALAITIS

LINCOLN CENTER THEATER

Abe Lincoln in Illinois

By Robert E. Sherwood. Directed by Gerald Gutierrez. 1993

When Bernard Gersten commissioned me to do the poster for *Abe Lincoln in Illinois*, he said he wanted it to feature the star, Sam Waterston, and that the actor was willing to pose for me. This meant that my concept for the poster could be narrowed to an idea that focused on a portrait.

I owned a wonderful book on Lincoln that Knopf had published in connection with the PBS-TV biography of the sixteenth president. It gave me many pictures of Lincoln to look at and think about in preparation for photographing Sam Waterston.

One thing that struck me about the images in the Knopf book was the formality of the Lincoln portraits. Another was the addition, in several pictures, of a book on a table, which I suppose symbolized the presidency's connection to history and to the law. In one of the most famous Lincoln photographs, the president stands with his hand lightly resting on a book, almost as though he had just taken some vow. It was a very minimal gesture, but I felt it enlarged the feeling of the portrait a great deal.

I took the book along with me when I went to a Lincoln Center Theater rehearsal room to photograph Sam Waterston. I showed Sam several of the photographs. I suggested that we might try to take off on the poses in the book by changing some part of the gesture in each pose. In this way, I thought that we might break the formality of the poses to give a more candid feeling, as though the viewer was privy to the real Abe Lincoln.

Sam Waterston got into the idea good-naturedly, and gave me many variations of the hand-on-the-book pose. He then came up with several sitting-with-his-legs-up postures and standing-scratching-his-head gestures—each of which could have launched a dozen posters.

1, 2, 3.
Sam Waterston giving me his impersonations of the puzzled young lawyer Abe Lincoln.

4, 5, 6.
Stages in developing a sketch from the Sam Waterston pose.

7.
In seeking to "de-formalize" the image of Lincoln and to suggest that the play was a candid view of the man, I tried this pose, which was fun but went too far.

1

2

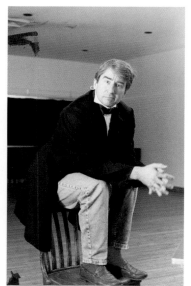

3

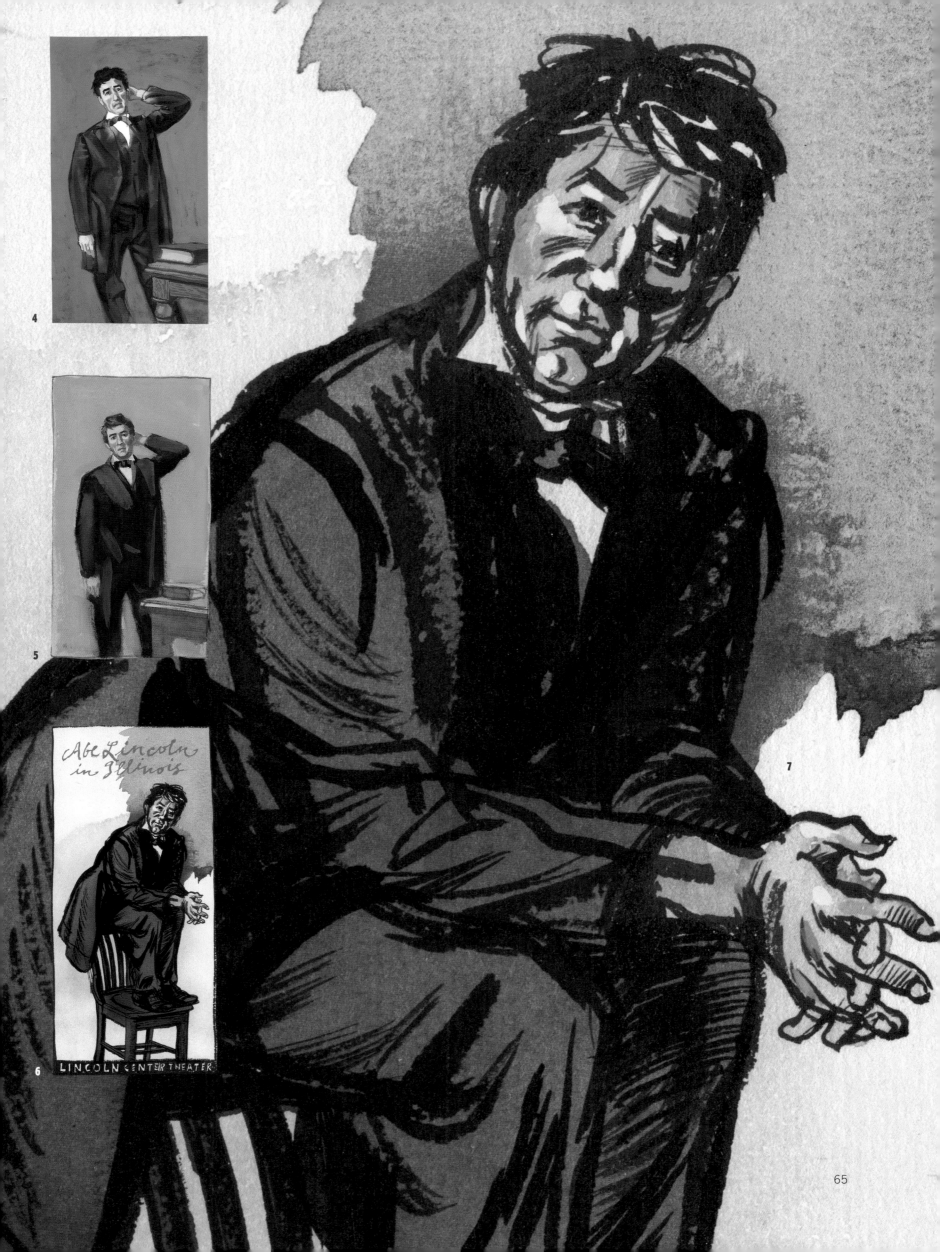

4

5

Abe Lincoln
in Illinois

6 LINCOLN CENTER THEATER

7

His generosity and his wit during the hour and a half he posed for me were a highlight of my experience with Lincoln Center Theater.

All the good visual material that Sam Waterston provided for me made my search for the right image very rich. Yet having too much of a good thing also made it very long. I did many sketches in many mediums of many of the poses, even experimenting with an un-Lincolnesque image of Sam Waterston perched on the back of a chair. Another of my graphic wild-goose chases involved trying to paint with a brush and black ink, but this attempt failed to capture the crisp drama that I felt I had achieved in my *Front Page* poster.

I kept coming back to the hand-on-the-book idea that had intrigued me in the first place. Sam's variation on the pose was to move slightly forward, as though he was about to lift his hand and walk away from the formal setup. Besides giving the image a candid quality, it also suggested that Waterston's Lincoln was about to turn toward the viewer. The tilt of the body and the trailing sense of the left hand gave the whole pose a dynamic that the original Lincoln photograph did not have.

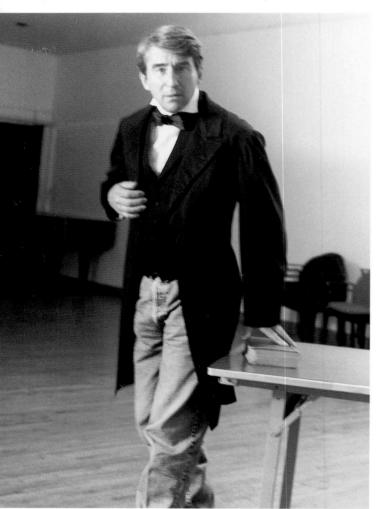

8

After settling on the trailing-hand pose, I did several versions of it in order to solve problems of drawing and technique. At the same time, I was dealing with what is, for me, a much harder problem—a likeness. Portraiture is not my strong suit. I have been known to struggle with even a sure bet like Groucho Marx. And even though Waterston's features are craggily unique, I had to work hard to capture them. After several studies, however, I managed to paint a face that looked like some generic cross between Sam Waterston and Honest Abe.

8.
The photo that gave me the pose for the poster.

This version was green-lighted by everyone at Lincoln Center Theater, but when I saw the printed poster I realized that someone along the line had decided to crop in on my art and make the poster a close-up. It was a tightly framed image of the head. All Sam Waterston's subtle movement and my enthusiasm for the forward drift of the trailing hand had ended up, as they say, on the cutting-room floor.

Here is the poster as I conceived it: the moving as opposed to the static Abe Lincoln.

McMullan

Abe
Lincoln
in Illinois
by
Robert E.
Sherwood
Lincoln Center Theater

Hello Again

By Michael John LaChiusa. Directed by Graciela Daniele. 1993

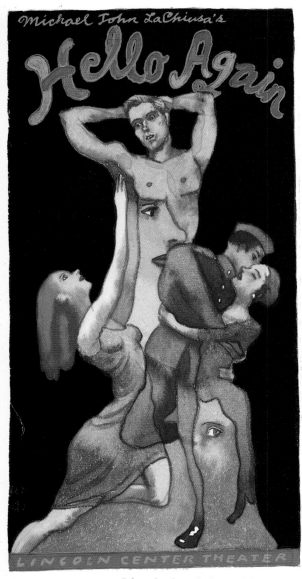

1

2

This musical, based on Arthur Schnitzler's *La Ronde*, connects the stories of ten sexual encounters by having one character from each story appear in the next. So it runs from the meeting of a soldier with a streetwalker through many interconnecting couplings to the final scene, where a senator has an assignation with the streetwalker from the beginning of the play. Michael John LaChiusa's words and music are both explicitly sexual and very stylized, and Graciela Daniele's direction and choreography brought out the full sensuality of the play. That this was clearly her intention became apparent when I met with her to show her my sketch.

Graciela said, "Before I look at what you've brought me, I want to tell you something about what I want from the poster." This sounded a little ominous, but when she had had her say, I was very relieved. "I want the poster to make it clear that no children should come to the production—it's very sexy!"

I laughed and showed her my image of interwoven figures, all suggesting that they were in some stage of pre- or postcoital rapture. "That's perfect," she said. I responded that it was just a sketch, and if she could arrange for me to photograph some of her actors, I could make it more specific to the production and, hopefully, better. She agreed to do this, and the next day I spent a morning photographing four actors moving sensuously and trying out various kinds of clinches for my camera.

I wish I could say that my final art was better than my sketch, but in retrospect I see that I became somewhat overwhelmed by having so much terrific specific information. The art became too much an accumulation of details rather than a flowing synthesis of what I had photographed.

1.
The sketch I showed Graciela Daniele, and which she was relieved to see would not encourage children to come to the musical.

2.
A drawing exploring ways of further entangling the entangled lives.

3, 4, 5.
Three of the many photographs I took of the actors.

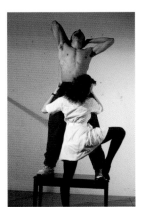

3

4

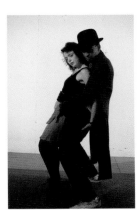

5

Johnny on a Spot

By Charles MacArthur. Directed by Richard Eyre. 1994

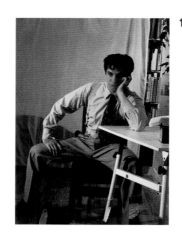

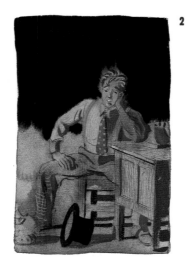

Richard Eyre, the artistic director of the Royal National Theatre in London, asked me to do the poster for a new production of *Johnny on a Spot* by the American playwright Charles MacArthur. He had seen my posters for Lincoln Center Theater and particularly liked the one for *The Front Page*, another MacArthur play.

I read the script, which described the shenanigans of a 1930s state governor's publicity agent named Johnny. The governor inconveniently dies in the middle of an election, and through various ruses Johnny manages to keep the public convinced that the governor is alive until the votes are in. I decided to try for a funny, obvious kind of image that would be in keeping with this broad-humored, physical kind of play.

I forget at this point in what order I did the sketches, and which sketch elicited which criticism, but after doing three entirely new drawings in response to those criticisms, I realized I had gotten off on the wrong foot with the Royal National Theatre. Each time I faxed a sketch to London, Richard Eyre's assistant would phone saying that, unfortunately, Richard's schedule made it impossible for him to get on the phone himself, but that he would like this or that change made in the sketch, with comments such as "Richard thinks Johnny's foot shouldn't be on the desk," "Richard thinks that Johnny should look slightly more puzzled," or "Richard thinks that Johnny's expression is too happy."

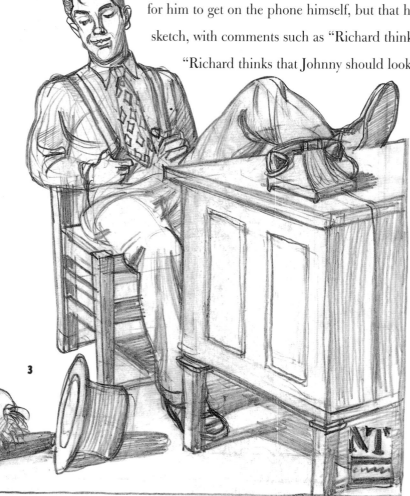

After the third go-round, my expression wasn't too happy. I felt that we were dealing with random details without considering the poster as a whole. I needed a real dialogue. I told the assistant that if Richard Eyre wanted the problems he saw in the poster solved, he had to phone me directly.

When Richard called me, we talked for a while and, in a civilized and efficient way, resolved the uncertainties involving the poster. We also set up a good working relationship that paid off on our next project together, *Racing Demon*.

1.
Rob Babboni, my assistant, achieves the comically puzzled expression and appropriate body language for the poster's "Johnny."

2.
A color sketch I did just before painting the final art.

3.
A pencil sketch I did trying out a variation in the pose and facial expression.

Carousel

By Richard Rodgers and Oscar Hammerstein. Directed by Nicholas Hytner. 1994

The assignment to do the poster for *Carousel* started in an odd way. Bernard Gersten called, saying that Lincoln Center was producing *Carousel* in partnership with the English impresario Cameron Mackintosh. Bernie wasn't sure whether Mackintosh would insist on using the poster from the previously mounted London production, but he asked me nonetheless to come up with a sketch that might "be a variation of the Mackintosh poster." Bernie had never seemed so anxious to end a conversation before. When I got off the phone, I felt a little like Oliver North getting an untraceable call from the Oval Office: I was to do a sketch that might or might not liberate Lincoln Center from certain unspecified contractual obligations to a foreign power.

When the English *Carousel* poster arrived at my studio, it turned out to be a photo of a man carrying a woman, à la romance novel jacket, with a carousel horse behind them. In addition to the posed, fake look of the two actors in the photograph, the image was marred by the unfortunate placement of the horse. All that one could see of the animal was its rear end protruding from behind the girl's legs. The glitzy lettering of the title completed the cheesy look of the whole thing. This was a poster for which I had no "variation" in my repertoire. I put that part of Bernie's request out of my head.

I embarked on the project by watching a video of the Gordon MacRae–Shirley Jones film version of the musical to familiarize myself with the story. The music and songs were as beautiful as I remembered, but the story itself was so sugar-coated that I could hardly concentrate on what was happening. From the London production poster and the video, I gathered I was to do a poster for a happy 1940s-style musical. I decided on an image of Billy and Julie, the hero and heroine, cavorting romantically on a carousel horse. I photographed two attractive models at the carousel in Central Park doing whatever they could together without falling off the horse. I realized that the sketches that resulted from studying these pictures relied more on elegance than concept, but since "happy" is not my most natural creative tone, I was glad that my sketches succeeded as well as they did.

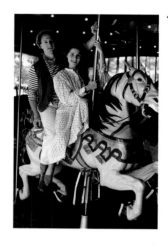

1.
Michael Swain and Marissa Heller cavort on a horse at the Central Park carousel.

2.
This sketch shows some kind of vague connection between the "C" and the carousel going around.

3.
A sketch that emphasized the linear quality of the drawing and had a restrained palette. I think I had been looking at Japanese prints again.

4.
This is the sketch I showed the producers at Lincoln Center, and which they thought was too happy.

I took them to Lincoln Center, and the response was basically "No! No! No! This art is far too happy. We're doing a production that has a lot of edge, that goes back to the original dark side of the story that was suppressed in the 1940s."

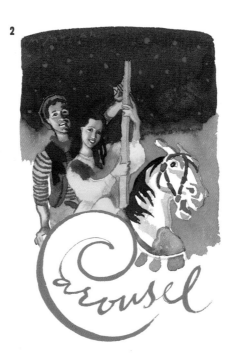

LINCOLN CENTER THEATER

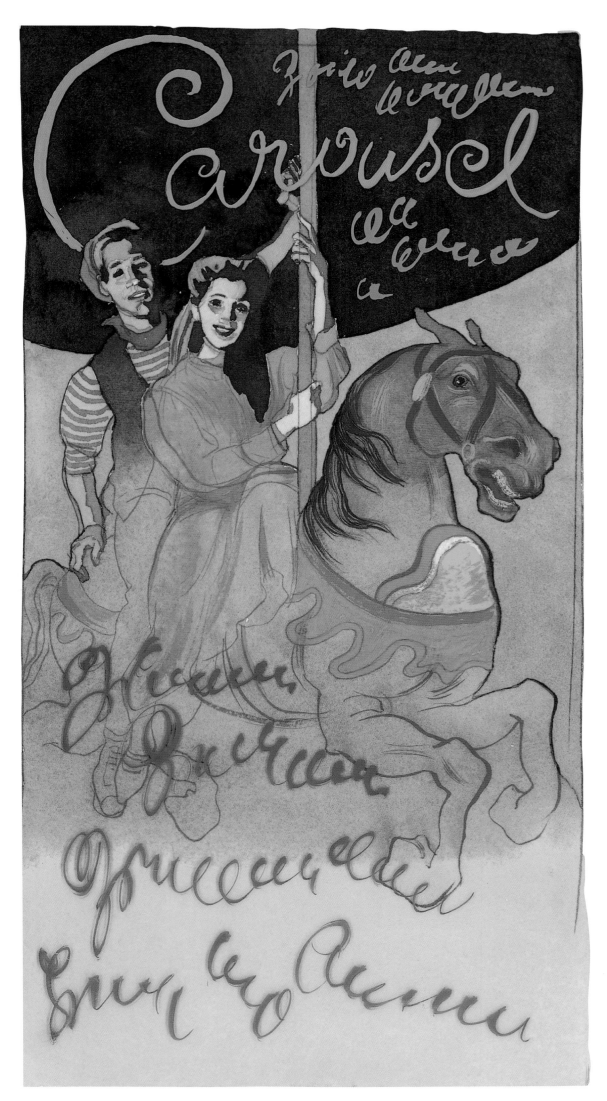

4

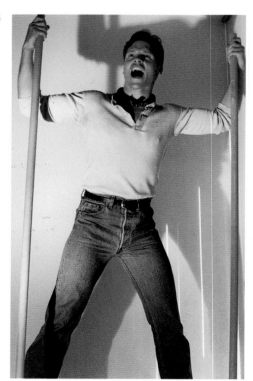

Someone could have mentioned this to me, I countered. They conceded that there had not been enough communication, but now they were prepared to tell me the whole story. Since that original phone call from Bernie, the situation with Cameron Mackintosh had been clarified, and it was agreed that Lincoln Center would do its own poster. So with a clearer commission, darker and more sympathetic to my melancholic temperament, I started again.

One of the aspects of this *Carousel* that became clear in my meeting at Lincoln Center was that the main character of Billy Bigelow has a good side and a bad side, and the struggle between these two selves would give the current production much of its tension. In thinking of this duality, I happened upon the idea of Billy straddling two carousel horses, one white and one black, representing his good and bad sides. I did a small pencil sketch of this idea in preparation for a meeting with the director, Nicholas Hytner.

I immediately liked Nicholas Hytner when he immediately liked my sketch. Without fussing about the fact that it was a tiny pencil doodle that gave me all kinds of latitude in carrying it out, Hytner essentially said, "Great! Do it!"

The next stage was pure pleasure because the star of the show, Michael Hayden, was available to be photographed. Michael turned out to be an intelligent, agreeable young man who had gone straight from the Juilliard Drama School into the starring role of the London production of *Carousel*—a role he would now repeat in New York.

I explained my straddling-carousel-horses idea to Michael. He climbed on top of my flat files to give me a low camera viewpoint and, hanging on to two closet poles from the hardware store, burst into a beautiful rendition of "My Boy Bill." I photographed Michael in every conceivable position, with his mouth slightly open to wide open, and with every change of weight as his body rocked back and forth between the poles.

The photos were great. With very little variation in the composition, I began to experiment with

5.
The small pencil idea I showed director Nicholas Hytner before I took the photo.

6.
Michael Hayden, the star of *Carousel*, poses for me as the horse-straddling, song-singing character Billy.

7.
Color sketch.

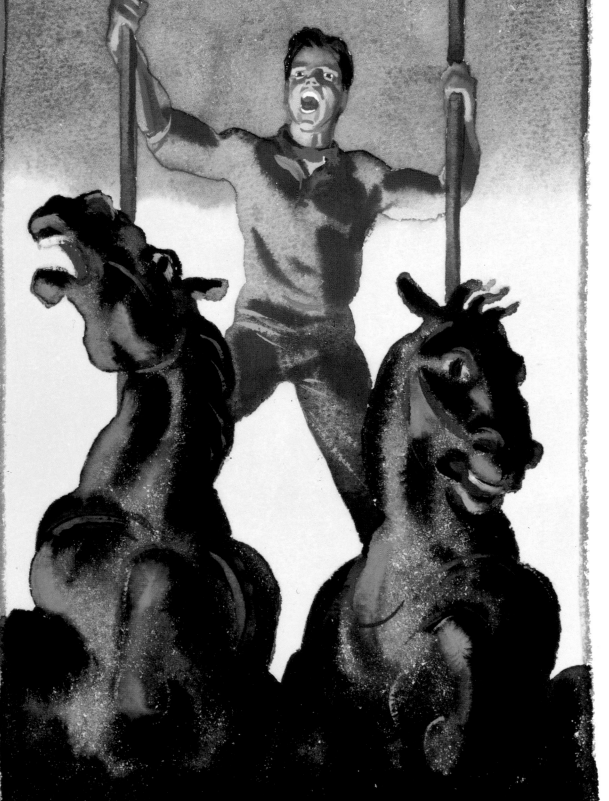

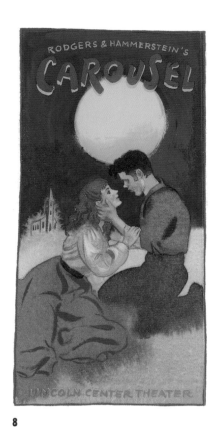

8

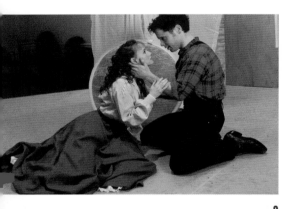

9

a heavier-than-usual painting, relying on the thick texture of gouache. Since I was making up the carousel horses, I was particularly free in inventing their forms with broad strokes of dark green gouache melting into a base layer of transparent medium. Somewhere along the line I abandoned my idea of one white and one black horse, and the horses that began to emerge felt more like wild beasts than decorative carved animals. After a few attempts, I did a painting I was ready to show Bernie and André.

They were both very enthusiastic about the art. But after keeping it in his office for a day, Bernie called me with what he said was a small criticism. Because the figure's hands grasping the carousel poles ended up on the same horizontal plane, he felt the figure was more static than it should be. I realized his criticism, "small" as it was, meant that the art had to be totally redone. But on consideration, I realized he was right.

I have always appreciated Bernie's ability to see my posters in an artistic way, and despite our disagreements on one poster or another, I respect his intuitions. Here was yet another occasion where he had picked up something subtle yet crucial to the art.

I hired another model, to study what happened to hands and arms when one pole is grasped farther up than the other. With these new photos and the original ones of Michael Hayden I was able to do a new piece of art that, fortunately, lost no energy in the repetition.

Carousel was a great success on Broadway, and the poster basked in some reflected glory. The long run of the play also meant that I got to do a bus poster. Once again I had the interesting problem of taking a vertical image and squeezing it down to a horizontal sliver. My solution involved a composition in which the horse's head, Billy's head, and Billy's hand grasping the pole pop up into the horizontal space like Punch and Judy figures seen through a mail slot. It was a very awkward cropping of the elements of the original poster, but for some curious reason it worked.

10

Perhaps more than any of my bus posters, *Carousel* had real drama as it slid past on the side of a bus. It was particularly weird if you happened to be in a taxi stopped at a red light next to a *Carousel* bus, and the hysterical expression on the horse's face filled your view out the window.

Sometime in the latter part of the musical's run, ticket sales began to flag. In the inevitable search to find a culprit for this slowdown, someone targeted my poster as a likely suspect. The poster, the theory went, was too dark in mood and was not attracting the crowds from the outer boroughs who were flocking to *Guys and Dolls*. Jim Russek was given the task to ask me to do a poster with a clearly expressed list of elements: Billy and Julie in an embrace or about to embrace, a full moon, and a white church with picket fence.

I could hardly believe that we had gone full circle on the happy/dark issue, and I was angry that my once-much-admired poster had been chosen as scapegoat for God-knows-what market forces that influence ticket sales. Protesting all the way, I photographed the lead actors in romantic poses and did a new piece of art. It wasn't good, and given the grudge in my heart, I don't think I could have made it good. Bernie recognized that it wasn't as effective a piece of art as the first one, and it was never printed.

8.
The doomed second poster for *Carousel*, which was never produced. It was done to the advertising agency's specifications, and I couldn't feel the romance of their idea. As far as I was concerned, I had already done my *Carousel* poster.

9.
The photo for the doomed art.

10.
The bus poster I developed from the cesign of the three-sheet poster. It was an awkward cropping of the elements, but somehow it worked.

11.
A New York City bus displaying the poster. I wish I had taken a photo of the bus poster from inside a cab— the horse's head filling the cab window was dramatic.

11

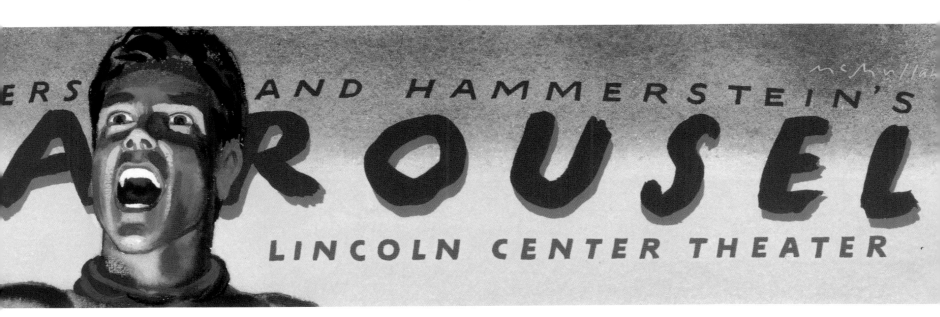

The Heiress

By Ruth and Augustus Goetz. Directed by Gerald Gutierrez. 1995

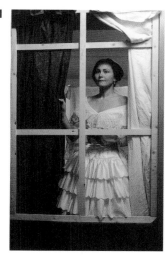

For this classic of the American theater, written in 1947 by Ruth and Augustus Goetz, André Bishop had a simple idea that I had no trouble working with. He saw the poster, he told me when he commissioned it, as an image of Catherine, the daughter in the play, standing at the window of her house on Washington Square. She should be waiting for the arrival of her fiancé with a glimmer of hopeful anticipation on her face.

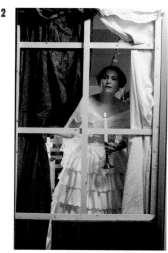

Lincoln Center Theater cooperated with me on the reference photographs to a degree I had never enjoyed before. On the afternoon of the photo shoot the star of *The Heiress*, Cherry Jones, arrived at my studio with the director, Gerald Gutierrez (and his dog), the stage designer, John Lee Beatty, the costume designer, Jane Greenwood, and her assistant, as well as Tom Cott from the Lincoln Center Theater office. For about two hours, my studio had the glamorous chaos of a small-budget movie.

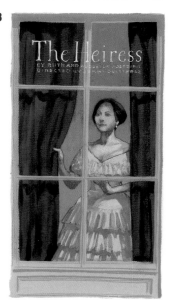

I had rigged up a "window frame" and a curtain in one of the entries to the studio so that I could see realistic shadows and folds when Cherry Jones stood behind it. It was all very crude carpentry, but through the magic of illustration I knew it could be turned into a reasonable approximation of a Washington Square town house parlor window.

I had been hearing a buzz about what a marvelous actress Cherry Jones was, and I got to see a little of her prowess when she posed for me. Largely because of the compelling reference photos that resulted from her acting, I completed the art in fewer tries than usual. My first attempt to paint the image foundered on trying to bring too much texture into the process. I realized that the painting style had to be fairly controlled in order to exploit the subtlety of Ms. Jones's expression.

Cherry Jones went on to great acclaim in this role, winning the Tony for best actress, and she gave me one of the most personal compliments my art has ever received. During rehearsals she wrote me a note that included the line "You captured Catherine long before I knew her and if truth be told I've returned to your work more than once while seeking her."

1, 2.
Photos of Cherry Jones.

3.
Color sketch.

The Heiress

LINCOLN CENTER THEATER AT THE ⑤**CORT**

Grand École

By Jean-Marie Besset. Produced in France. 1995

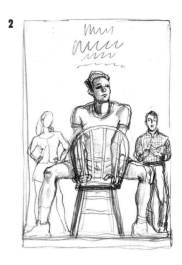

1.
The reference for the final art.

2.
A pencil study.

3.
Often when I start looking at the photos I have taken, I need to do straightforward studies to understand the information.

The writer Tor Seidler has a house in Bridgehampton, not far from mine in Sag Harbor, and through him I met the French playwright Jean-Marie Besset. Jean-Marie immediately confessed to an enthusiasm for my Lincoln Center posters.

When Jean-Marie asked me to design a two-color poster for his new play, which was to be produced at Théâtre 14 in Paris, I quickly accepted the commission. The agreeable circumstances of sitting with a new friend on my Sag Harbor porch, drinking red wine and making a transatlantic deal, gave everything a rosy glow, including the modest fee he could afford.

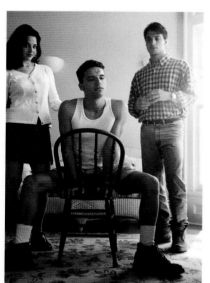

The play *Grand École*, which roughly translated means "The Best of Schools," concerns a group of bright, privileged college students, their lives, and loves, in a shared apartment. Paul, the main character, is coming to terms with his romantic feelings for one of his male roommates, as well as with his longtime platonic relationship with a girl.

I decided that a tableau of Paul, his straight roommate, and his girlfriend, simple as that sounded, would make the best poster under the circumstances. The photos I took of my models turned out well, but I began to have some misgivings about the artificial physical connections between the figures. They kept looking like three people I had jammed together, but I hoped, through some trick of stylization, I would find a good way of painting the trio.

1

I started with the figure of Paul, drawing him in a red-brown gouache line and filling in the skin tone with lighter shades of the same color. After I finished this figure, I sat back and studied it and realized I didn't want to add anyone else. The drawing was particularly lively, and the shape that this single figure made straddling a chair was dramatic and satisfying. So I decided to stick with my instincts, leave it as a one-character poster, and complete the design by adding background tone and lettering.

The drawing was reproduced as a tiny symbol on the published copy of the play script, but it was never printed as a poster, perhaps because I did my job too well. The producer found the figure shockingly homoerotic and refused to have it represent the play.

3

Arcadia

By Tom Stoppard. Directed by Trevor Nunn. 1995

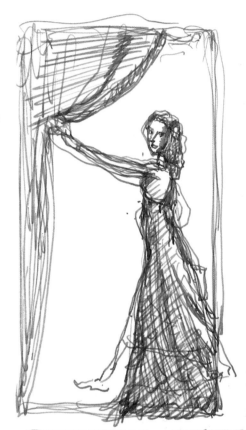

For my sixtieth birthday, my wife took me to London because she knew I wanted to hide out from my New York friends while I tiptoed past this difficult marker on the road of life. London was the perfect place to be. I felt that I had stepped into an older, more civilized city where time seemed to stand still, and for a few days I could act like a gentleman of indeterminate age.

One of the diversions we chose in London to keep my mind "indeterminate" was the theater, and among the plays that we saw we were lucky to catch Tom Stoppard's *Arcadia*. I say lucky both because it was an extraordinary play and because it gave me a chance to see it and think about it before doing the poster for its New York production.

There was much to think about in *Arcadia*. As I left the theater in London, my head was filled with the sound of the steam engine that boomed throughout much of the third act, and which figuratively amplified the theme of the emerging industrial revolution. I turned to Kate as we walked along and said, "I'm going to combine a steam engine with a big oak tree for the New York poster." "Hmm," she replied. I didn't realize then that this play, which seemed chock-full of ideas, including my sidewalk inspiration, would lead me on one of the longest searches for a metaphor of any poster I had worked on. The problem was, of course, that the play was so rich and complicated in its ideas. I could think of many—too many!—ways to represent it. The simple answer came finally from an unexpected direction. But before that answer arrived, I explored many ideas through many sketches.

When I first returned to New York, I was still thinking about the steam engine. The oak tree had become more of a garden in my mind. In trying to imagine a way of representing the engine, I narrowed my focus to the great iron flywheel that was the most dramatic visual element of those machines. This iron wheel became, in my imagination, a circle through which the garden is seen and on which the young girl languorously leans. By the time I had jettisoned the identifying spokes of the flywheel I had become enamored of the idea of a circle, perhaps representing rationality or geometry or mathematics, framing the view of the "wild." Such is the winding, self-rationalizing nature of my creative process.

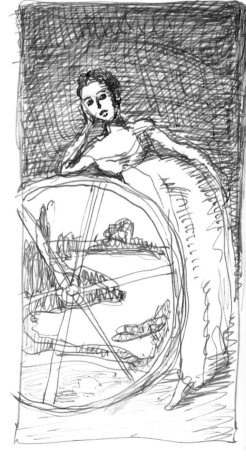

Working mostly without reference, I did several versions of the girl, the circle, and the landscape. In one of these versions, I repeated the realistic landscape in the background behind the girl as a disassembled group of flat shapes. In another, the landscape is represented by a single tree, whose strictly lined-up fruit became a geometric grid.

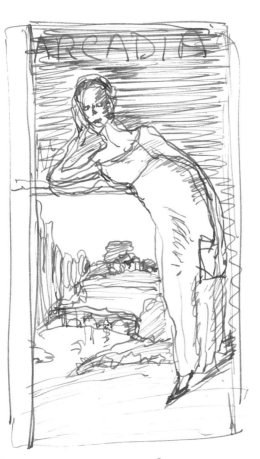

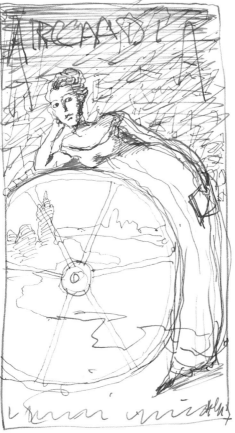

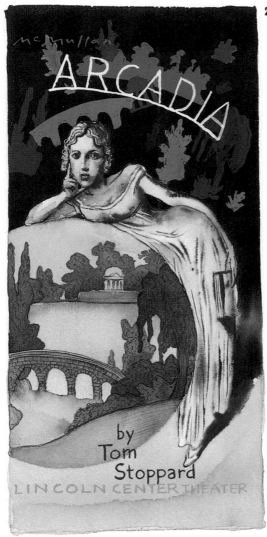

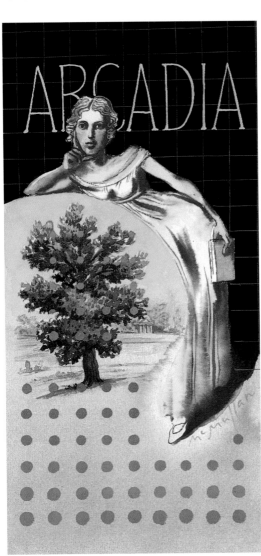

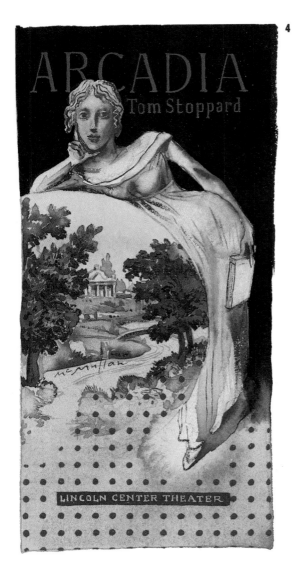

1.

A sheet of pen and ink sketches, to try out poses for the young girl.

2, 3, 4.

Three variations of the girl leaning on a landscape within a circle. The circle had started out as the flywheel of a steam engine that I hoped would symbolize the logical machine contrasting with the implicit chaos of nature.

I was pleased with the primitive, slightly archaic look of the girl in the sketches. She really was like a memory of the girl in the London production. I also liked the complexity of the image, which suggested, even if it didn't make entirely clear, some contrast between the organic world and the man-made world of grids and circles. I felt I had achieved a design that hinted at the intellectual playfulness of the play.

Unfortunately, no one else saw it that way. Bernie and André didn't understand it and weren't attracted by the image, an incontestable fault for a poster. When the sketches were sent to Tom Stoppard in England, he wasn't attracted to the idea either. But he came up with a suggestion that gave me a clear direction to pursue and stopped my search from moving down twenty different blind alleys. "Why don't you," he queried in a fax, "consider the dancing scene at the very end of the play in some combination with the landscape?"

5

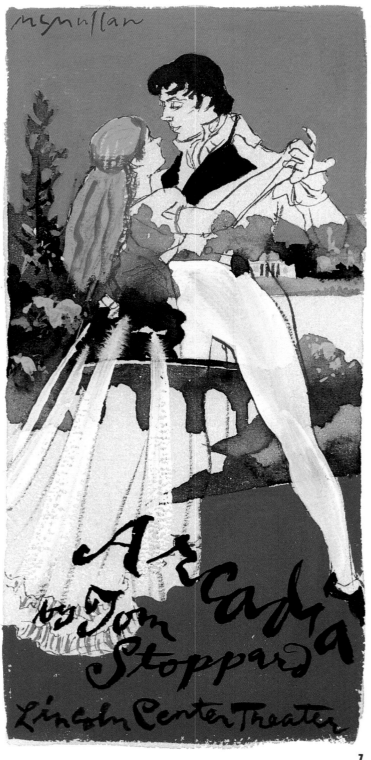

7

8

84

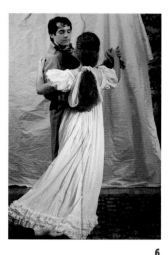

6

5, 6.
Photos of my models that pro-
vided the basis for the
sketches, figures 7 through 10.

7, 8.
Two versions of the same
idea, which I'm not quite sure
why I rejected, except that
they may not have felt classi-
cally "removed" enough; all
the elements were clamoring
to the surface in a perhaps
too noisy way.

9, 10.
Two sketches exploring the
idea of a partially transparent
dancing couple.

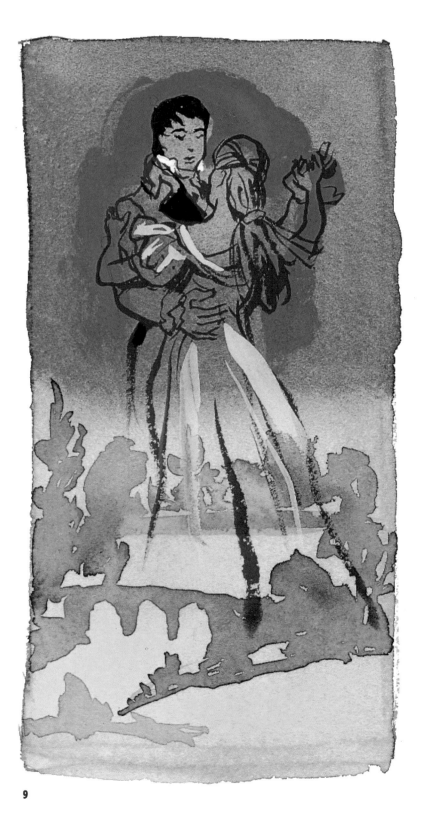

9

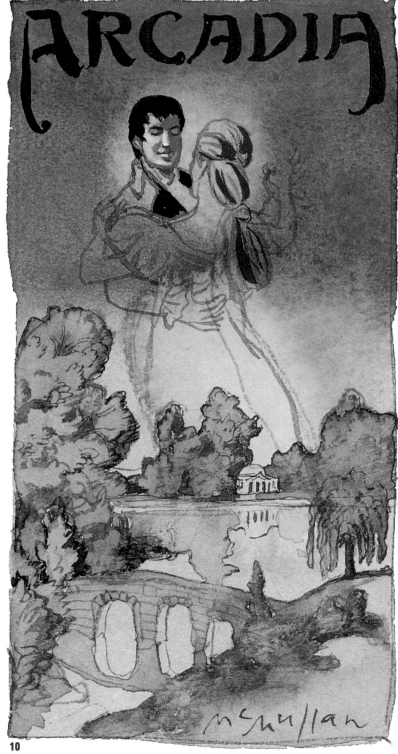

10

After I had struggled to unlock the puzzle of *Arcadia*, it was a relief to have its creator give me a big hint, and one I knew I could use. Now I could concentrate on finding an image without worrying that the playwright and Bernie and André would question the basic path I was following. I knew that once Stoppard had named the direction he hoped the poster would take, no one was going to second-guess him. I can't explain why I took his rejection of my sketches and his suggestion in such good spirit except to say that he had given me a wide enough path to follow so that there was plenty of room for me to invent something of my own.

12

It was almost as if he were saying, "Listen, I know my play is famously complicated, and I've thought about it longer than you have, so here's a tip. . . ."

Lincoln Center Theater arranged for two models, a member of the cast of *Carousel*, which was still playing, and a theater student at Juilliard. The Lincoln Center Theater had also provided me with costumes, which added greatly to the possibilities of the poses.

I had decided that the fusion of a dancing couple with a landscape should suggest a metaphoric rather than a realistic connection, and all my sketches from this point on used some kind of transparency to relate the elements.

The first idea I carried out in two versions. I showed the dancers in side view, with the elements of the landscape showing through them in certain sections but not in others. This approach

11.
A sketch trying a darker, richer texture.

12.
A study I did while preparing to paint the young man's head for the final version.

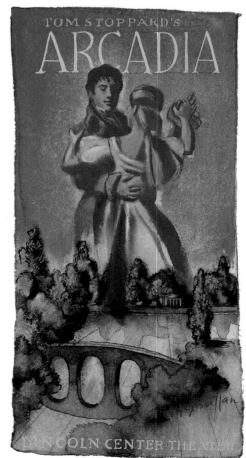

11

brought the dancers and the landscape into the same shallow plane and gave the sketches a jumpy, patterned look that I liked. I'm not sure now exactly why I moved on to another idea, but I suspect that I felt these two sketches didn't suggest enough of the romantic flavor of the play—that everything was a bit too real and up-front.

I next began to explore the landscape as a lower horizontal in the poster, the dancers being higher, with the girl turned away and the big shape of her white dress providing a sort of canvas for the distant view of lake, trees, and classical buildings. I did several sketches with this kind of composition and finally moved toward a little more groundedness by tying the sky around the dancers to the edge of the poster and having the landscape emerge from behind the edge of the skirt.

It was the drama of the white dress isolated in the powdery blue sky that really satisfied me and gave me the feeling that I had arrived at the right solution. The landscape had enough delicacy to work successfully against the bolder elements in the composition, and the color seemed to capture something of the lucid English light of the play.

ARCADIA

by Tom Stoppard
directed by Trevor Nunn

LINCOLN CENTER THEATER

Twelve Dreams

Written and directed by James Lapine. 1995

A key character in the play *Twelve Dreams* is the twelve-year-old daughter of a psychoanalyst father. Her unusual and precocious dreams form the central riddle in the story, around which the personalities of the adults are tested. The girl appears to have tapped into primal stories of existence in the strange, symbol-packed narratives of her dreams.

As I doodled out the possibilities that came to mind, I kept envisioning the girl walking down stairs as though moving down into her own subconscious. There were stairs in the play, but they weren't really the impetus for my idea. My stairs were more metaphoric.

I found my model, Maggy Taft, through the networking of my wife, Kate, who as a cheerful, charming Midwesterner had made contacts in the "mummy world" of our daughter's school. Maggy lived with her family in a beautiful apartment on Gramercy Park that had all kinds of prewar architectural detail and classic furniture, which made a perfect context for the photographs. After several

versions, in which pieces of oriental carpet or the edge of a Chippendale chair were included, I finally stripped the image of all its prewar charm. Maggy gamely walked down a little ladder many times as I adjusted details of her dress and her hair.

Using these photos, I did a piece of art which pleased me. It showed a redheaded girl stepping down cellar-like stairs, which seemed more subconscious than the regular kind, beaming the greenish light of a flashlight ahead of her and holding a teddy bear.

The art was sent to James Lapine, the playwright as well as the director, for his approval. He had two problems with the art: the teddy bear under her arm made the girl look too childish, and he asked that several white doves be added, flying around her head.

I replaced the teddy bear with the school notebook in which the girl in the play writes her dreams. As you can see, the birds became a relatively muted pattern in the background.

1.
My model, Maggy Taft, walks down some improvised stairs.

2.
An ink drawing in which I try out a scarier version of the idea, adding the bear shadow.

88

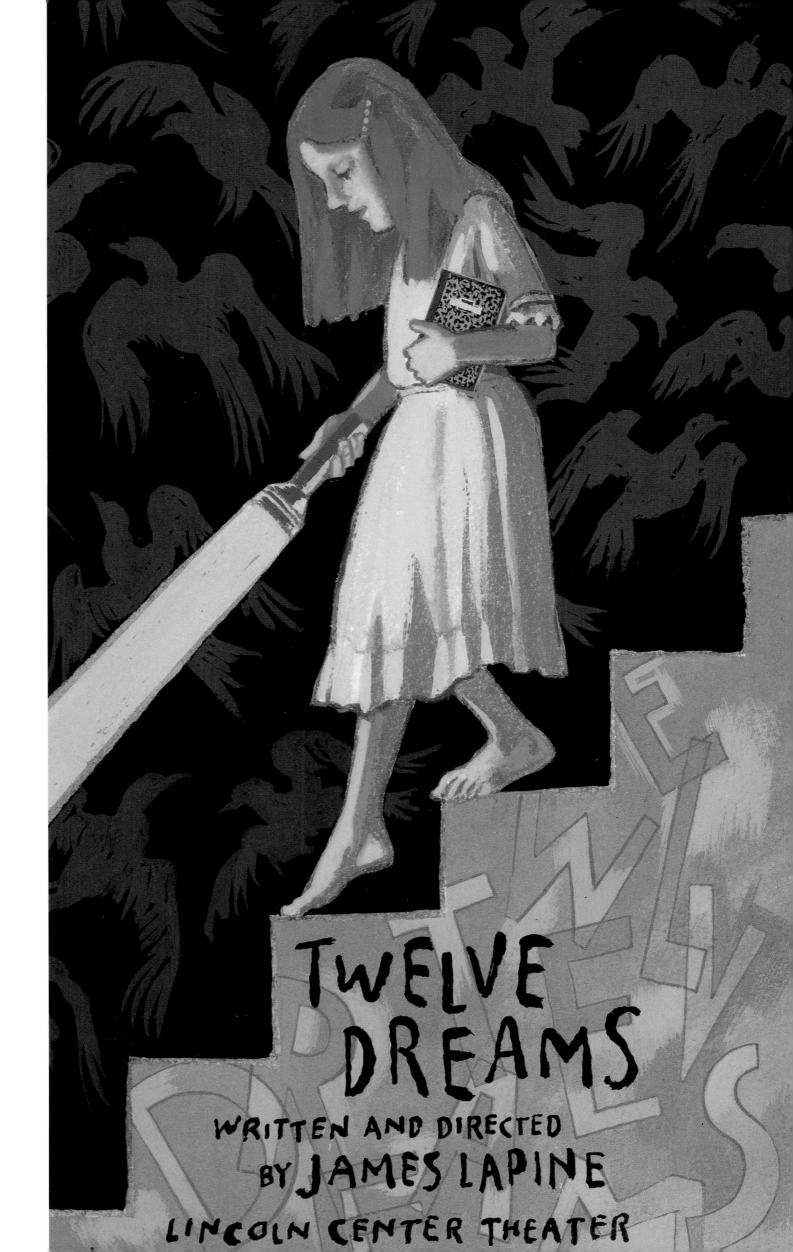

TWELVE DREAMS

WRITTEN AND DIRECTED BY JAMES LAPINE

LINCOLN CENTER THEATER

Racing Demon

By David Hare. Directed by Richard Eyre. 1995

Before I came up with the poster image for David Hare's play, I photographed three different models posing as the central character, Lionel, an Anglican priest.

The first person I approached to impersonate Lionel was John Kenlon, a man I knew casually from the tennis courts in Sag Harbor. After we played tennis, I asked him if he'd mind coming to my house and getting down on his knees so that I could photograph him speaking to God. He said that he hadn't done that in a while, but he was willing to try.

I didn't know until he and I were talking as we drove from the courts to my house how inspired a choice John Kenlon was for the role of the God-questioning priest. It turned out he was the CEO of the Miracle-Gro company. Perhaps that explains with what good humor and pious intensity he managed to act out my instructions.

The idea I had for the gesture came from the first scene in the play, where Lionel questions God with a mixture of faith and humor, as though he were talking to an old, respected friend who has puzzled and disappointed him:

"God. Where are you? I wish you would talk to me. God. It isn't just me. There's a general feeling. This is what people are saying in the parish. They want to know where you are. The joke wears thin. You must see that. You never say anything. All right, people expect that, it's understood. But people also think, I didn't realize when he said *nothing*, he really did mean absolutely nothing at all."

I was attracted to the power of this scene, with Lionel isolated on the stage on his knees and looking up toward an omnipotent being. I felt I could change something in this primitive symbolic position, either the facial expression or the gesture, to suggest that this was not a pious medieval believer praying but a contemporary man of faith, who nevertheless is riddled with questions and feels a sense of irony. Since the play deals with big questions about the meaning of religious faith in today's world, the image of the priest in a slightly ambivalent attitude of prayer seemed to me a good metaphor for the poster.

1, 2, 3.
My three models, John Kenlon, Richard Clarke, and Josef Sommer.

4.
A sketch done before photography, trying out the spiritual praying priest against the symbols of the poor criminalized neighborhood he worked in. At this point I became fixed on the idea that the name of the play was "Speed Demon."

5.
A page of pencil studies of all the things I could think of that suggested the bad or, at least, the secular side of life. Some of these elements I integrated into the backgrounds of the subsequent four sketches.

Before taking these first photos, I had phoned the director, Richard Eyre, in London to discuss this image with him. He was amenable to my praying-man idea, but he described another aspect of the play that was important to him. The scruffy working-class neighborhood, the presence of pornography, violence, and drugs was, he said, the dramatic counterpoint to the spiritual questions raised by the Anglican priest in the play. He described a billboard showing a perfume ad that was part of the set in his London production. It showed a very sexually provocative woman lying along the length of the advertisement.

When I began reacting to my photos of John Kenlon and thinking about Richard Eyre's comments on real-world London, I made a page of drawings of all the things I could think of from the universe of sex, drugs, and violence. I thought that I could play the image of the priest against a background of these evocative secular objects. What I got from the experiment was an image that was interesting, but so flat and abbreviated in its drawing that it became merely an oddly decorative design rather than the edgy forcing together of good and evil that I had imagined.

4

My art had ended up looking like a weird advertisement promoting the power of prayer to bring you all the guns, knives, and hypodermics you could ever wish for.

5

And to top it off the face in my sketch looked eerily like Bing Crosby playing a priest in *Going My Way*. If there was ever a post-postmodern musical version of the play, maybe I could use this version of the art, but for now I knew I needed to start again.

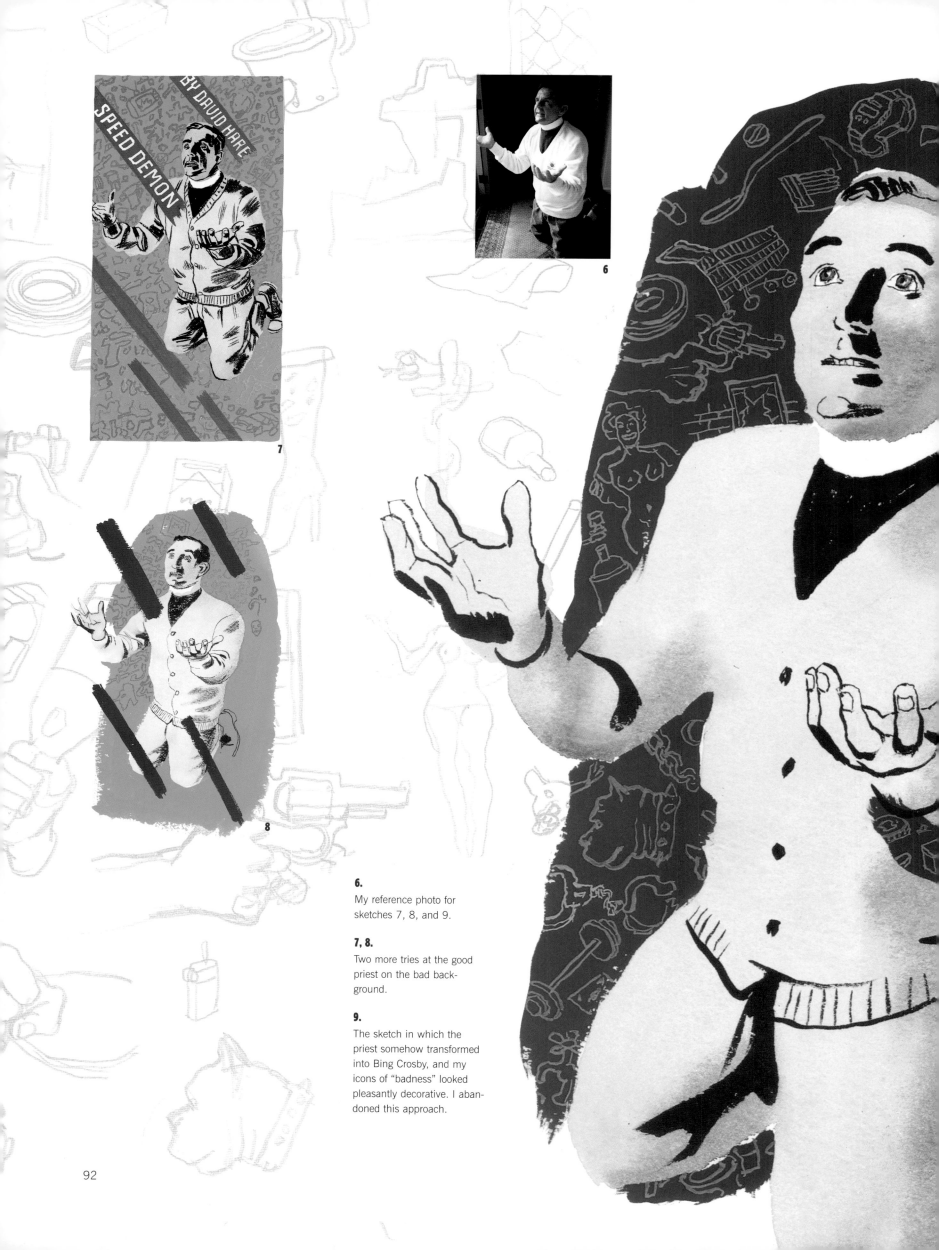

6.
My reference photo for sketches 7, 8, and 9.

7, 8.
Two more tries at the good priest on the bad background.

9.
The sketch in which the priest somehow transformed into Bing Crosby, and my icons of "badness" looked pleasantly decorative. I abandoned this approach.

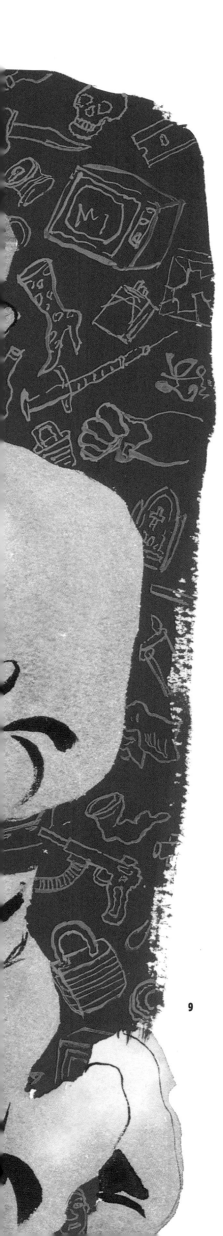

Perhaps as a result of John's face turning into Bing Crosby's

or perhaps because I simply wanted the figure to seem more anonymous and metaphorical, my next drawing was less realistic, both in the proportions of the figure and in the simplicity of the head. It was a painting that I arrived at after washing out the whole surface of a first painting layer and working quickly into the moist paper with a combination of transparent and opaque mediums. I really liked the glowing everyman figure that emerged from this experimental process. It had a talismanic quality that I hadn't anticipated, and I designed lettering to try to sustain the idiosyncrasy of the image.

When I showed the sketch to Bernie, André, and Jim Russek, there were those extra beats of silence that I have come to know as the beginning of the end for that particular design. Bernie finally articulated what I sensed was in the minds of the other two: everything I loved about the image—the priest's compact body, his smooth, anonymous face, the suggestive halo around his figure, the abrupt change of lettering style and direction—all these things Bernie hated. To him, the guy looked like a tubby gnome—and a gnome who was far too young to be the central character of the play. He thought the lettering was confusing and maybe even silly. It was obviously a piece of art that could be viewed in two ways—either you saw it, as I did, as a symbolic man expressing an intriguing radiance of faith, or you saw it the way Bernie did, as a cartoonish mess. There was no middle ground or any way to argue the point, and after a halfhearted attempt to win them over, I agreed to begin anew.

This time I asked Lincoln Center Theater to arrange for me to photograph an actor from the cast, because I realized that it would be very hard for me to find a new viewpoint looking at the photographs I had taken of John Kenlon. I needed to start with a different face and a different set of gestures that would stimulate a different approach in the art.

Josef Sommer, the actor who had been cast in the starring role, was not available. But Richard Clarke, who played one of the other roles, was willing to come to my studio and act out the gestures for my camera. He was of the right age and demeanor and, of course, he was a very accomplished actor, so I was very pleased that he could do it.

I described to Richard the scene in the play that I was using as the basis for the poster art, and I showed him some rough sketches of the praying gesture I had in mind. He gave me a great range of poses, kneeling, half-kneeling, both hands raised, one hand raised. Apart from his skillful and imaginative physical movements, I thought that Richard also looked convincing as a Church of England clergyman.

The photographs I took of Richard turned out so well that I used them to work from without changing much of the information. This made it possible for me to try a straightforward drawing in the manner of my *Front Page* poster, using brush and ink to make strong, parallel strokes. It's a fairly hair-raising way to work, because I don't put down any preparatory lines, but when it's successful it has a satisfying blend of riskiness and authority.

93

10

11

12

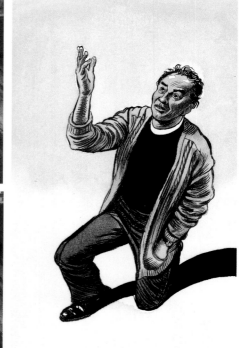

13

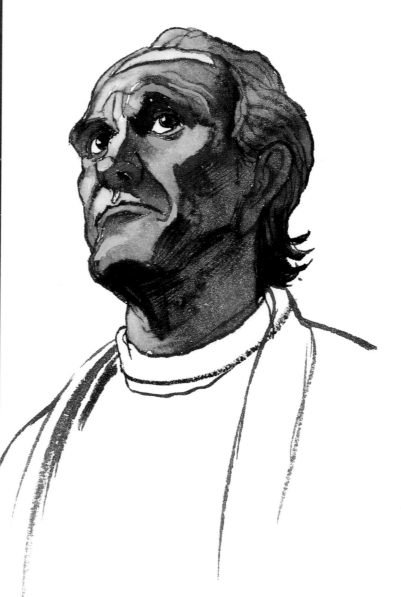

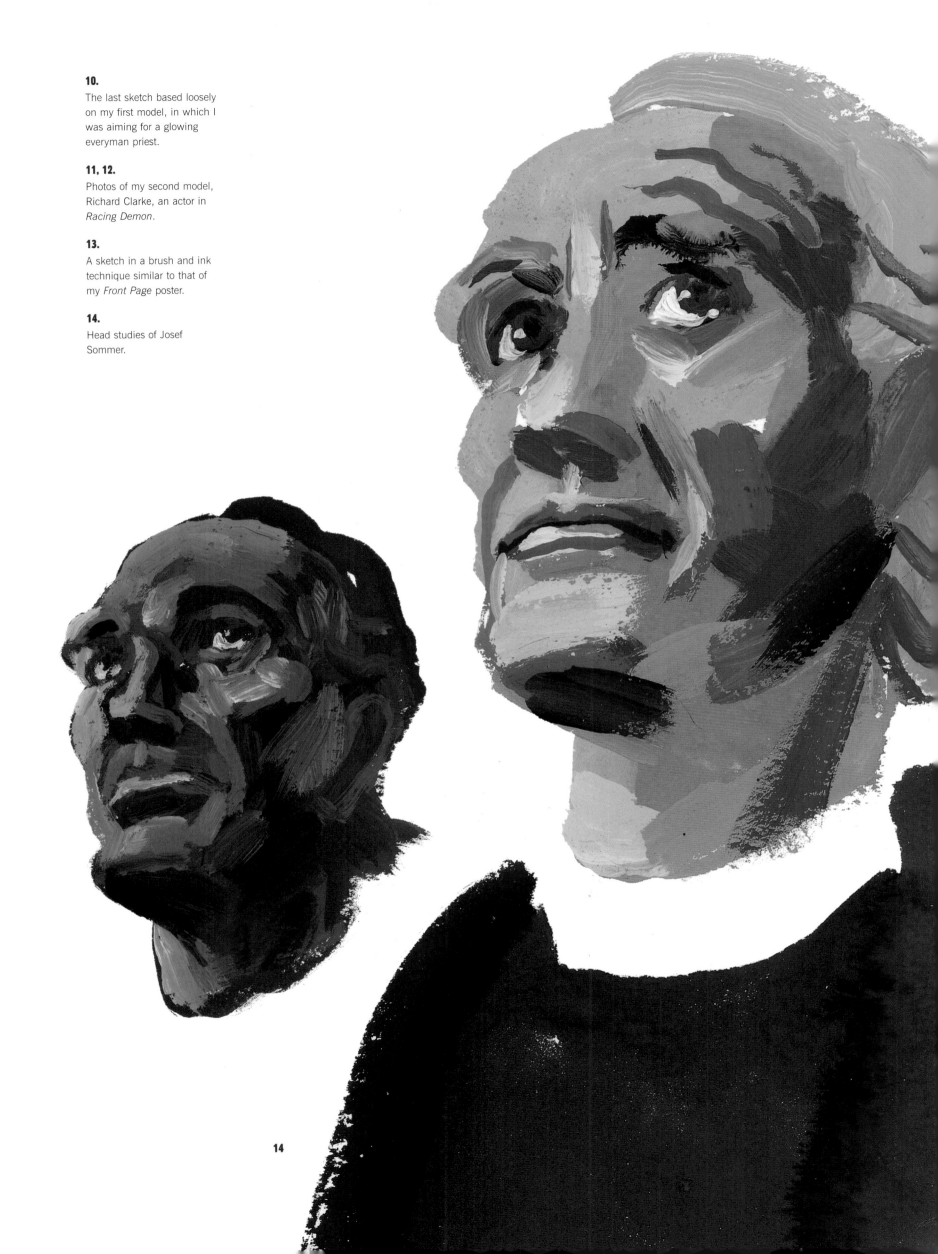

10.

The last sketch based loosely on my first model, in which I was aiming for a glowing everyman priest.

11, 12.

Photos of my second model, Richard Clarke, an actor in *Racing Demon*.

13.

A sketch in a brush and ink technique similar to that of my *Front Page* poster.

14.

Head studies of Josef Sommer.

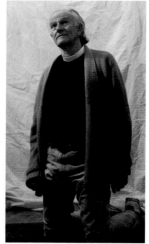

15.

A photo of my third model, Josef Sommer, who actually played the character I'm representing in my poster.

16.

A pencil study of an alternative pose.

After a few tries, I came up with a version that I liked, but before I colored the ink drawing, I added an overlay of lettering and took it to Lincoln Center to show the team.

This time the extra beats of silence were followed by Bernie's explanation of what he didn't like. After that, everyone made a halfhearted attempt to find something nice to say. The generalized discontent finally ended with one concrete criticism—my drawing didn't look enough like Josef Sommer, the actor in the starring role and the best-known person in the cast. This was the first I had heard that making a portrait of Josef Sommer was a priority for the poster.

I made it clear that I couldn't do a likeness without photographing Josef Sommer, so André and Bernie agreed to arrange for him to pose for me.

Josef Sommer—the ultimate model! The real guy!—showed up at my studio the next week. In a somewhat worried, weary way, he changed into the dog collar and began to work out my idea of kneeling and praying. Joe was already in rehearsal, so he knew the play, and he finally admitted to me that he didn't see the body language of the character in quite the same way I did. I told him that I was very open to his interpretation and to go ahead and do it his way.

He did very little, basically kneeling on both knees and looking up. But of course, his little was a lot. The sense of ironic resignation that came from his arms being at his sides, and the searing look of intelligent doubt that came from his uplifted face were far more powerful than any of the praying gestures that I had asked of him and the other two models.

What a journey to arrive at such a simple solution! Within three days I had completed a painting that I liked, and once again I made the trip up to Lincoln Center Theater with my art. Maybe Bernie, André, and the others were simply as exhausted by the process as I was, but at this showing there was nothing but enthusiasm for the art, and without further ado it went into production. Praise be to God!

16

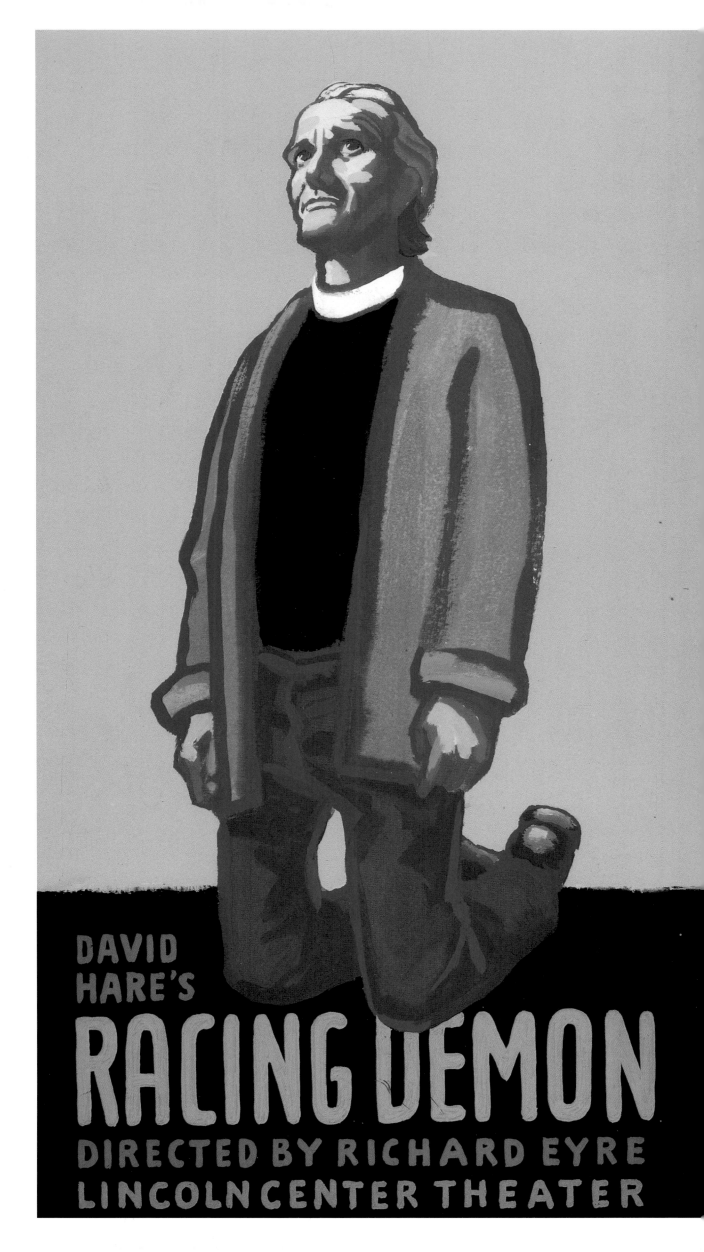

DAVID
HARE'S
RACING DEMON
DIRECTED BY RICHARD EYRE
LINCOLN CENTER THEATER

A Fair Country

By Jon Robin Baitz. Directed by Daniel Sullivan. 1996

Lincoln Center Theater tended not to assign me posters for the plays that ran in the smaller of their two theaters, the Mitzi Newhouse. I believe this was partly because they rarely printed the large, three-sheet posters for these shorter-run plays, and partly, I suspect, because many of these plays were by younger playwrights. I think, in the minds of Bernard Gersten and André Bishop I was appropriate to do a poster for a playwright such as John Guare or Tom Stoppard, who are somewhere in my age neighborhood, but I was not postmodern enough to create a poster for a playwright in his or her twenties or thirties.

From my point of view, there was a harsher and less romantic aspect of my work that I felt lent itself to contemporary subject matter, and which I wanted to have more chance to explore. Plays like David Mamet's *Bobby Gould in Hell* or Howard Kordier's *The Lights*, which I hadn't done the posters for, intrigued me creatively in a way that was quite different from thinking, for instance, about the intellectual historicism of *Arcadia*. And, of course, like all aging artists, I was loath to concede that there really might be something about the life of a thirty-year-old that I couldn't understand or react to creatively.

So it was with a great deal of interest that I met the thirty-year-old playwright Jon Robin Baitz at a party in Sag Harbor in the summer of 1995. Baitz's play *A Fair Country* was going to be staged at Lincoln Center Theater that winter, and before I had a chance to tell him that I would like to do the poster for his play, he announced to me that he had insisted to Bernard Gersten that his play should have a McMullan poster. This request, as far as I knew, had not been agreed to. After I thanked him for his endorsement and admitted my own enthusiasm for his previous play, *Substance of Fire*, we agreed to approach Bernie together. About a month later, at the Joan Cullman awards dinner at Lincoln Center, Jon Robin and I had a chance to corner Bernie and wring from him his agreement to let me do the poster for *A Fair Country*.

Baitz's play, set primarily in Africa, is on one level a suspense drama about whether or not a father has turned over a list of names of his son's militant friends to the CIA. On a deeper level, it is a play about the illusions that each member of a family uses in order to keep going in an essentially corrupt expatriate existence. The most significant of the relationships in the play is between the younger son, who is gay, and the mother of the family. The young man, after the father's betrayal, flees to a remote archaeological site in Mexico, and the play opens in a flashback, as the mother arrives at the desert dig to tell the son of his father's death.

I was attracted to the stripped-down environs of the dig scene and to how much the dialogue, in a charged, minimal way, suggested about the conflicting feelings between mother and son. I decided to concentrate on the encounter between these two characters as the basis for the poster.

1.
A sheet of drawings I made as I began to think about possible images for the poster. Some of the sketches incorporate part of a tent, an element I eventually decided was too complicated.

2, 3.
Photos I took of Matt McGrath, who played one of the leads in *A Fair Country*.

4.
The sketch that came very close to what I wanted. In the final stage I simplified the painting.

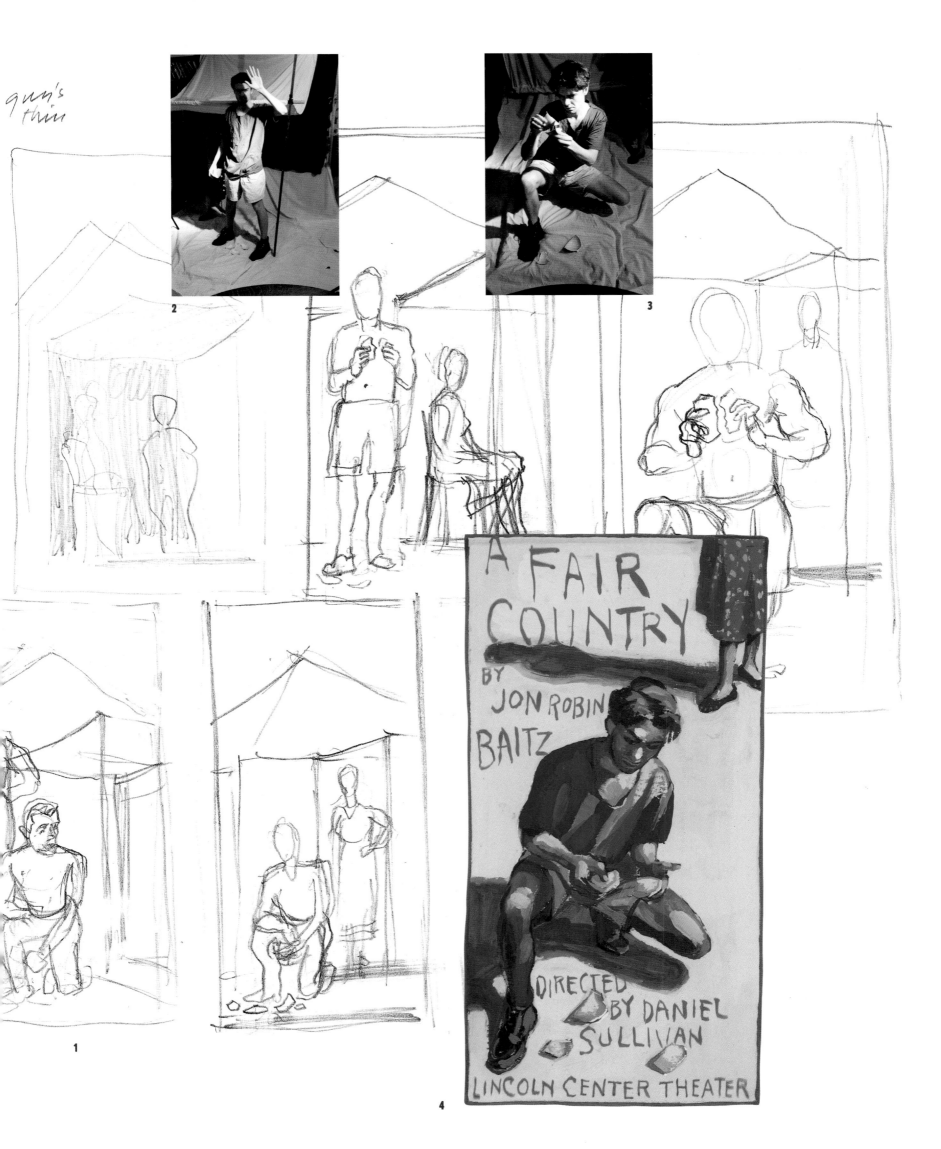

There was an interesting linking of details between the first scene in the play, in which the son describes finding pieces of ancient pottery in the sand, and the second scene, where the family's African maid breaks a vase. It seemed to me that both of these incidents echoed the larger theme of the family breaking apart and the reciprocal search by the son for pieces that would still fit together. I felt that picturing the son puzzling out shards of pottery while the mother looks on could suggest the underlying action and mood of the play.

I discussed my idea with Jon Robin Baitz, and he agreed that it was a promising and appropriate direction to follow. I talked to Bernie and André about the basic idea, and after they saw my rough pencil sketch, they also agreed I should pursue it.

Although rehearsals hadn't quite started, the actors for *A Fair Country* had been cast, and I was lucky that Matt McGrath, who played the younger son, was willing to pose for reference photos. Matt had already played the role in a workshop production, so when he arrived at my studio he understood what I was asking him to do in relation to the whole play. My wife, Kate, was willing to stand in for the mother.

I photographed three kinds of poses with Matt, exploiting the fact that he could bring subtle variations of intensity to a limited range of movements. Two of the poses involved his interactions with a "tent flap" I had rigged up in my studio. One pose had him standing in the front of the tent, and the other had him kneeling, half in the shadow, underneath the tent flap. The third pose was a more straightforward kneeling, holding the shards of pottery. As much as I was inter-

5.

A pencil study.

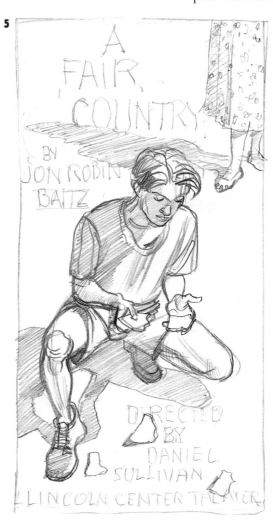

ested in the play of light and shadow that the fabric hanging over him allowed me to observe, I finally decided that it was too complicated to establish that the piece of cloth was a part of a certain kind of tent. Having the figure simply kneeling in the foreground with the partial figure of the mother behind him seemed to put the emphasis more strongly where it belonged, on the hands holding the pieces of pottery, and invested them with more of a symbolic meaning. As I did paintings of this third pose, I began to crop the figure of the mother to make her look more ominous. Her shadow falling behind the young man's head also suggested a connection that was not entirely benign.

My first color painting of this arrangement felt as if it was on the right track, but it had taken too many brush strokes and too many colors for me to arrive at the image. I hadn't achieved that primalness of gesture that, as in all my recent work, I had been aiming for.

I started again, on a larger scale, and this time I managed to strip the drawing and the painting down so that the lines and shapes very quickly read, "squatting man holding fragments." Although the drawing was almost crude, the anatomy was convincing.

This poster, with its curious arrangement of shapes and its evocation of a hot tropical light shadowing the man's face, is one of my favorites.

A Delicate Balance

By Edward Albee. Directed by Gerald Gutierrez. 1996

Reading the play script for *A Delicate Balance* felt like a trip back in time. It is a play about suburban WASPs living a life of smug gentility that would be very difficult to support anymore—psychologically, if not economically—and that was bolstered (or anesthetized) by serious hard drinking. It was the kind of fifth-a-night drinking I remember from my parents' generation when we lived in China and Canada in the 1940s and 1950s, an intake that seems physically impossible when I think about it now. Too, the play's realism is fashioned with such extraordinarily witty dialogue and achieves so many layers of covert and overt vitriol that I could not help but hear it as the speech of a distant and more sophisticated time.

The three main characters in the play—Tobias and Agnes, husband and wife, and Claire, Agnes's sister, who lives with them—are nasty in a droll way to one another as a defense against the emptiness they feel and the disappointments and grudges they bear from their shared history.

As I read Albee's words, and the personalities began to emerge, I saw each character lashing out at the others from his or her isolated position in a room. All the Jacobean furniture and the fussy accoutrements of a 1950s upper-class interior held these characters immobile, like a spider's web holding captive flies. And like insects caught in this way, they were heavier than the web and yet stood frozen there, held in the grip of its tracery.

I experimented with this visual conception in three-color sketches, seeing the characters as dense boulders against the linear complication of their furniture. I sensed that the next stage would be for me to begin final art, so I stopped at this point and made an appointment to show the three sketches to Bernard Gersten, André Bishop, Jim Russek, and Tom Cott. And when they saw the sketches all four were warily positive, anticipating, perhaps, that the sketches represented a strong conception of the play that the author might not entirely agree with. They asked me to show my ideas to Edward Albee, who happened to be at the theater that day at a casting audition.

I had met Edward thirty years before in the San Remo Bar in Greenwich Village, and this was only the second time I had seen him since. Edward looked at my sketches without much visible

1, 2, 3.
Color sketches I did before photographing models, in which I tried out the idea of heavily painted figures against a more delicate background. I hoped this would suggest their psychological immobility.

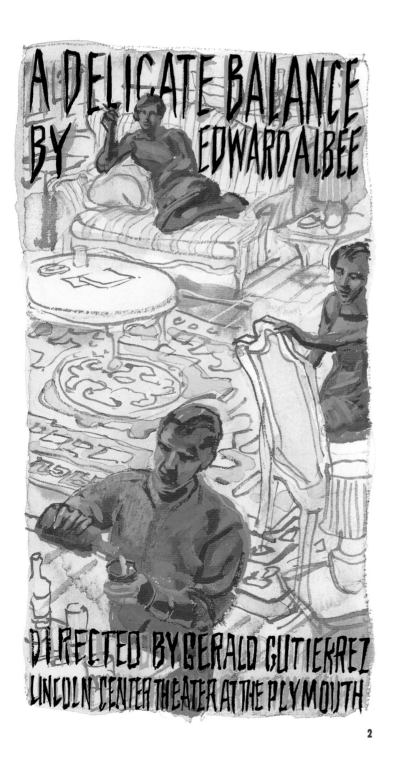

2

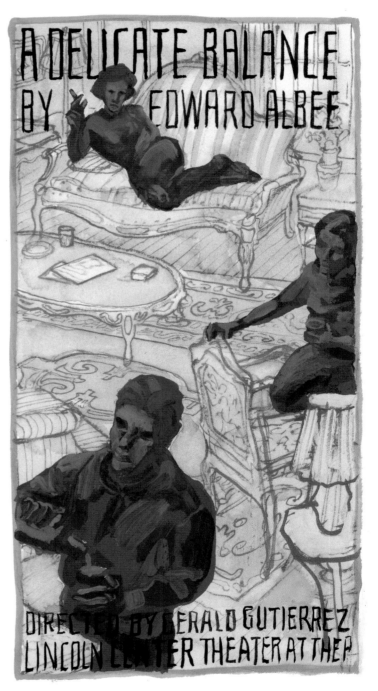

3

reaction, and then handed them back to me, suggesting that I might do something more symbolic, an image of a glass and an ashtray, perhaps. I managed to convey to him that I wanted to show some arrangement of the characters from his play, and I explained that my sketch was based on the idea of the figures being isolated. Once he began to think about the poster in this way, he agreed that "isolation" was an appropriate response to the meaning of the play, but he said he would be more comfortable with the art if it could suggest that Tobias and Agnes operated as a couple to gang up on Agnes's sister, Claire. I told him I thought this was a good idea.

My general impression of Edward's response was that his mind was on other aspects of the production, and he wasn't that interested in the poster. I checked in with Bernie and André on my meeting with Edward, and they both said the revised idea sounded fine to them.

With this rather oblique go-ahead, I proceeded to hire models from an agency. I knew that the roles had already been cast, with Rosemary Harris as Agnes, George Grizzard as Tobias, and Elaine Stritch as Claire, so I tried to match them the best I could with agency models, knowing that it would be impossible to schedule all three of the actual actors for a photo session. I arranged with a friend who had an appropriately furnished apartment to use it for the shoot.

After my talk with Edward, I had a clearer role for my models to play. Agnes, the wife, was determined to control the underlying chaos of their lives by pressuring Tobias, her husband, to make a united front with her, which he does not entirely feel, against Claire. Despite her alcoholism, Claire is the most provocative, ironic, and truth-telling character in the play. She stands apart from Agnes and Tobias, observing the breakdown in the family and commenting with cutting humor on her own descent into drunkenness.

I took many photos of my three models in various combinations of poses, but I kept coming back to one of the husband sitting rather disconsolately in a chair, looking into the drink in his hand, with his wife standing next to him, her hand territorially guarding the back of his chair. Claire, meanwhile, is standing apart, looking on.

I encouraged the model playing Claire to pose with a certain challenging sauciness in the tilt of her hips, and in the angle of her arm and hand holding the goblet of brandy. I asked her to look at the other two characters with a sarcastic smile.

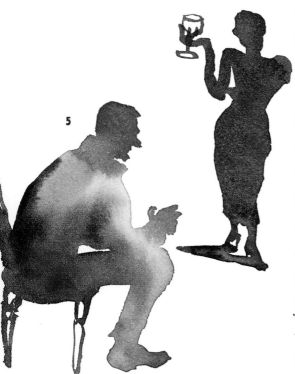

Using the information in the photos, along with some magazine pictures of interiors, I began by using a brush to draw a symmetrical room in fine-lines. I laid over this drawing a sienna wash that suggested light coming in from two windows. Atop this almost schematic interior, I began to paint the three figures in heavy strokes of gouache. My first two attempts didn't quite make it, but my third painting came together for me. When Bernard Gersten, André Bishop, Tom Cott, and Jim Russek saw the painting, they lifted the mat on the art, and we all agreed that it was a more effective piece of art when the figures were surrounded by a bigger area of the elegant room.

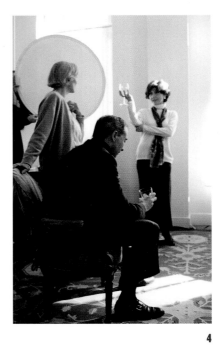

4.
A photo of the models I hired to act out the final idea.

5.
A calligraphic study of the gestures of the insouciant sister-in-law and the dejected husband.

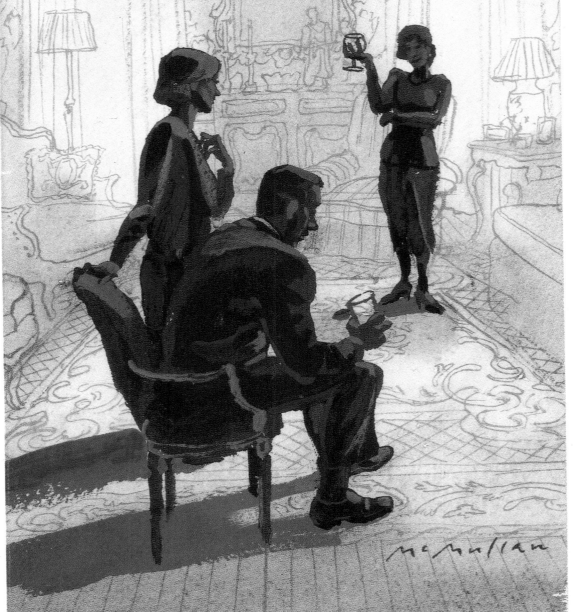

Edward Albee's
A Delicate Balance

directed by
Gerald Gutierrez

Lincoln Center Theater
at the ⑤PLYMOUTH

It's a Slippery Slope

By Spalding Gray. 1996

There was no script for this monologue by Spalding Gray, but I was given an audiocassette of the early stages of the piece to listen to. *It's a Slippery Slope* was ostensibly about Spalding learning to ski, but like all of his monologues it had complex subtexts, in this case dealing with fear, fatherhood, and "what's waiting at the bottom of the mountain." I didn't really feel compelled to suggest any of these topics in the poster because I wanted to achieve another kind of visual objective. Spalding is so interesting to watch in his monologues that I felt if I could capture something quirky in the physical man, it would be more than enough drama for the poster.

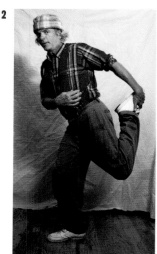

Before Spalding came to my studio to pose for me, I had thought of only one promising idea, which was to show him balancing precariously on a sloping surface as though skiing, but without poles or skis. When he arrived, we tried many things, including the balancing act I had sketched out. After we had been working for about forty-five minutes, Spalding suddenly began to give me a series of strange physical postures that came out of my balancing idea but were his own, idiosyncratic take on balancing. The poses were silly, wonderfully charming gestural inventions that revealed the playful, risk-taking performer under the polished and controlling writer.

I spent some time doing sketches based on the side view of Spalding in leaning-forward balancing poses, because they went so well with the title. But eventually I came to my senses and realized that Spalding's improvisations were so personal and visually intriguing that I would be a fool not to base the poster on one of them.

The final art owes a great deal to Spalding's inspired clowning and to the clear, head-to-toe information in the photographs. This happy combination gave me a chance to do the kind of thick-lined, simplified figure drawings that currently interest me.

1, 2.
Two photos of Spalding Gray.

3.
An example of sketch overkill. Six versions of the "teetering on the brink" pose. It still didn't work.

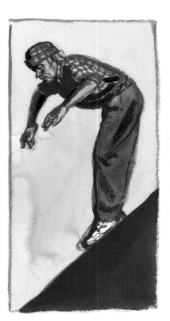

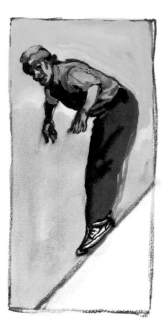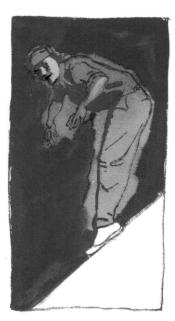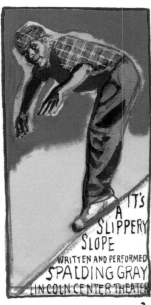

IT'S A SLIPPERY SLOPE

WRITTEN AND PERFORMED BY SPALDING GRAY

LINCOLN CENTER THEATER

God's Heart

By Craig Lucas. Directed by Joe Mantello. 1997

In a phone conversation, Craig Lucas, the author of the play, gave me a phrase that became the underlying motif of my hunt for a poster image. The phrase was "yearning to merge," and it summed up as well as anything could the play's five central characters searching to cross boundaries of race, sex, and class, and finally to connect with one another.

The two most yearning characters in the play are Carlin and Janet. Carlin is a fourteen-year-old black boy, a student and a part-time lookout for a drug dealer. Carlin says, "We gonna save mankind and vanquish death forever!" Janet, a thirty-year-old white, middle-class mother, says, "And if there were a place . . . where everyone could touch." Carlin's quest to save mankind involves a computer regeneration of a dying woman's life, and Janet's longing to touch leads her to try to save Carlin from poverty.

There is an ironic flip-flop in the way things develop during the play. Although Janet is far richer than Carlin, and she sets out to save him, he comes through as the stronger person, with more to give to Janet

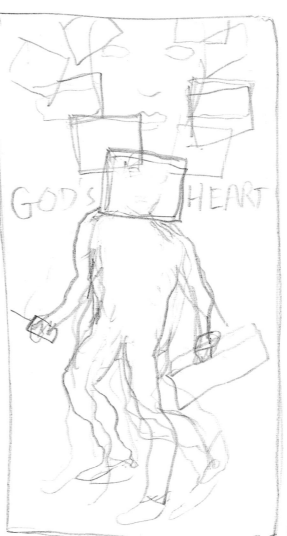

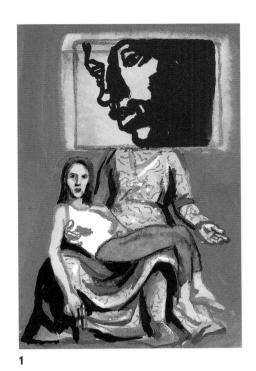

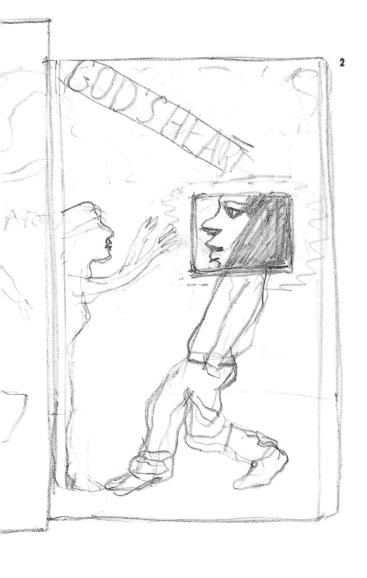

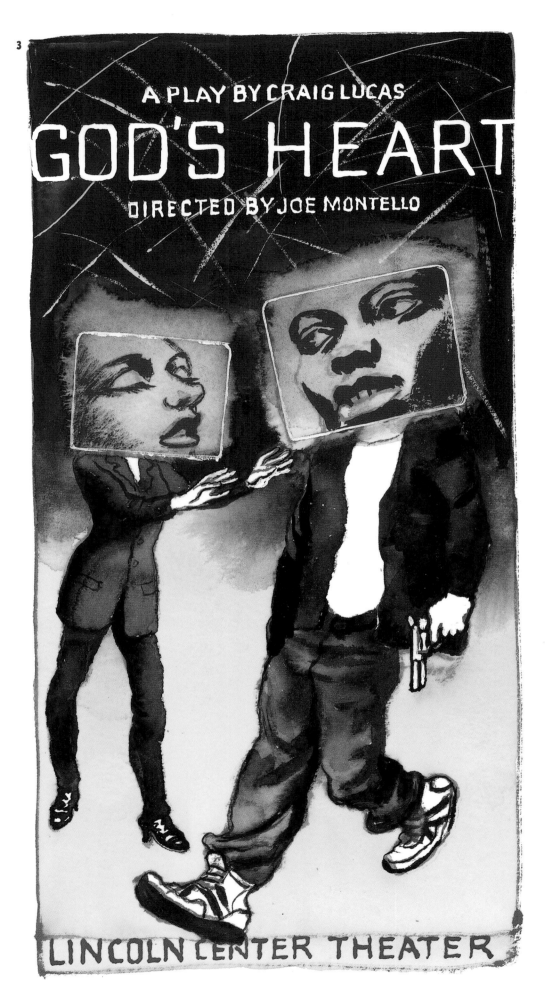

4.
Photographs of Rob Babboni acting out the idea of the "yearning reach."

5.
A pencil study that included a third figure, which I finally decided was unnecessary.

than she has to give him. It was in considering this paradox that I lit on a curious association: I suddenly saw a version of Michelangelo's sculpture of the Pietà, with Carlin playing the role of the Madonna and Janet lying across his lap as a not-so-dead Christ. I further imagined that the head on the Virgin figure was not Carlin's real head, but his face enlarged on a TV screen. This last notion came out of the play's liberal use of huge monitors and video images to stand in, at times, for live actors.

As intriguing as this pastiche was as a poster idea, actually achieving enough similarity to the original sculpture to make the connection obvious involved a great deal of tedious rendering. The image I ended up with was too heavy to lift off into the ether of whimsical poignancy—a rare subdivision of humor that has not been much recognized.

The cute route to a solution having hit a dead end, I decided to try a simpler idea, which involved Janet reaching out to Carlin. I thought of Janet as a well-meaning liberal white woman whose attempt to reach Carlin is somewhat naive, so I showed her as a sleepwalker, or perhaps as someone playing blindman's bluff without the blindfold. I thought of Carlin as embodying the street smarts and the charm of someone with a lot of life force, so I drew him walking, his weight back on his heels, with a kind of ghetto insouciance. I equipped both characters with monitor heads, and I crisscrossed the dark blue background with streaks that I hoped would suggest the tracery of electrons making complex connections.

Craig Lucas didn't like the sketch at all, and he told me why very politely in three long phone messages over the next weekend. Basically he felt I hadn't caught the romantic, transcendental quality of his play, that my sketch felt too earthbound and prosaic. He particularly objected to the gun in Carlin's hand, which he felt stressed the underclass circumstances of the kid's life too much and turned him into a cliché. I understood his objections, although I thought my image had a little more magic than he was giving it credit for.

Craig suggested that I consider painting a large TV monitor showing the face of Eleanor, a black woman who is dying of cancer, and Carlin reaching up toward the screen. I wasn't enthusiastic about this idea because I had already sketched out several designs with a large TV rectangle at the top of the poster, and I had concluded that there was something too square and locked-in-looking about this arrangement.

Without much conviction that it would succeed, I decided to try for the figure of the reaching Carlin by photographing my assistant Rob Babboni in variations on reaching poses. I hoped that I could later resolve some kind of TV face that would not seem like an immobile box sitting like a lump at the top of the poster.

The photographs of Rob were very lively, and I was able to do pencil studies from them that encouraged me. The vitality of the figure changed my view of Lucas's idea. After some experiments with a very simplified face in a glowing rectangle, I knew I could solve the problems at the top of the poster, too. The art resolved itself fairly quickly after that.

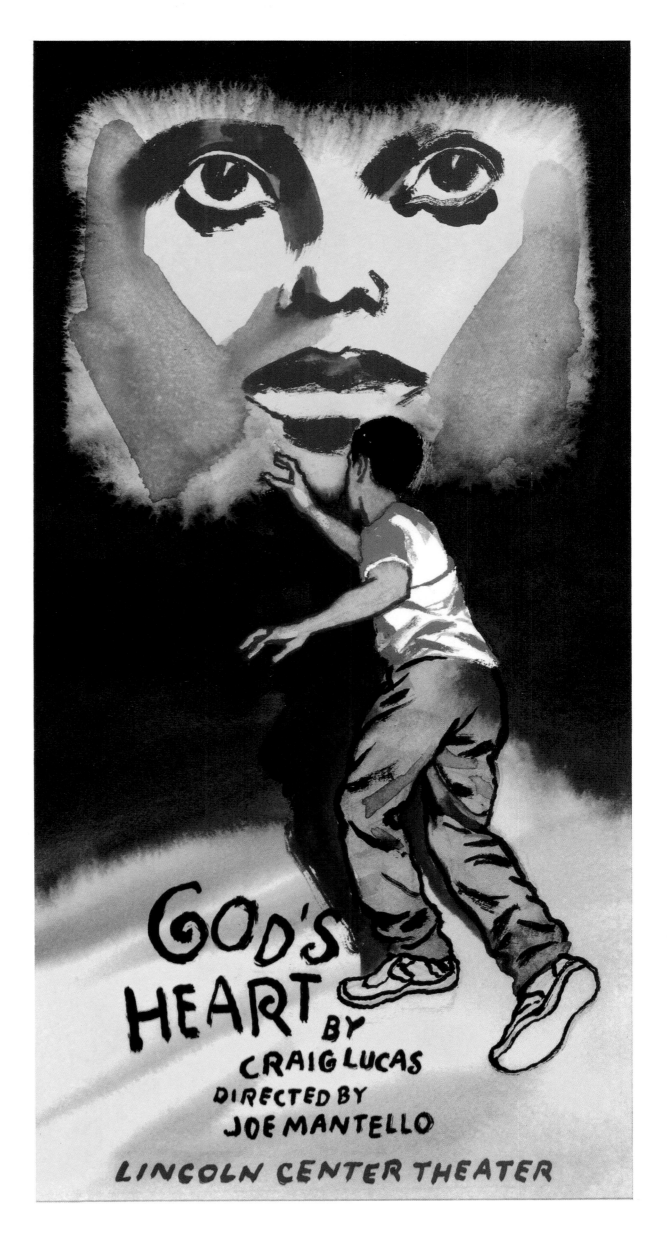

An American Daughter

By Wendy Wasserstein. Directed by Daniel Sullivan. 1997

Because a Lincoln Center poster is created with input from producers, directors, playwrights, and advertising executives, there is sometimes an understandable muddle of ideas at the beginning of the project. *An American Daughter* had its fair share of cooks. The first person to add to the soup of poster ideas was Jim Russek, who suggested to me that the central character's ancestor, Ulysses S. Grant, was a legitimate contender for inclusion on the poster. I saw Jim's point, because Grant's letters are quoted throughout the play as a historical counterpoint to the contemporary political machinations. I was also inclined to agree with Jim because the Civil War figure would give me great graphic opportunities to set up anachronistic tensions in the poster.

I immediately saw in my mind's eye a defiantly modern woman set against the stern demeanor of the handsome Civil War general.

When I brought up this idea with Tom Cott, the director of marketing at Lincoln Center Theater, he said that he didn't think Wendy Wasserstein, the playwright, would go along with including Grant on the poster. So I called Wendy, and I explained why I thought the contrast of her modern heroine, Julia, with Ulysses S. Grant would make a good poster. She said that she understood my concept, and that in any case it was my decision.

At the photography session with Kate Nelligan, the actress playing Julia, Tom Cott suggested that I make the idea of a TV journalist interviewing the character Julia as strong as possible, but Kate Nelligan and I kept returning to poses that I saw in relation to a photograph of Ulysses S. Grant that I had found.

I began my work on the poster by doing a subdued watercolor portrait of Grant as a base for the whole image. Using sheets of clear acetate over the Grant art, I experimented with drawing various poses from my Nelligan photos until I found one that worked. I then painted, in simple black contours and flat gouache tones, directly on top of the Grant watercolor. I added bars of lettering, top and bottom, which stabilized the architecture of the poster.

I was very pleased with this art and took it in to show Bernie, André, and Tom Cott. Both André and Bernie were enthusiastic. André said that it was nothing like any theater poster he had ever seen before, but he was fascinated by it. Bernie simply liked it. Tom felt that the Grant figure was too dominating, but because André and Bernard had been positive, I left the meeting feeling that I had sold my design.

1

on General

tydom

1.
A sheet of preliminary ideas.

2.
The photo of Ulysses S. Grant, which was a very intriguing element to me.

3.
An early drawing of the idea of the modern woman set against the stern Civil War general.

My ebullience was short-lived. A few days later, Bernie and André told me in a conference call that both Wendy Wasserstein and the director, Dan Sullivan, felt that the art was inappropriate for the play. They both felt that the Grant figure shouldn't be in the poster and that Julia should look more formal, more like a candidate for the position of attorney general.

This was the most dramatic difference between a first and a second opinion that I had ever heard, but none of my arguments could convince André and Bernie to override the play-wright and director.

I reshot photos of Kate Nelligan. This time she was wearing an Armani suit and facing a TV camera and its glaring light, which I had borrowed from a journalist friend. I experimented with various styles of showing the camera, the light, and the woman before ending up with a close-cropped version that made the most of Julia's anxious expressions, her wringing hands, and her squirming body.

4.
Photos of Kate Nelligan that I used as the basis of the figure in the first piece of art I showed to Lincoln Center Theater.

5.
A pencil sketch.

6.
The rejected first design.

4

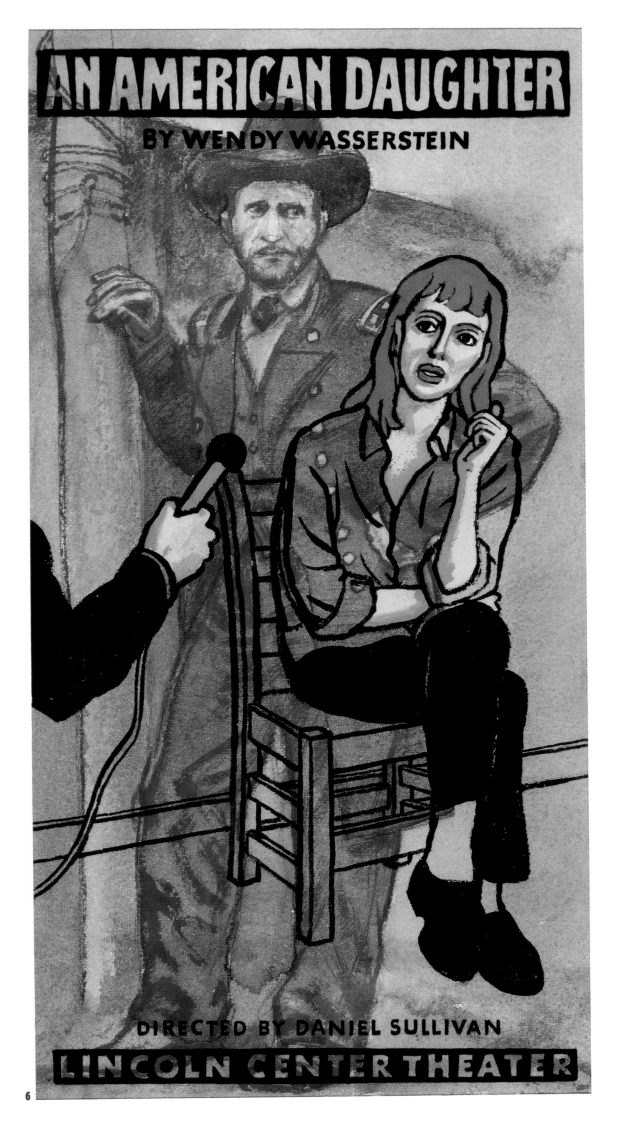

5

6

115

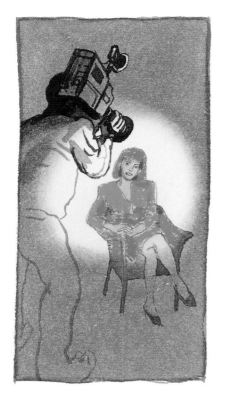
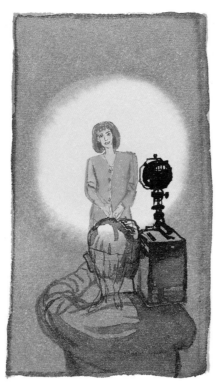
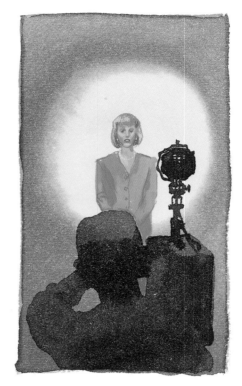

7.
Various sketches I did on my way to the final design.

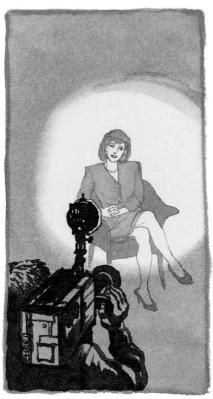
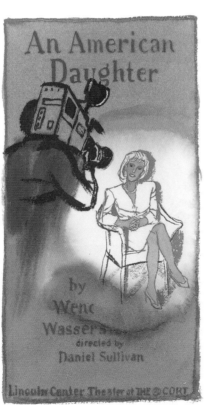
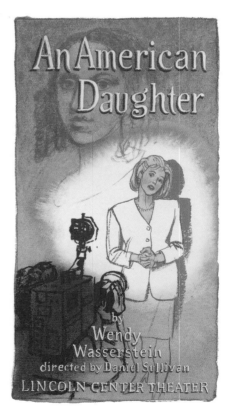

7

116

The Little Foxes

By Lillian Hellman. Directed by Jack O'Brien. 1997

What a good, solid melodrama this play is! A cruel wife whose machinations fuel the plot, a saintly husband, a strong brother humiliating a weak brother, a fortune to be won or lost, an innocent daughter caught in the middle: what more thrilling elements could a poster designer ask for?

When I spoke with the director of *The Little Foxes*, Jack O'Brien, he agreed with me that the character of the villainous wife, Regina, was the obvious subject for the poster. As he imagined the poster, Regina would be seen climbing the stairs from the viewpoint of a "camera" at the top of the stairs. I agreed to try this idea, although I realized I had to overcome the inherent difficulty of this viewpoint. A woman climbing stairs in a long dress and seen from above could be a very static image. The head-on view foreshortens the figure, and the dress disguises the action of the legs. The one thing I didn't want was a poster with a frozen, boring figure on a staircase.

After a disastrous attempt to photograph my not-altogether-cooperative sixteen-year-old daughter in

1.
Photo of my model climbing the stairs.

2.
Four small studies.

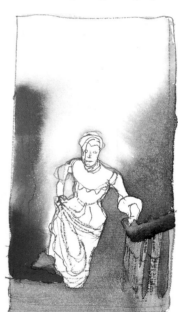

a rented period costume on the staircase of John Scanlon's Sag Harbor mansion, Lincoln Center Theater provided me with a model and a brownstone location with a good staircase. I did have problems during the subsequent photo session finding a way to instruct my model so that the view through the lens was interesting. As I had anticipated, there was simply not enough sense of action in most of our attempts. In frustration, I asked my model, instead of beginning her climb in the middle of the staircase, to start walking at a brisk pace on the landing below, and to swing around the banister as she began the climb. This strategy led to a greater sense of movement, both in her body and in her dress. So finally I was able to catch a woman in action moving up the stairs with a strong sense of purpose.

I painted from these photographs, exploiting both the tension in the model's gesture and the zigzag of shadows as they fell across the agitated fabric of her dress. I matched some of this angular feeling in the painting with spiky lettering for the title.

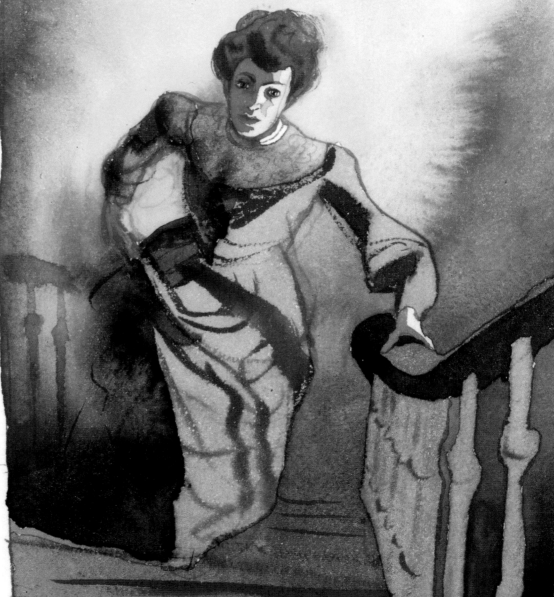

The Little Foxes

by Lillian Hellman

directed by Jack O'Brien

LINCOLN CENTER THEATER

Pride's Crossing

By Tina Howe. Directed by Jack O'Brien. 1997

This design may represent the furthest a poster image of mine has moved away from the action that actually happens on the stage in the play. Clad in a one-piece bathing suit, Cherry Jones, the star of the play, does dive into the arms of other actors, but this is as close as she gets to the 1920s swim of the English Channel that is a central memory of the play's main characters and which I ended up symbolizing on the poster. I resisted the idea because I didn't think I could pose Cherry Jones believably as a swimmer in my studio, and I didn't want to paint an image like a sports photo explaining the mechanics of swimming and showing all the little water droplets.

1.
Photo of Cherry Jones.

2, 3, 4, 5.
Sketches of early ideas.

So my first sketch was based on Ms. Jones as a diver, my second as someone "looking out to sea." When both of these sketches were turned down, I realized that as wonderful as the photos of Cherry Jones were, I had to think of an idea that wasn't restricted to the poses I had taken.

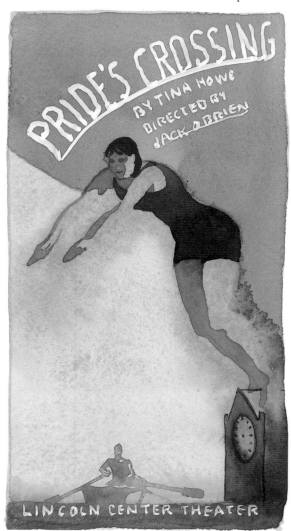

2

3

4

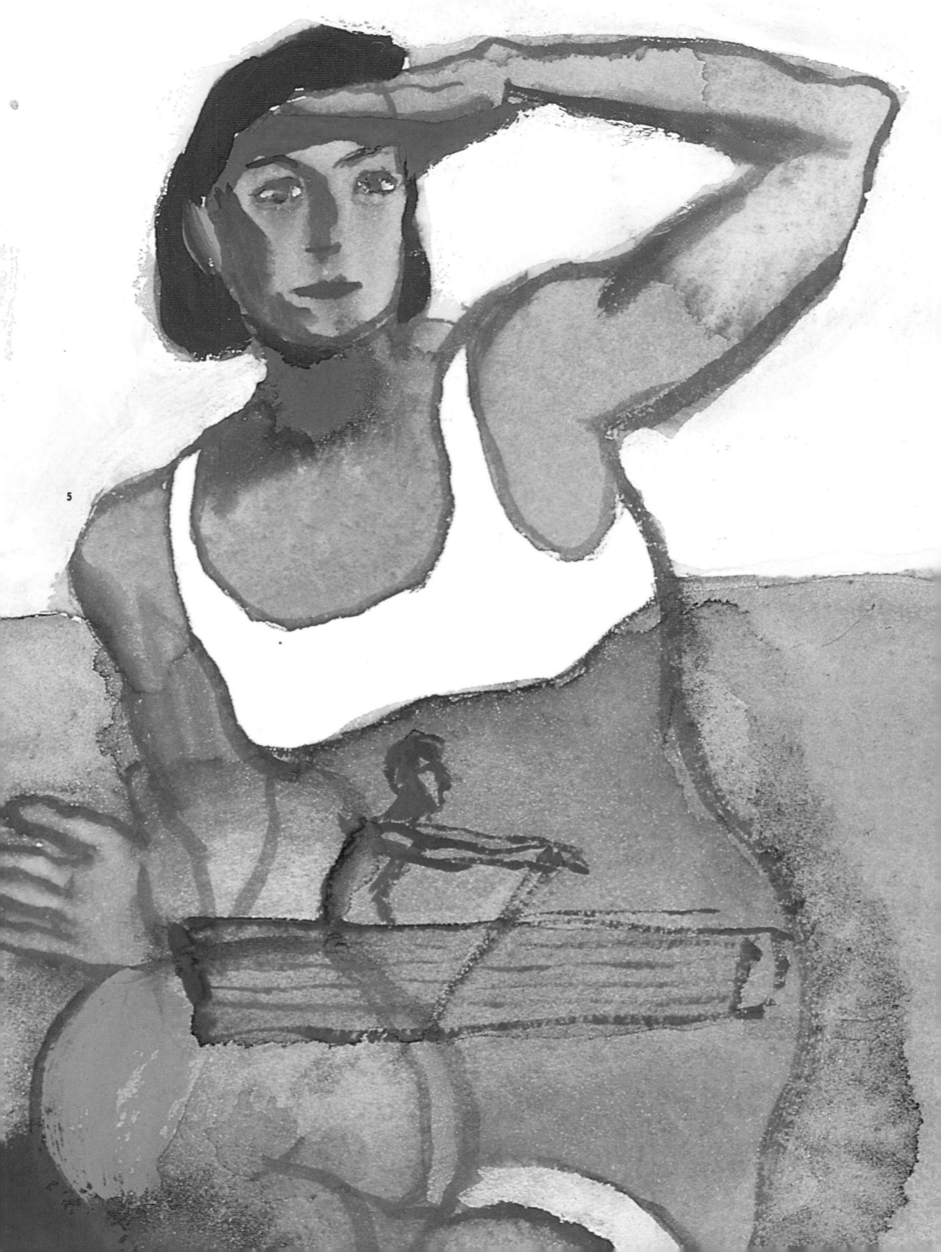

It was then that I thought of the sea itself as the main character and the swimmer a smaller element, battling the rough waters.

This took the emphasis away from the close-up "freeze frame" of arms flailing through water droplets, the kind of painting I didn't want to do, and let me create a strong pattern of waves by painting them quickly and calligraphically, a kind of painting I was delighted in doing.

6.
An early photo of Johnny Weismuller that I was able to transform into the play's heroine.

7.
The transformation.

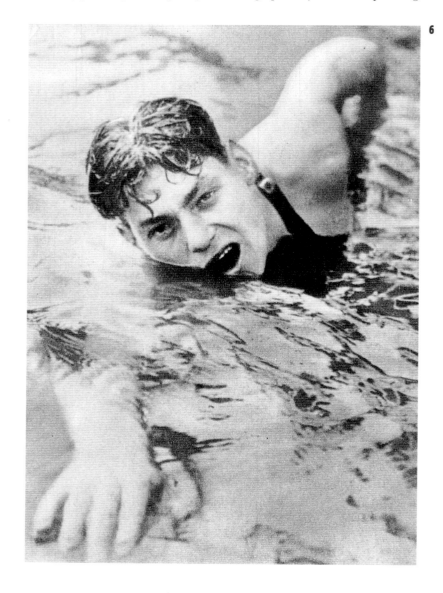

6

7

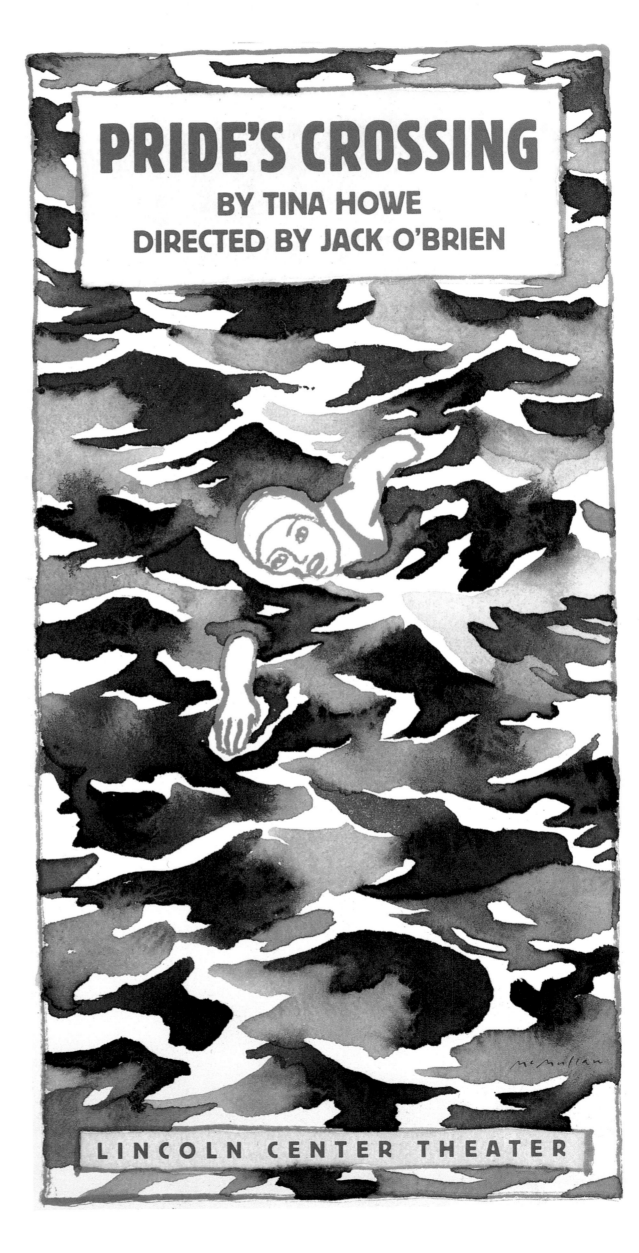

PRIDE'S CROSSING
BY TINA HOWE
DIRECTED BY JACK O'BRIEN

LINCOLN CENTER THEATER

Ah, Wilderness!

By Eugene O'Neill. Directed by Daniel Sullivan. 1998

1.
A sheet of drawings in which I am working out possible poses for the Byronic, poetry-spouting adolescent in the play.

2.
A photograph of Eugene O'Neill and his family on the beach in 1934. His body language confirmed my idea of how certain artistic types sit or stand.

3.
Photos of Sam Trammell, who plays Richard, the main character.

4, 5.
The photo that became my main reference and a pencil study I did from it.

6.
A color study.

Eugene O'Neill gives Richard, the sixteen-year-old central character of his play, this description: "There is something of extreme sensitiveness added—a restless, apprehensive, defiant, shy, dreamy, self-conscious intelligence about him. In manner he is alternately a plain, simple boy and a posey actor solemnly playing a role."

This evocation of a teenager trying on a persona, particularly the role of the tortured artist, rang a loud bell with me. I remember myself at sixteen reading poetry I didn't understand, playing dissonant Bartók music I didn't really like, speaking condescendingly of the bourgeois knickknacks in my mother's curio cabinet—in short, behaving in every way to ensure my stagey isolation from what I considered the Philistines of the world. In thinking about *Ah, Wilderness!* I became fascinated with how I might do a poster based on the image of the "posey actor solemnly playing a role"—a central aspect of the drama and a condition of adolescence with which I had a strong identification.

In the third act of the play, there is a scene in which Richard is waiting on the beach for his girlfriend, Muriel. This scene seemed a natural setting in which the young man might self-consciously play his role. I saw Richard sitting on a rowboat, staring up into the moonlit sky and practicing the poetry that he would recite to Muriel, and probably try to pass off as his own. What I wanted to achieve in this portrait of Richard was his youthful intensity and also the kind of physical awkwardness I associate with people who live more in their heads than in their bodies. It occurred to me that if I were right in making a connection between intellectual precociousness and physical awkwardness, I would find some evidence to back this up in looking at candid photographs of Eugene O'Neill. I was convinced, on a deep level, that the character Richard was a stand-in for the playwright.

Sure enough, I found photos of O'Neill and his family sitting on the beach in Provincetown in 1934, where the playwright's knees are pressed together in ungainly defensiveness and his hands flop over each other with the softness of taffy. It wasn't effeminacy, exactly, but a carelessness in the use of the body that reflected how much his attention was turned inward to the boiling hell of his haunted childhood and the creative stew he was making of it. He looked, in these photographs, like a man who could barely endure the charade of a family picnic at the beach and all the physical good times that it was supposed to represent.

I explained my concept of adolescent angst and my research into O'Neill's body language to Sam Trammell, the young actor

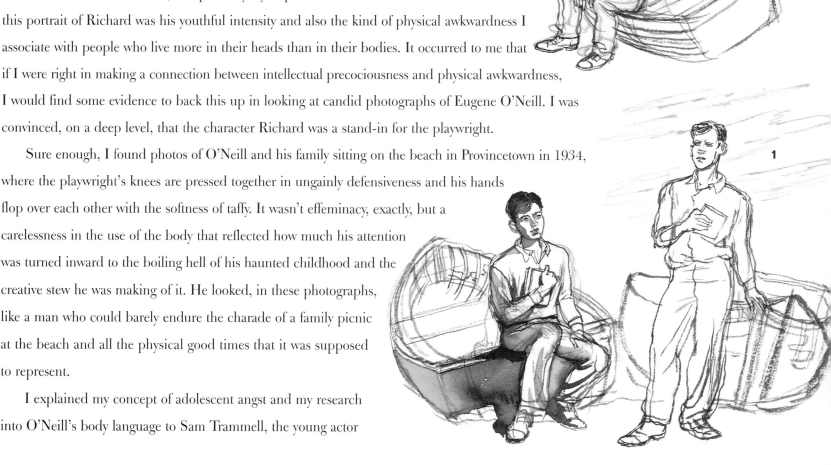

1

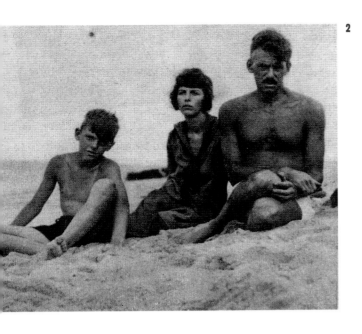

2

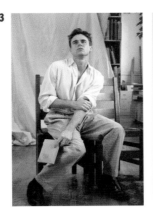

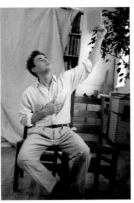

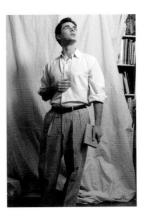

3

4

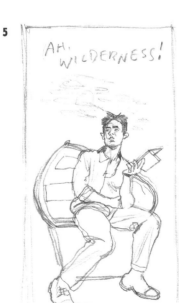

5

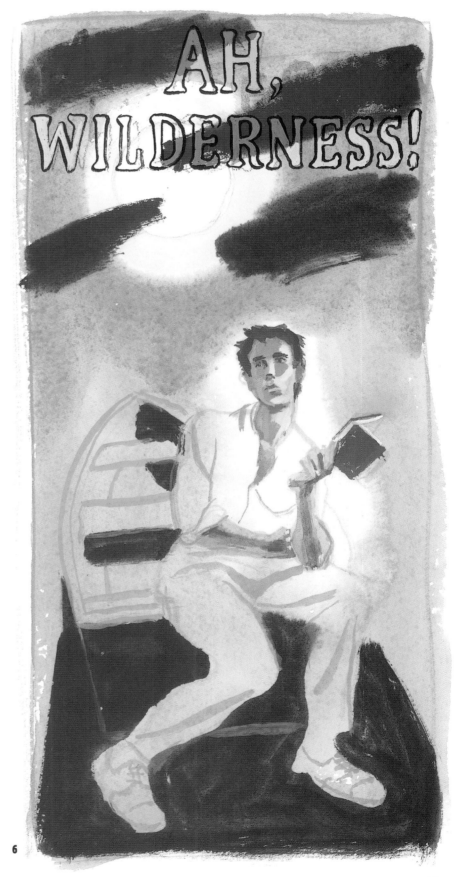

6

playing Richard in the play, when he arrived at my studio to pose for reference photographs. The degree to which he understood my thesis is clear in the photographs I took of him. He gave me knock-kneed, starry-eyed impersonations of an arty young man, exactly as I had imagined. These pictures of Sam, based as they were on an idea close to my own heart, inspired the intense portrait I then made. In many ways it is the most complex and idiosyncratic head I have ever painted. When I showed the art to Bernie and Tom, they both responded immediately and enthusiastically to the drama of the figure, and the art went into production. Unfortunately the story doesn't end there. At the company that did the color separations, the art was destroyed. In a fluke accident, the paint in my illustration was melted into a foggy mess and the art was totally unusable. The only record of my painting was a color Xerox that the advertising agency had made before sending the art to the separator. When I got the news about the fate of my painting

7.
A head study done from the photos of Sam Trammell.

7

it was a great shock to me because I knew that I could never really get back into the particular state of inspiration that had led to the painting in the first place. That didn't stop me, however, from spending three days trying to recapture the intensity of the ruined art. It was hopeless. My mood of anger and mourning prevented me from doing anything but lifeless versions of the original image.

At this point, I reconsidered the color copy again. Although the copy had out-of-focus areas, the head itself was a good facsimile of the original portrait, and I decided to use it in a reconstruction. I painted a body and background matched to the original proportions and glued in the carefully cutout Xerox head. After I had delicately painted areas of the head to adjust the color and bring it into balance with the background, I was very satisfied with this revived art. With enormous relief I sent this second piece of art to Lincoln Center Theater.

At this point, Daniel Sullivan, the director, confessed a misgiving he had had with the art from the beginning. He felt that the boy in the poster looked black, both in his skin tone and because of the shape of his hair. I was not alone in viewing his as an idiosyncratic response, but nevertheless, in the interest of bringing this bedeviled project to a conclusion, I agreed to work with designer Janice Brunell at Russek Advertising to make changes on the scanned art in the computer. Of course, once we made a few changes in the image, more changes were requested—the tyranny of the computer. The poster that finally emerged and that was printed by Lincoln Center Theater shows a pink-cheeked lad, lovely hair waving over his forehead, sitting in a background so lightened that the moon appears to have arisen in late afternoon.

I have opted to reproduce here the poster as I originally conceived it, with all its romantic darkness, color complexities, and spiky hair intact.

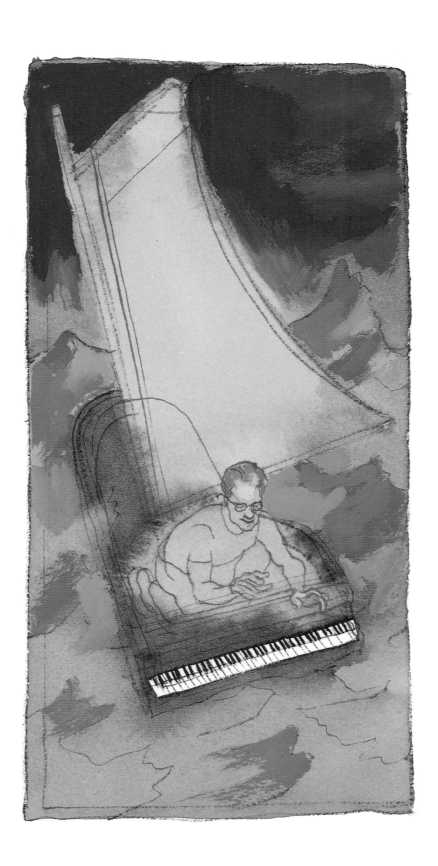

This sketch is an early idea for
William Finn's *A New Brain,* a
poster I was working on as this
book went to press. It shows the
composer hero of this musical
surviving a medical crisis and
going on to write more music.
But maybe it's me trying to
conceive of a poster in the
tumult of my chaotic method.

Postscript

My friend and fellow illustrator Seymour Chwast, witnessing my repeated attempts to get a drawing right, remarked, "I don't know how your nerves take it, the way you work." I felt like a guy in an artists' support group whose pain has finally been felt. Seymour, with that observation, had looked deep into my heart of darkness. What he had seen was that I couldn't seem to create something without throwing myself repeatedly at the problem in a way that seemed to him (and sometimes to me) like barely connected stabs in the dark: sketches that advanced my thinking not in some fluid progression toward refinement but in chancy, jerky steps that were almost as likely to take me away from a solution as to bring me nearer to it. Truly, a spendthrift's use of his nervous system.

This book, of course, is a record of that prodigal employment of "my nerves" (a very Victorian idea, with its hint of neurasthenia) as I composed these thirty-six posters. In each case my searches have left a trail of drawings and sketches that somehow brought me to the concluding poster design. Apart from the fact that I really don't have a choice in the way I work (transforming myself into an efficient, methodical artist just isn't in the cards), my superficially chaotic method serves my most important objectives well: maintaining the vitality of the work and connecting intuitively with the material in the plays.

What I hope will happen as I work on a poster is that the little spaces that occur between the jumps in thinking will allow the subconscious associations that my memory and my obsessions are causing to rise to the surface. It is these somewhat illogical yet pungent ideas that make the most important and interesting turns to the concepts of the posters—the twisting gesture of the reporter in *The Front Page* poster, the hero straddling two horses in *Carousel*, the primal crouch in the figure of the young man in *A Fair Country*. All of these figures and what they convey could have been staged in a more conventional and efficient way, but the idiosyncrasy of the pose or, in the case of *Carousel*, the addition of the second horse, satisfied some only partially understood impulse in me.

These eleven years of working on poster after poster for Lincoln Center Theater have been an unparalleled opportunity for me to strengthen the intuitive expressiveness of my work. This long time span has allowed my work to evolve within the framework of the poster form as my life and my interests have changed. If there is any sense of progression in the thirty-six posters, it is that more of my real biases are being revealed in some of the later posters. *A Fair Country* is not necessarily a better poster than *The Front Page* or *Anything Goes*, but it is a poster that, in its psychological mood, its viewpoint, and its drawing expresses more of what interests me now. I also feel deeply connected to both *Six Degrees of Separation* posters, the first version of *Four Baboons Adoring the Sun*, and perhaps most strongly to the last poster in the book, *Ah, Wilderness!* That poster, both in the way it was painted and in the freedom I felt in using my own history to conceive the idea, is the most successful so far in investing a project with my own autonomous spirit.

As I look back at the stylistic journey from the 1976 *Comedians* poster to that of the 1998 *Ah, Wilderness!* I spy at the far end of the telescope an artist trying for elegance and refinement, a patient artist. At this end of the telescope, I see an artist who is trying to strip down his style to a more immediate if cruder kind of drawing, one who wants to reduce body language to gestures that are simpler yet more evocative.

My methods of working have evolved from careful fusions of transparent watercolor laid down with fine-pointed sable brushes to heavier, flatter gouache paint, stroked on more texturally with scratchy bristle brushes. To some degree it has been a conscious strategy on my part to reach through my own tendency toward nuance, both in style and subject, to a more textural surface and a more direct view of the subject. Using a clumsier tool and a less ethereal medium has forced me to strip my drawing down to the essentials. A bristle brush makes it simply impossible to deal with every subtlety in a face or every wrinkle in a pair of pants. I have had to find a way of putting down only what is absolutely necessary. During the last ten years, I have been teaching and thinking about life drawing, and this has contributed enormously to my growing understanding of how the right few lines can communicate a powerful sense of a whole pose.

The remarkable experience of being able to reach for a higher level of expressiveness by doing a connected body of work would not have been possible without the faith in my talent and the patience with my stubbornness generously given me by two Artistic Directors of Lincoln Center Theater, Greg Mosher and André Bishop. I am also grateful for the enthusiasm of Tom Cott, the Director of Marketing, and the encouragement of Jim Russek, the principal of Russek Advertising. Along with my gratitude to those men I am particularly grateful to Bernard Gersten, the Executive Producer of Lincoln Center Theater. This once-in-a-lifetime opportunity to explore my ideas through a series of posters would never have happened had Bernie not chosen me for *The House of Blue Leaves* poster and then recognized that there would be some benefit to the theater by having one artist do the majority of the posters.

Knowing of Bernie's goodwill on my behalf has been a key to my own ability to take chances when conceiving the posters. Apart from the creative exhilaration it has given me and the professional recognition that only a connected body of work can bring, it has also been an unusually familial professional relationship. We have learned to appreciate and know each other as family members might, and to risk a few disagreements along the way. When Bernie, in his foreword, talks of the "Bermuda Triangle" that working with me represents, he hints at the posters that almost got lost in the turbulent weather of arguing out our different views of what the image should be. The opportunity for creative people to deal with each other as adults is rare in a world gone increasingly corporate and committee-minded. I thank Bernie most sincerely for seeing us both through the rough spots and most of all for the incredibly rewarding experience of doing posters for Lincoln Center Theater.